As children we grew up knowing our neighbors not as people living next door to us, but as relatives.

Our aunt and her family lived on one side, and our cousin and his family lived on the other.

That is the way it had always been.

A home is both the space inside and outside the building.

A home is more than just the structure, the house,

the ki:, the hogan, the wikieup.

Ki: in O'odham means both house and home.

It is the aroma, the textures of the buildings that help us remember.

The smell of the wet dirt walls,

the smell of dry dust.

It is the smell of the green brush on the roof, in the walls.

It is the texture.

The smooth mud walls,

the rough ribs from cactus and ocotillo,

the branches of cottonwood and posts from cedar and pine.

Home is a place that has the right feel,

the right smell,

the right sense of coolness when you touch the walls.

REDEFINING "HOME" ~ BY OFELIA ZEPEDA, TOHONO O'ODHAM

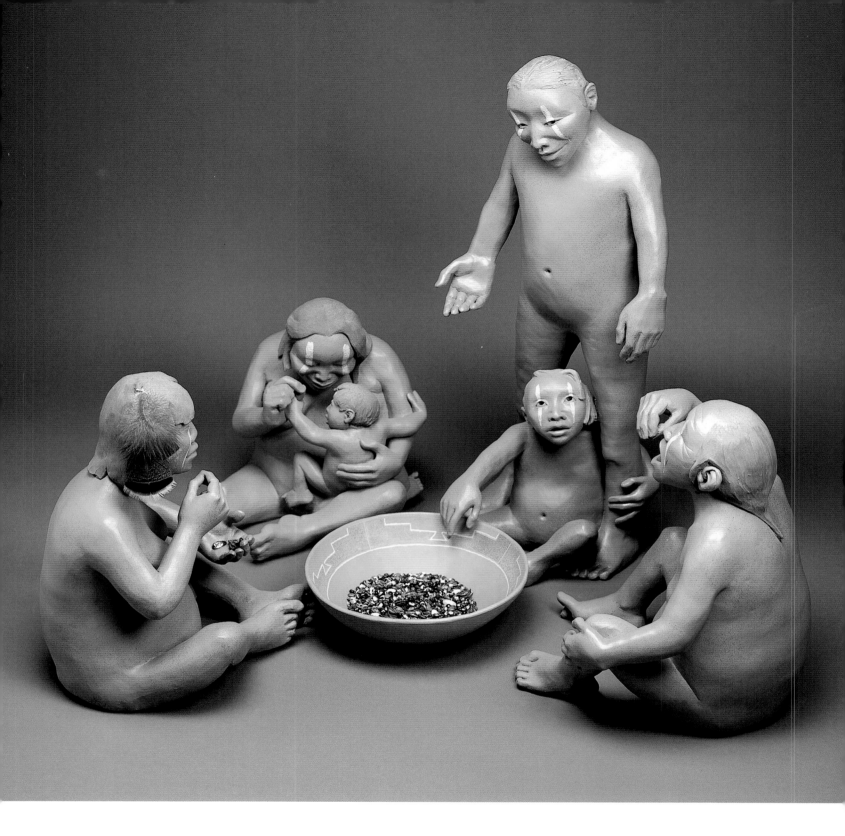

Home

Native People in the Southwest

ANN MARSHALL, EDITOR

WITH POETRY BY OFELIA ZEPEDA

HEARD MUSEUM ~ PHOENIX, ARIZONA

FRONTISPIECE: ROXANNE SWENTZELL (B. 1962), SANTA CLARA. *Tse-ping,* 1991, 31 x 14 x 13.5. "Tse-ping means belly button. In the Tewa world, the belly button is the center of the world. Each pueblo has a belly button in the pueblo. The belly button is in the middle of the plaza. It is a rock of where we come from. It is reminding us of where we come from, from the earth. In Tse-ping, the bowl is the center of the earth and is like the belly button. We are all centered around the earth. We all come from the earth. We are all eating out of the earth. Because of that, we all become one family." Roxanne Swentzell. Gift of the Najafi family and an anonymous donor.

PAGE 6: Detail of a "ribbon wall" created for the installation of the exhibition *Home: Native People in the Southwest.* Craig Smith, photographer.

PAGE 8: MARIO MARTINEZ (B. 1953), PASCUA YAQUI. Garden Mural (detail), 2004. The Mario Martinez mural is a cultural portrait of the Yaqui people in Arizona. In this detail of the mural, Martinez references the cosmos, animals and plants that reflect the spiritual world of the Yaqui. Other parts of the mural incorporate historic photographic images of important leaders as well as family and community snapshots from the artist's personal experience. The historic diaspora from Sonora, Mexico, is represented, and hope for the future is shown by groups of young people and an idealized landscape. Gina Fuentes Walker, photographer. Gift of Joy and Howard Berlin.

LIBRARY OF CONGRESS CATALOGING-IN-PUBLICATION DATA

Home: Native people in the Southwest / Ann Marshall, general editor ; with poetry by
 Ofelia Zepeda ; [overall text coordination and organization, Diana Pardue].
 p. cm.
 Catalogue published in conjunction with the opening of an exhibition held at the Heard
Museum beginning May 22, 2005.
 Includes index.
 ISBN 0-934351-76-7 (hardcover)—ISBN 0-934351-75-9 (pbk.)
 1. Indians of North America—Southwest, New—Material culture—Exhibitions. 2. Indians
of North America—Southwest, New—Social life and customs—Exhibitions. 3. Indians of North America—
Southwest, New—Antiquities—Exhibitions. 4. Southwest, New—Antiquities—Exhibitions.
5. Heard Museum—Exhibitions. I. Marshall, Ann E. II Zepeda, Ofelia. III. Pardue, Diana F.
IV. Heard Museum.

E78.S7H73 2005
745'.089'9707907479173—dc 22

 2005040400

DESIGN: Carol Haralson, Carol Haralson Design, Sedona, Arizona
PHOTOGRAPHY: Craig Smith, Heard Museum, unless otherwise noted
PUBLICATION COORDINATION: Lisa MacCollum, Creative Director, Heard Museum
COPYEDITING: Juliet Martin, Director of Marketing Communications, Heard Museum, Mary Siegfried and Joy Tomasko

HEARD MUSEUM STAFF CONTRIBUTORS TO TEXT

OVERALL TEXT COORDINATION AND ORGANIZATION: Diana Pardue, Curator of Collections
APACHE, YAQUI AND HOHOKAM TEXT: Janet Cantley, Exhibit Consultant to the *Home* project
HOPI TEXT: Gloria Lomahaftewa, Hopi/Choctaw, Assistant to the Director for Native American Relations
NAVAJO TEXT: Wendy Weston, Navajo, Education Program Specialist
PHOTO RESEARCH AND CAPTION TEXT: LaRee Bates, Warm Springs, Archivist
CLERICAL SUPPORT: Angelina Holmes, Hopi

Dimensions of artwork are given in inches, height preceding width.

The exhibition *Home: Native People in the Southwest* opened at the Heard Museum on May 22, 2005.

Printed in Hong Kong

Heard Museum
NATIVE CULTURES & ART

2301 North Central Avenue
Phoenix, Arizona 85004
602.252.8848
www.heard.org

Home

"From this work our life is brought forth."

MADELINE NARANJO, SANTA CLARA

PREFACE

TONY JOJOLA (B. 1958), ISLETA, AND ROSEMARY LONEWOLF (B. 1953), SANTA CLARA. *Indigenous Evolution (detail)*, 2005, 8 feet x 30 feet. This collaborative artwork is a glass and micaceous clay fence commissioned from glass artist Tony Jojola and ceramic artist Rosemary Lonewolf. The artwork references the land of the Southwest—the organic fences built by Native people from materials such as adobe and ocotillo or saguaro cactus. Lonewolf remarked, "This linear installation reminds visitors to leave stereotyped preconceptions behind and enter a world where indigenous people blend the past with the present and firmly establish a limitless future." Gift of David and Sara Lieberman and Bank of America.

HOME IS THE PLACE WHERE ALL OF US WANT TO BE. When we leave home, as we must, we all look forward to returning. Back home is the ultimate destination. Home is a familiar and safe harbor, a place of comfort and nurturing, where one has the advantages of home. It also is a place that tells more about us than any other single place. Home tells our individual and collective stories.

This publication that accompanies the exhibition *Home: Native People in the Southwest* is built around the theme of home. The origins of this theme sprang from initial conversations with Native advisors, who asked us to utilize the great Southwest collections of the Heard Museum to present information about Indian families, homelands, communities and languages. The theme took form from 50 interviews with Native peoples conducted by Dr. Tessie Naranjo, Santa Clara, and Gloria Lomahaftewa, Hopi/Choctaw, who asked questions about a wide range of topics regarding home. These interviews, along with the poetry of Dr. Ofelia Zepeda, Tohono O'odham, Professor of Linguistics and American Indian Studies at the University of Arizona, form the conceptual heart of this publication and exhibition. Many Indian people came to the Heard to review our collection and to recommend pieces to include in the exhibition. To all of these individuals, we extend our deepest thanks. We also thank the National Endowment for the Humanities and the Nathan Cummings Foundation for funding these important interviews and collection reviews.

The exhibition and publication *Home: Native People in the Southwest* have taken more than four years to organize. Their realization represents the work of the entire Heard Museum staff; every department has played an important role in getting us across the finish line. Writing for this publication has been done by several staff members. Dr. Ann Marshall was the general editor and principal writer, with contributions from Wendy Weston, Janet Cantley, Gloria Lomahaftewa, Diana Pardue and LaRee Bates. Object photography was done by Craig Smith. The publication has been designed by Carol Haralson. Lisa MacCollum was the publication coordinator and Alissa Wahl provided graphic support. Joy Tomasko, Mary Siegfried and Juliet Martin were the copyeditors. Angelina Holmes provided clerical support.

The Heard Museum is grateful to the Dr. and Mrs. Dean Nichols Publication Fund and to Life Trustee Mareen Nichols for funding the development of this publication and for continued support of Heard Museum publications that contribute to knowledge and understanding of Native American cultures and art.

Our goal from the outset of this project has centered around the idea of "getting it right"— creating a rich and culturally sensitive interpretation of the art of Native peoples through the exhibition and this publication. It is our sincere hope that our efforts have set a national standard for the interpretation of Native American arts and culture.

FRANK H. GOODYEAR, JR.

DIRECTOR, HEARD MUSEUM

JANUARY 2005

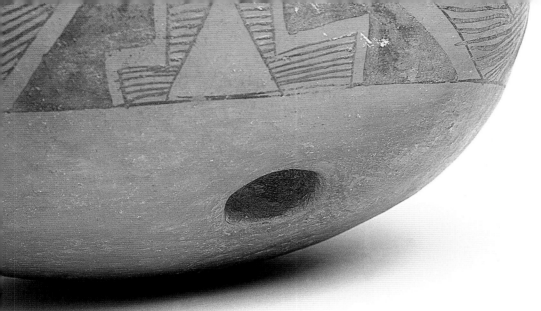

"We weren't the first ones to live here. People have always been moving from north to south. We have settled this area since the time when Mesa Verde was still occupied. Almost a thousand years we've been here as a community." ULYSSES REID, ZIA

1 Home in the Pueblo

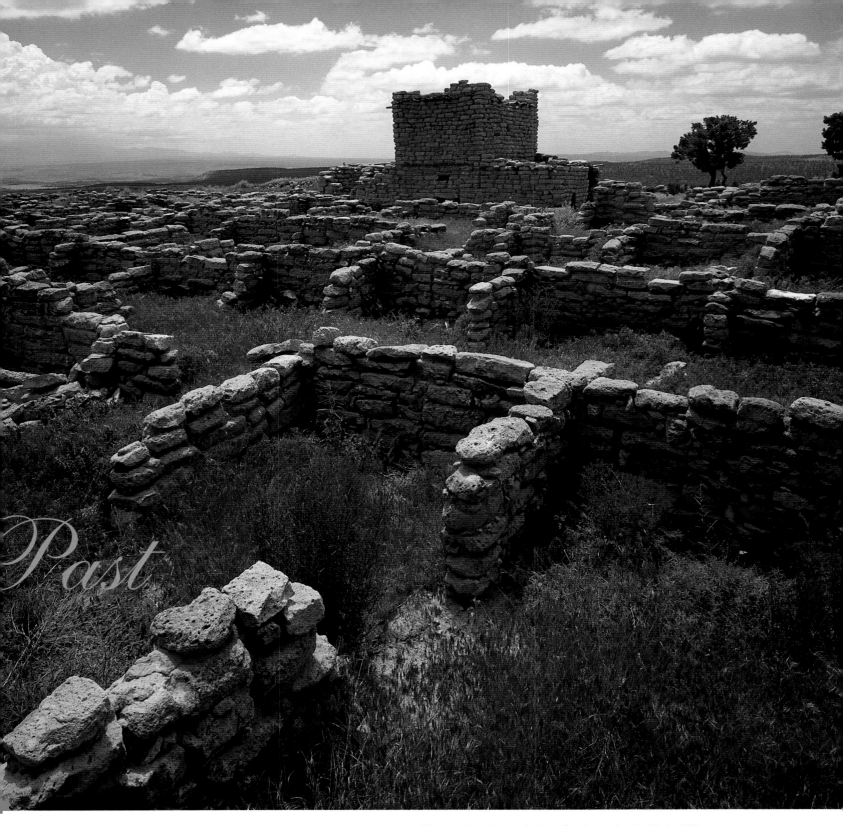

Past

Mesa-top ruins at Puye on the Santa Clara Reservation, New Mexico, 1985.

Jerry Jacka, photographer. Jacka Photography, Payson, Arizona.

ANCESTRAL PUEBLO. *St. John's black-on-red jar,* A.D. 1275-1325, 11 x 12. This jar is fairly large and would have been rather heavy when full, so the potter made it easier to handle by placing indentations in the base on either side (see detail). Normally, these indentations are placed much higher on the jar. Fred Harvey Fine Arts Collection.

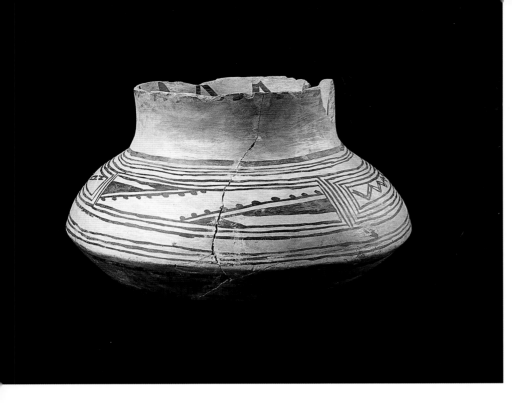

"We were the first peoples who migrated onto this land thousands of years ago, and today we're still very much a part of what was intended for us." BRIAN VALLO, ACOMA

THE SOUTHERN COLORADO PLATEAU, at an average elevation of 5,000 feet, is the highest plateau in North America. Precipitation varies from seven to 13 inches annually and is undependable both in amount and timing. In good years, steady soaking rains of winter are followed by the quick violent storms of summer. On its eastern edge flows the Rio Grande, one of the major rivers of the Southwest. For centuries, people have been drawn to this valley to make homes, especially in times of drought. Colorado Plateau land has 12,000-foot snow-capped mountains and basins as low as 3,000 to 4,500 feet. In the higher elevations, winter is bitterly cold, but in spring slowly melting snow that soaks into the ground makes life possible. In summer, with temperatures of 80 to 90 degrees, the summer rains are needed for crops, and herds are moved to higher, cooler summer pastures.

Ancestral Pueblo people made a home on the Colorado Plateau by learning the careful balance that is needed to become agriculturalists in a dry land that is marginal for agriculture. Over time, they became master adaptors at developing extensive knowledge of their homeland. Survival depended on knowing when rain might fall, which areas of land would retain moisture, when frost might end a growing season, the location and seasons of wild food plants and animals, and how to plant crops and save the right seeds for the next season. With a range of strategies including cobbling together a diet from multiple sources and developing homes that could shelter them through cold winters, they made the Colorado Plateau home for several millennia. But no hard-won knowledge could mitigate the one constant: that people periodically had to move from one location to another in order to avoid the other constant, the possibility of starvation. Sometimes, people moved a small distance when the supply of firewood, fertile soil, game and wild plants had been depleted. Sometimes, drought years

ANCESTRAL PUEBLO. *Red Mesa black-on-white storage jar,* A.D. 870-1000, 15 x 15. Storage jars with a small neck could be readily sealed to protect the contents from animals and insects. The design on this jar resembles a textile design. Storage jars were a necessary part of household equipment for every family during this period, when people were beginning to build homes above the ground.

meant an entire region had to be abandoned. The stories of these migrations remain in the oral traditions of Pueblo people and increasingly inform the work of archaeologists as they develop information that paints a fuller picture of what home was like for ancestral families and communities.

From at least 5500 B.C. to A.D. 450, small groups of families lived by following game and harvesting wild plants as the seasons changed. In time, people refined their knowledge of the land and acquired plants that, if properly tended, provided sufficient, dependable food to permit them to settle in one place. Between 1500 and 1000 B.C., corn and squash were two of the first foods acquired by the people of the Southwest. Domesticated in Mexico, corn and squash could be dried, feeding families through cold winter months. By 500 to 300 B.C., domesticated beans provided a needed source of protein to people's diets. With the development of bows and arrows, they could kill more game than with spears. Settled in one place, pottery as opposed to baskets became more effective containers for cooking, carrying and storage. Family homes were pithouses—partially set into the ground, some lined with stone slabs around a packed earth floor, cribbed log or jacal walls, and a conical or domed roof with wooden posts supporting a roof of logs, sticks, grasses and soil. After A.D. 700, people in some areas of the Colorado Plateau began building increasingly complex multi-room masonry homes entirely above the ground.

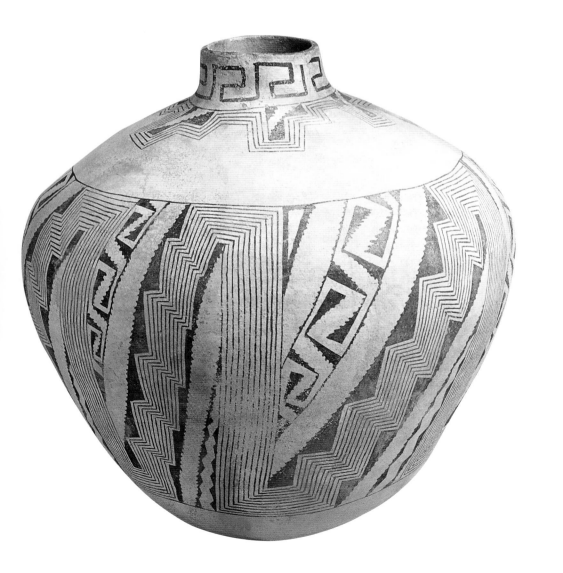

"I'm always reminded of the intellect of my people; they knew this earth so well. They knew every inch of the place that they inhabited. They knew the cycles; they knew what the sky was saying to them, the shape of the moon, what that meant. I am so in awe of that."

RACHELE AGOYO, COCHITI/ SANTO DOMINGO

Communities developed as food production improved. Then as today, communities varied in size. Some families continued to live in pithouses on small farmsteads. Some lived in small farming villages that included fewer than 25 above-ground rooms, with the basic pithouse design reflected in a kiva ceremonial chamber. In Chaco Canyon alone there were 200 to 400 such villages in the 11th century. After A.D. 1000, people built towns containing as many as 700 to 900 rooms. In the 1100s and 1200s, Yellow Jacket in Colorado had a population of 2,500. Some major urban centers were essentially master-planned communities, with large portions constructed at one time according to a plan using timber, sometimes cut 50 miles away, shaped and stockpiled to be ready for construction. Some communities were settled for several generations, others only a year or two. People eventually moved on from these communities to places with more water, more fertile land, more firewood, more game animals and more peaceful neighbors.

By A.D. 1300, Ancestral Pueblo people had left the northern parts of the Colorado Plateau. Pueblo people have stories of the migration journeys of the clans. In the period from A.D. 1350 to 1550, people drew closer to their present-day homes—some toward Hopi, some toward Zuni and Acoma, many toward the Rio Grande and its tributaries. Closer to historic times, the linkage between the migration stories and ancestral sites becomes more specific.

The clans of the Hopi ancestors migrated along different routes before coming together at Hopi. Homol'ovi, Canyon de Chelly, Wupatki and Tuzigoot are some of the sites the Hopi associate with their history. Some of the clan stories link to the south and the Hohokam. The Hopi village of Awatovi was established around A.D. 1000 and Oraivi on Third Mesa, around A.D. 1200.

WESTERN ANCESTORS The Hopi call their oldest ancestors who hunted and gathered Motisinom, and they call agricultural people of the Southwest Hisatsinom, meaning People of Long Ago. Between A.D. 200 and 800, family groups lived in pithouse villages and rock shelters across northern Arizona and southeastern Utah. They lived by hunting and gathering plants, with piñon nuts as an important food source. These western families lived in pithouse farming communities long after people in the east were building above-ground pueblos. Only in A.D. 1000, when the powerful eastern communities of Chaco were at their height, did the Hisatsinom begin to build above-ground houses. From A.D. 1000 to 1150, farming conditions were good and people were spread over a wide area. Around this time period, the oldest Hopi villages, such as Oraivi, were established and people remained in these locations. From A.D. 1250 to 1300, the Western Ancestral people built larger communities. But as the effects of the Great Drought (A.D. 1276 to 1299) deepened, people of this region moved again. Some went south toward Hopi.

WESTERN ANCESTRAL PUEBLO. *Medicine black-on-red jar and cotton yarn,* A.D. 1075-1125, 3.25 x 5.25. The protection that ceramics offer household goods is demonstrated by the condition of these hanks of beautifully spun and dyed two-ply cotton yarn that were stored in this jar. Historically, the Hopi people grew cotton and traded both raw cotton and cotton cloth with many neighboring groups.

WESTERN ANCESTRAL PUEBLO. *Lino black-on-gray bowl,* A.D. 500-600, 3.25 x 6.75. Fred Harvey Fine Arts Collection.

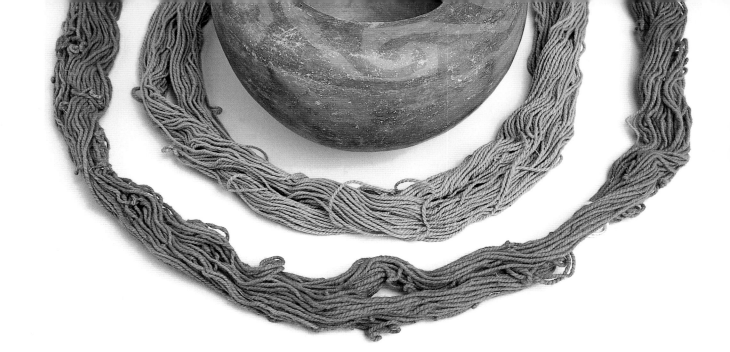

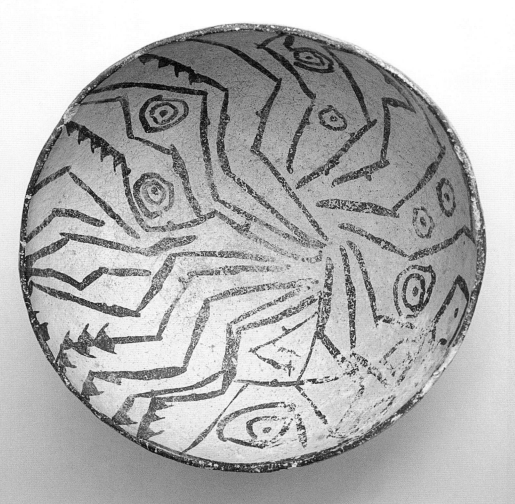

"Hopi began as a gathering of different peoples from different directions of the earth. *They call it the gathering of the clans. They brought their own languages. The language we have now is a combination of all these languages that came together.*"

ALBERT SINQUAH, SR., HOPI-TEWA

CENTRAL ANCESTORS By A.D. 900, Ancestral Pueblo populations expanded southward through the mountains along the borders of Arizona and New Mexico into the Mogollon region. The Mogollon region was home to people who had been among the first farmers in the Southwest and who made some of the first pottery located to date. The farmers of the Mogollon region had developed from the hunters and gatherers of the Desert Culture. They lived in small pithouse villages, and their pottery was plain brown or red colored. In the steep mountainous country where travel and communication were difficult, many varied local traditions developed. After A.D. 1000, the homes and pottery made by people of the Mogollon region changed and began to look more Puebloan, with above-ground dwellings and black-on-white pottery.

Barbara Gonzales, San Ildefonso, 2004. Craig Smith, photographer.

"Each pot has a story that only the maker knows." BARBARA GONZALES, SAN ILDEFONSO

"We as a people know in our hearts, in our minds, our ancestral roots.

We know that we must continue and not forget any of our ancestral areas."

CAVAN GONZALES, SAN ILDEFONSO

CENTRAL ANCESTRAL PUEBLO.
Tularosa black-on-white canteen, A.D. 1100-1250, 6.75 x 8.25. This canteen was meant to be seen from the top and bottom. The potter flanked the spout with dog effigy handles and painted the figure of a person on the canteen base. Effigy handles were fairly common on pitchers, rarer on canteens.

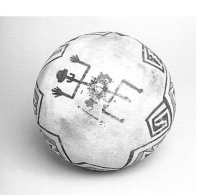

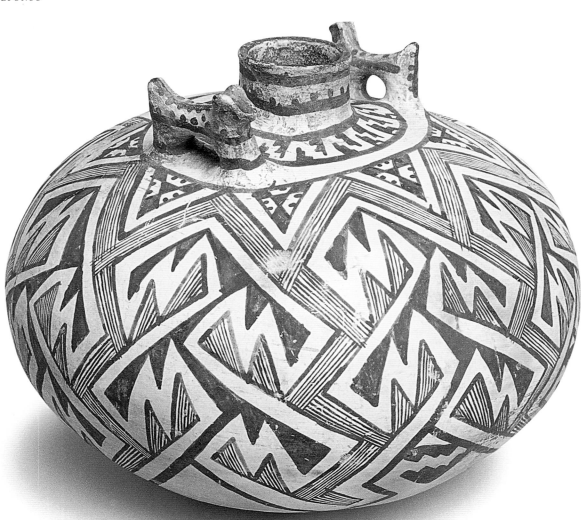

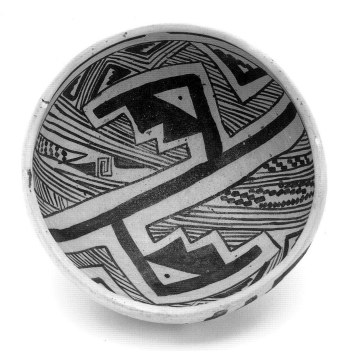

EASTERN ANCESTORS Some of the earliest Ancestral Puebloan homes and pottery are found in the San Juan region along the New Mexico/Colorado border. People hunted and gathered and lived in pithouses. By A.D. 200, they found ways to grow crops. These Eastern Ancestors developed distinctive lifeways. The residents of Chaco Canyon, from around A.D. 900 to 1140, influenced people for more than 100 miles in all directions. "Great" is the adjective associated with Chaco. There were Great Houses of four and five stories, Great Kivas 63 feet in diameter and Great Roads 30 feet across, built in a straight line regardless of natural features. Around A.D. 1140, the Chaco phenomenon began to end. Declining rainfall reached full drought in A.D. 1130. Despite sophisticated water management, once again moving to a new home was the only choice.

ANCESTRAL HOPI. *Jeddito black-on-yellow bowl,* A.D. 1300-1450, 3.5 x 8.13. By firing their ceramics with coal, ancestral Hopi potters produced highly fired, durable pieces that were very popular and traded widely among Pueblo people.

"When we were going to Chaco Canyon, one granddaughter, when she was small, she used to say, 'We're going to Old Grandma and Old Grandpa's home.' Our ancestors had migrated through there. It's so nice to go back over there 'cause you get a good feeling being there."

DOLORES LEWIS GARCIA, ACOMA

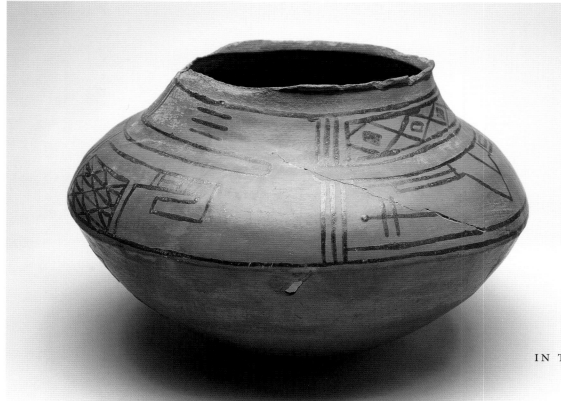

ANCESTRAL PUEBLO. *San Lazaro glazed polychrome jar,* c. A.D. 1490-1550, 9.75 x 14. This glazeware has a dragonfly design, which is associated with water and has been favored for centuries as a design element. Fred Harvey Fine Arts Collection.

BIRTH

Our birth is announced by the smell

Of cedar burning through the village.

We gain our entry by our clan, our name.

When we leave this world

It is by our clan that we are embraced,

Recognized in the next world.

FAMILY

Family, they're there in sorrow.

They're there in happiness

They're there if you want them to be there.

Knowing your relatives

Knowing who you are

And where you come from.

Singing in the night, singing in the morning …

LANGUAGE

I hear them laughing,

A joke.

I have no clue.

In my grandmother's mind a million

Pieces of information.

I cannot access, at least not yet.

I bought a book for learning Navajo.

Other times I hear them talking.

I know they are talking about me

By the rhythm.

Right in front of me!

It hurts.

I scream!

They look at me.

Guilty.

FOOD

Massive amounts of food.

Massive amounts of relatives.

And still, massive amounts of leftovers.

HOME

I will go back home

Whether it is to live

Awhile longer

Or whether it is in death

You know, that's where I'll be.

SOUNDS OF HOME

Shuffling of feet on the earthen floor

The rattling of a pot

in the kitchen

The echo of someone chopping wood

A dog in the distance

Barking as if it belonged to someone.

SOUNDS OF CEREMONY

It is the sound of the jingle of bells

The sharp rattling of seashells

The muffled sounds of butterfly cocoons

The sound of pebbles inside a solid gourd

It is wood against wood of a rasp

Hide against hide of a taut drum

Wood against the wind of a bullroarer

It is a basket faced down

It is the sound of voices

In song, in oratory and prayer

All uttered in the language they were meant to.

CORN SOUP

Boiled all night for special events.

In the morning the whole house

Smells like soup.

HOUSE

A house is not just a structure.

A house needs to be kept alive.

Someone must be there to maintain.

That life.

The walls.

The red rocks turn into powder.

Using sheepskin to layer the color on.

And then caliamite came in a box.

My grandmother was so happy.

She mixed it, used sheepskin to layer it on.

She taught her children to do this.

We taught ours.

Now this is a bygone era.

Today we go to Wal-Mart.

Buy wall paint and slather it on.

AVON BRUSH

My polishing stone.

My paintbrush.

There are always stories about them.

My stone is my mother's

She loaned it to me one day

She said, "Try this one,"

I did, I kept it.

She never asks about it

I never bring it up.

My paintbrush is an old one

From Avon, you know, Avon Calling,

I got it in the '60s.

It is a fine-haired brush for fine lines.

It works.

GOING HOME

The Navajos who leave the reservation

And come to Phoenix

Never intend to stay.

In their bags they pack their plans

For returning home.

CHILE STEW

The smell of food

Chile cooking

We know how hot it will be

Just by the smell.

Bread, tortillas baking outside.

There is no other cuisine like it.

The memory of women who say,

"I practically sing when I cook."

POTTERY

A pot that might have a crack

An imperfection

For some may not be aesthetic

But at the same time

It can still be useful to somebody, somewhere.

IDENTITY

When it is three a.m.

And it's crunch time

Who are you going to call?

Your family. No question.

Family means dependability.

I go home for events,

Christmas, fairs, birthdays, funerals.

A Navajo family is like the mob

Without the violence.

In the end, being a good Navajo

Is knowing how to juggle,

How to fix a car.

LAND/LANDSCAPE

Shiprock, Monument Valley

Just seeing a picture of it

Can take a Navajo home.

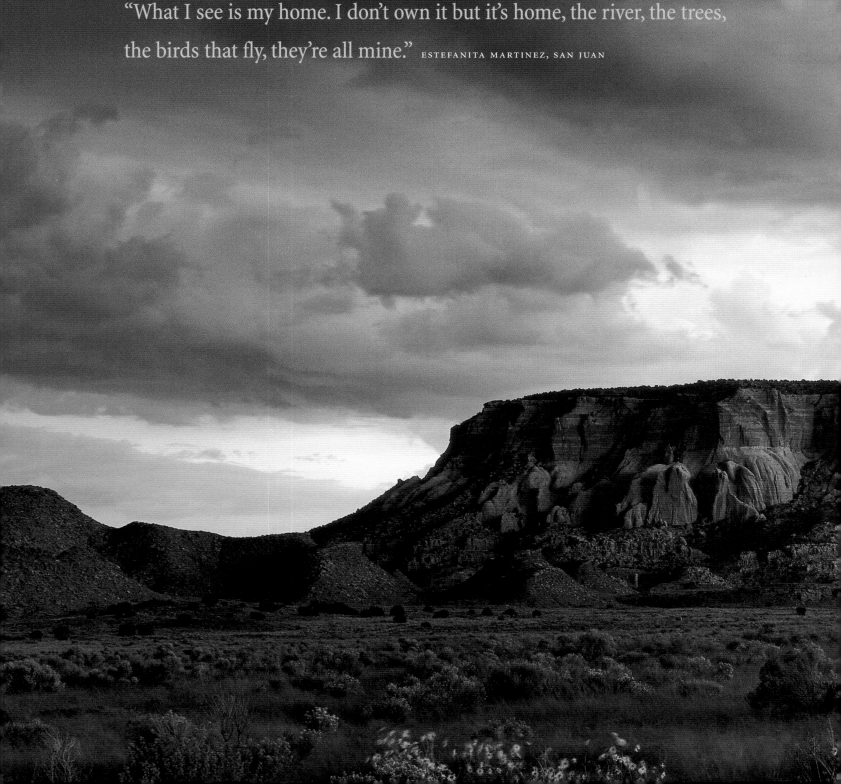

2 Home Along the

"What I see is my home. I don't own it but it's home, the river, the trees, the birds that fly, they're all mine." ESTEFANITA MARTINEZ, SAN JUAN

Rio Grande

HOME FOR 19 DISTINCT AND SOVEREIGN PUEBLO NATIONS in New Mexico means a connection to their land for more than 1,000 years. Homeland for 16 pueblos is primarily in the Rio Grande Valley, with three Western Pueblo communities at Acoma, Laguna and Zuni. By 1700, all of the present-day pueblos were occupied. The pueblos can be grouped by geography into eight Northern Pueblos, eight Southern Pueblos and three that are west of the Rio Grande Valley.

"As a Pueblo people we don't move, we stay here. Our umbilical cord is here, out in the field, in the farmland. *Our ancestors, our parents left the land for us and places to build homes and also the traditional doings that we participate in; it's very important. I want the kids to grow up and know who they are and what they are and to practice the Indian traditional ways."* SALVADOR YEPA, JEMEZ

SCENTS AND FOODS OF HOME

"The smells are seasonal. When there are no dances taking place, you may smell food like potatoes and beans. During the springtime when it's raining, you can smell the cedar, the flowers and the wet earth. You can hear the wind. When it's feast day, you can smell posole and chili beans, roasting meat and baking bread, cookies and pies."
BARBARA GONZALES, SAN ILDEFONSO

"The first smell I can remember as a child was the smell of wet clay. My great-grandmother was probably making pottery or plastering her wall. Later, as an adult when I was working with clay myself, plastering, it triggered the memory of that smell and how much I loved it. It's the kind of smell that makes you want to grab a handful of clay and eat it."
LAURA WATCHEMPINO, ACOMA

"I remember during my childhood, my mother, who was a great cook, would cook plants—wild spinach, different varieties of greens that grew in the fields. Every time she cooked something, before we sat down to eat, she would get bowls and serve a little bit from this big pot, and I'd take it to my grandpa, my uncle or my aunt. So as a child, I learned the value of bringing food to somebody, to know that someone wants to share this with you."
RACHELE AGOYO, COCHITI/SANTO DOMINGO

DOLORES: "The favorite food I remember my grandmother made was rabbit stew with ground white corn in it. Oh, boy, that was delicious. Our mother, Lucy, fixed hot tortillas."
EMMA: "And hot tamales."
DOLORES: "Chilis are always our favorite, and dried bone soup with dried sweet corn in it. That's what we remember. Wild spinach—one of the ancestral foods of long ago—we still eat it today."
DOLORES LEWIS GARCIA AND EMMA LEWIS MITCHELL, ACOMA

LANGUAGE Pueblo people have survived more than 460 years of various efforts to deprive them of their land and change their lives by eradicating their beliefs and language. Historically, with more than four Native languages in the region plus Spanish and English, Pueblo people have had to be multi-lingual. The names by which many people know the pueblos are not the names the residents have for their home villages. Six pueblos have saints' names, such as San Juan. Yet, in the Tewa language of the people, their community is Ohkay Owingeh, which means Village of the Strong People. Many of the names describe a place by which the village is known. Taos or Tu-o-ta in the Tiwa language means the Place of the Red Willows. The word pueblo itself is a Spanish word that means village.

"There's a continuum between Gia Khun (grandmother) and Gia (mother), because Gia would say the same thing that Gia Khun would say, which is 'divi hu-yung (Have you eaten)?' The most important questions that she asked anybody when they came into the house were 'Are you well?' and 'Have you been fed?'" TITO NARANJO, SANTA CLARA

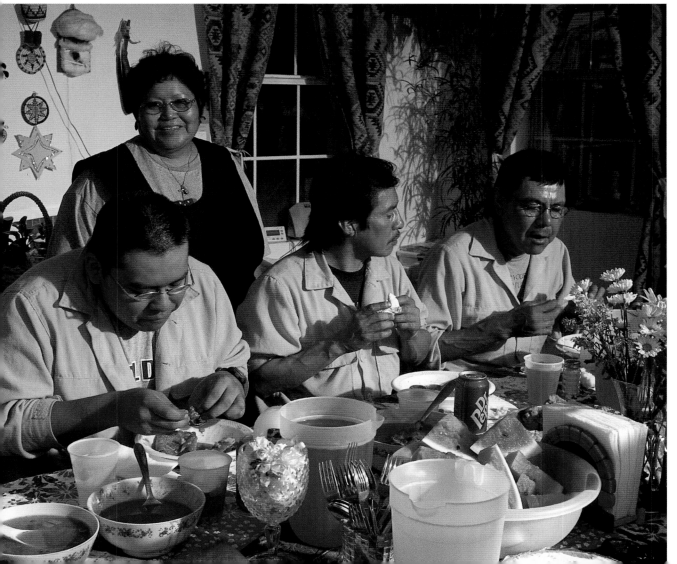

Florence Yepa serving a feast supper to "Jemez Eagles" fire-fighters, Jemez Pueblo, New Mexico, 2004. Walter BigBee, photographer.

25

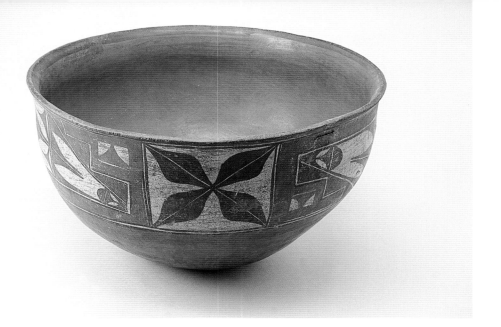

ZIA. *Bowl*, 1880-1910, 19.75 x 11.5. This bowl has a classic Zia dough bowl design that was beautifully painted. The bowl has gained a mellow patina through much use. It is heavy and would have had good stability as dough was being mixed. Fred Harvey Fine Arts Collection.

Today, the continuation of Native language is seen as critical to a full understanding of ceremony and belief. The fight is against decades of education policy that has suppressed Native languages, marriage outside of a language group and the omnipresence of English through radio, television and the workplace. For some, the ways of learning have changed from informal family contact to language classes. The question of whether to write a language remains a topic of discussion.

"Language is important to keep alive a lot of the traditions at my pueblo. Technology and modern times are changing the mindset of everyone who is exposed."

CAVAN GONZALES, SAN ILDEFONSO

FAMILY AND COMMUNITY Discussions with Pueblo people about family quickly merge into talk of community. In the memories of the middle-aged and elderly lives a clear sense of the community working together, not just at ceremonies but cooperating on planting and harvesting, house renovation or construction, and supervision and teaching of children as well as support for single parents. Modern conveniences such as electricity and indoor plumbing arrived in the pueblos later than in many non-Native communities. Wage-earning jobs increasingly take people away from the community during the workday. While televisions, telephones and computers bring mainstream society to Pueblo people, parents and community leaders make choices about what changes to embrace and how to preserve traditions.

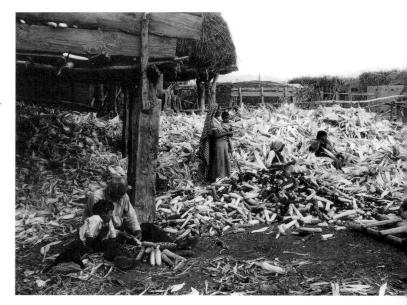

Husking and braiding corn at San Juan Pueblo, New Mexico, c. 1935. T. Harmon Parkhurst, photographer. Museum of New Mexico, Santa Fe, New Mexico.

"In Tewa there is no word for family, but there is a word for all of us." TESSIE NARANJO, SANTA CLARA

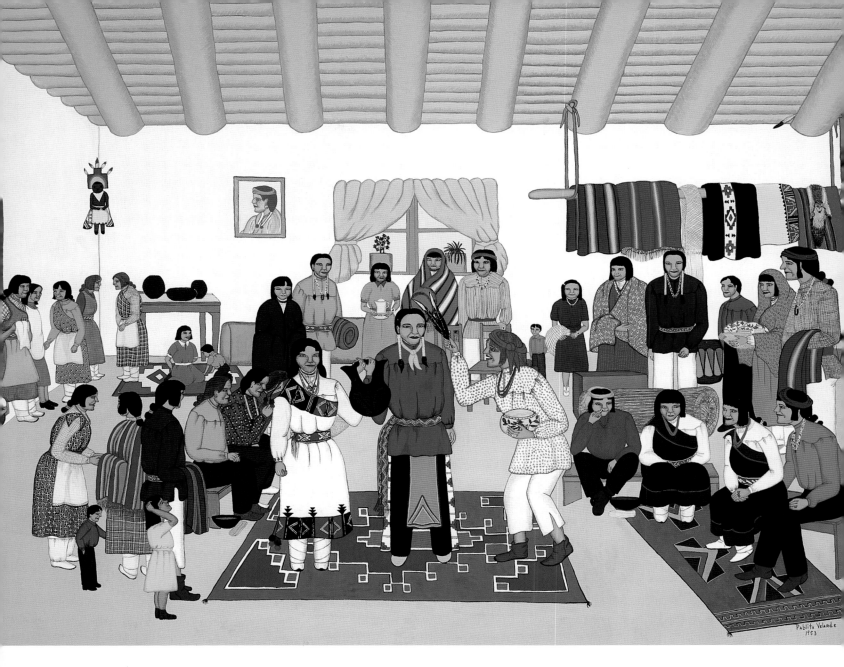

PABLITA VELARDE (B. 1918), SANTA CLARA. *Betrothal*, 1953, 21.5 x 27.5. Pablita Velarde depicts a pueblo home interior with the guests gathered around to witness the betrothal ceremony. Through the door to the kitchen is a glimpse of chili cooking on the stove. Sharing food and extending hospitality are important aspects of Pueblo life. Gift of James T. Bialac in honor of the Heard's 75th Anniversary and Pablita Velarde.

"You can talk to any elder, and they'll probably identify family as their community, because we're all related in some way. That becomes a part of your life from birth until death. And while our community has grown, or our family has grown so much over the years, knowing that you have 6,000 other Acoma people as part of your family, as part of your support mechanism, is such a great feeling. Not many people in the Western world can identify with 6,000 other people." BRIAN VALLO, ACOMA

"Your people, all people, we're all from the same place. Our long ago people, they would say, my children, no matter who they were. We would also say, our aunties, our grandmothers, our uncles. We are all from the same place, same group. We all become one."
MADELINE NARANJO, SANTA CLARA

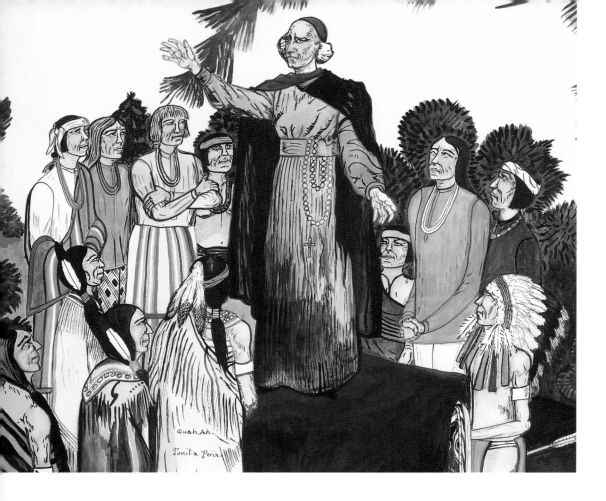

Quah Ah.

Tonita Peña

PUEBLO REVOLT: THE FIRST AMERICAN REVOLUTION

In the space of 140 years, from the first encounter with Spanish explorers in 1540 to the Pueblo Revolt in 1680, Pueblo people watched their sense of home change in horrible ways. Beginning in 1598, Spain sent settlers, soldiers and priests into the pueblo homelands. By 1680, a population of 80,000 to 100,000 Native people had dwindled to 11,000; of 100 villages only 31 remained. European diseases, especially small pox, killed many. The Spanish imposed the feudal encomienda economic system on the pueblos. Native people, whose land was now claimed by a Spanish owner, owed the owner repartimiento or tributes in the form of grain, cloth and firewood as well as labor. This obligation extended to the church and civil authorities, who required them to construct buildings and churches as well as plant and tend crops and animals. In a land that was marginal for agriculture, people had to work hard just to support their families in the best of times. During drought and famine, the burden of tributes meant starvation and death.

Attacks on Pueblo religion threatened deeply held beliefs that ceremony and prayers were needed for the well-being of the world. In public, there was participation in Catholic rituals, while in secret the traditional religions continued. When outlawed religious participation was discovered, reprisals included kiva burnings, destruction of religious materials and accusations of witchcraft, punishable by whipping and burning at the stake.

"When the men at Cochiti counsel us, they remind us how our great-great-great-ancestors practiced this way of life. They gave us a set of values, a belief system, and many of them had to die in order to protect these ideals for all generations to come."
RACHELE AGOYO, COCHITI/SANTO DOMINGO

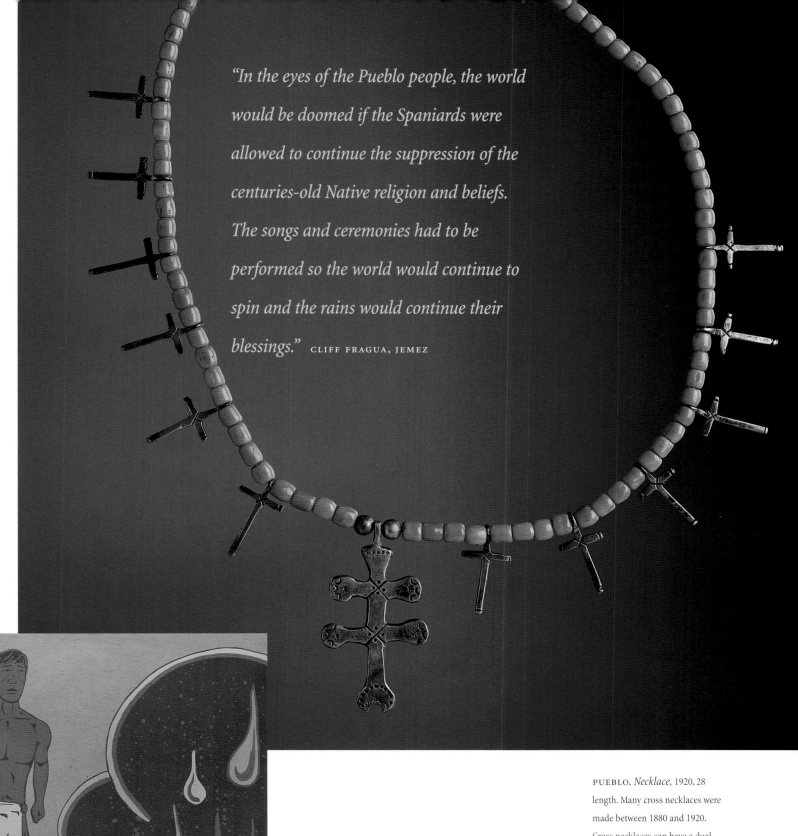

"*In the eyes of the Pueblo people, the world would be doomed if the Spaniards were allowed to continue the suppression of the centuries-old Native religion and beliefs. The songs and ceremonies had to be performed so the world would continue to spin and the rains would continue their blessings.*" CLIFF FRAGUA, JEMEZ

PUEBLO. *Necklace,* 1920, 28 length. Many cross necklaces were made between 1880 and 1920. Cross necklaces can have a dual meaning to Pueblo people, referencing both Christianity and elements of the natural world. Fred Harvey Fine Arts Collection.

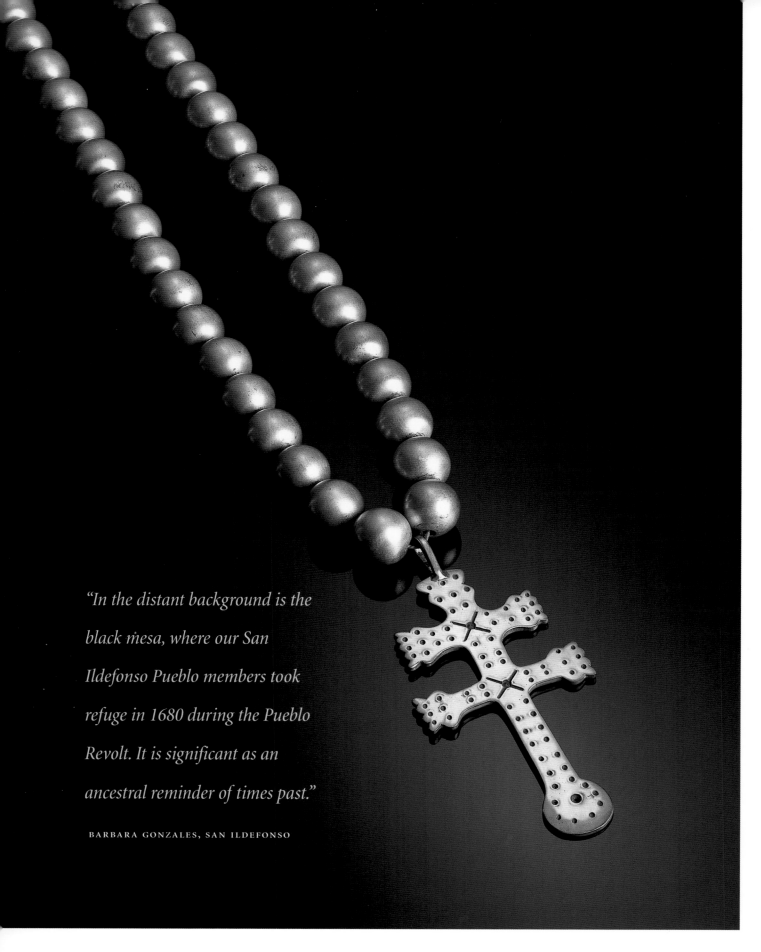

"In the distant background is the black mesa, where our San Ildefonso Pueblo members took refuge in 1680 during the Pueblo Revolt. It is significant as an ancestral reminder of times past."

BARBARA GONZALES, SAN ILDEFONSO

In 1680, the Pueblos united under the leadership of a San Juan man named Popé who, based at Taos, coordinated plans to expel the Spanish from the pueblos. This was the first time that Pueblos, as far to the west as Hopi, acted in concert. The Pueblo Revolt began on August 10 and continued until the Spanish were driven out, first to Santa Fe and then to El Paso, Texas. In the initial revolt, 400 Spanish and 21 of 33 priests in New Mexico were killed.

After numerous attempts at reconquest, Diego de Vargas was successful in returning the Spanish to New Mexico in 1692 and in putting down another revolt in 1696. In the reinstalled government, the encomienda system was abolished and land grants were issued, although various forms of forced labor and the burdens of tribute remained. With the Spanish reconquest, some people abandoned villages in the Rio Grande Valley for more inaccessible places, and some moved as far away as Hopi or even to neighboring Navajo communities.

The Pueblo Revolt and the sacrifice of Pueblo people is remembered and honored today. Marie Reyna of Taos said, "We contemporary Indians now really have to look to the past and realize that people gave their lives." When students misbehave in her art classes, Marie has reminded them, "People died for you 500 years ago just so you can be a jerk in 2002."

"Popé is our hero. Tribes were on the verge of losing their cultural identity when the Pueblo Revolt brought everything back on track for our people." HERMAN AGOYO, SAN JUAN

"I was able to bring four out of the seven Clan Leaders from the Tewa-Hopi, First Mesa. They were so respectful about coming back to their ancestral home because, at the end of the 1600s, they had to walk because of the Spanish oppression—many of the Tewas were forced to walk all the way from the Rio Grande Valley up to First Mesa." TESSIE NARANJO, SANTA CLARA

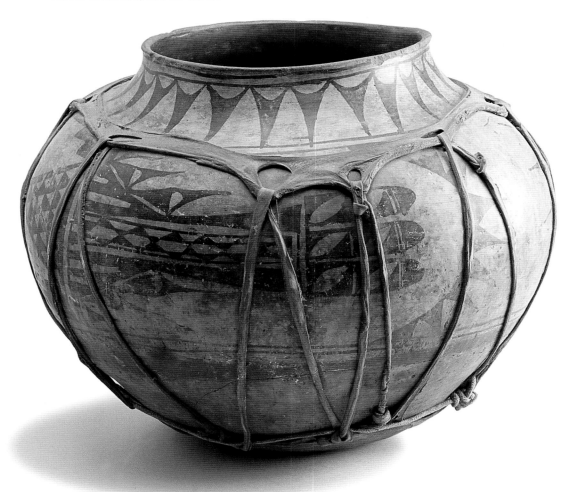

HOME UNDER THREE FLAGS After two centuries of hostility, the 18th century found the Northern Pueblos and the Spanish increasingly allied against raids from the Utes, Comanches, Navajos and Apache, who had obtained horses and guns. Spain issued land grants to the Pueblos that recognized their rights to portions of their homeland. Continued religious suppression established a dual religious life consisting of open Catholic worship and traditional religious practice observed in secrecy at night and in the kivas. Tributes demanded by civil and religious authorities remained a burden on Pueblo people, although as Spain's power waned, demands were less frequent.

For 25 years from 1821 to 1846, Mexico colonized pueblo homelands. Having won its independence from Spain, Mexico made all residents citizens, including the Pueblo people. While Mexico recognized the Spanish land grants, with citizenship came the burden of taxation. On a positive note, because Mexico had very little control of the northern reaches of its empire, the period provided a respite from persecution of Pueblo religious practices. By 1822, trade from the United States along the Santa Fe Trail began the influx of manufactured goods.

By 1846, the start of the Mexican War, the United States had effectively gained control of New Mexico. By 1850, the Pueblo population reached a low of 7,000 people surviving in 18 pueblos. In 1880, the Transcontinental Railroad was built through pueblo lands. A period of corrupt land dealing that lasted through the early 20th century resulted in more loss of pueblo homelands. Native religious beliefs were again under attack from Protestant missionaries. Under the United States' federal education policy, mission schools and boarding schools worked to "civilize" the Indians and eradicate connections to language and religion. As the myth of the "Vanishing Indian" took hold, the Pueblos refused to vanish. The strength of family, community ties and language is recognized as the rock on which Pueblo societies rest.

Tony Reyna, Taos, 2004. Walter BigBee, photographer.

"They maintained their traditions regardless of persecutions. That's why we have those traditions today—because of their strong desire to continue."

GARY ROYBAL, SAN ILDEFONSO/SANTA CLARA

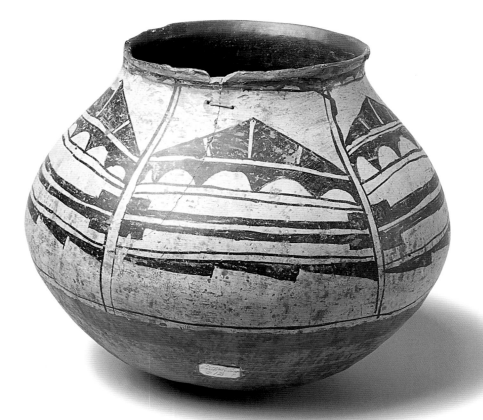

SANTO DOMINGO. *Kiua polychrome jar,* pre-1830, 14.75 x 17.25. This storage jar has been mended by drilling holes on either side of the crack and sewing the two sides together with rawhide, which shrank to make a tight mend. Mends such as this allowed a jar to continue its usefulness in the home. Fred Harvey Fine Arts Collection.

ZIA. *San Pablo polychrome jar,*
1740-1800, 12.8 x 12.8. When this jar
was made, New Mexico was still a
colony of Spain. This is one of the
oldest historic period jars in the
Heard's collection. Fred Harvey Fine
Arts Collection.

BELOW: ZIA. *Trios polychrome
jar,* 1800-1830, 14.5 x 13.5. Fred
Harvey Fine Arts Collection.

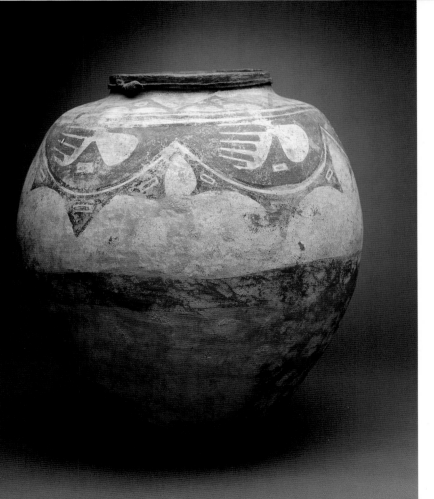

"*We survived all these years, and we
intend to survive the rest of time.*"

TONY REYNA, TAOS

Northern Pueblos

POTTERY has always served a variety of needs in the home. In ancestral times, potters made containers for ceremonial and practical use as well as to barter for other household needs. Some wares were widely traded. By the early 1900s, the influx of tourists and traders broadened the market and, since then, families who make pottery have seen their work change from functioning as household container to curio to art. Among certain of the Northern Pueblos, potters have established family traditions that bring the attention of collectors from all over the world. Two of the best-known potters are Maria Martinez of San Ildefonso and Margaret Tafoya of Santa Clara. Maria Martinez and her husband, Julian, became famous for the development of blackware pottery with designs in matte paint. Margaret Tafoya brought her own unique skills to blackware, with a talent for creating large jars and her own innovative impressed or carved designs. Pottery remains a family tradition and the economic lifeblood of these communities.

> TESSIE: "When your life is over, what do you hope your children will keep on doing?"
> ROSE: "Keep making pottery."
> TESSIE: "Why?"
> ROSE: " 'Cause it's beautiful."
>
> TESSIE NARANJO TALKING WITH HER MOTHER, ROSE NARANJO, SANTA CLARA

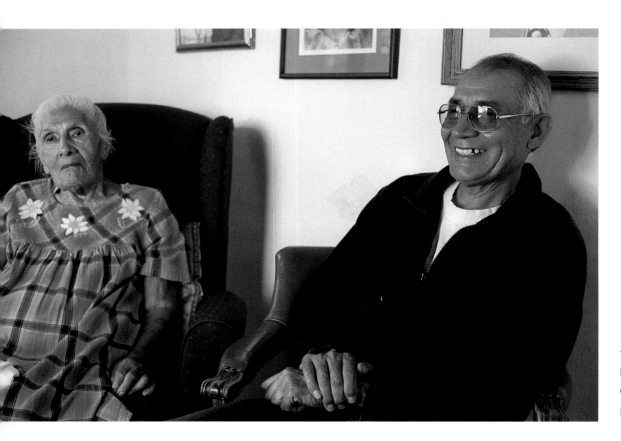

FACING, TOP LEFT: TESUQUE. *Bowl,* 1880-1900, 9 x 11.25. The design that looks like an interlocking scroll was a popular and distinctive Tesuque motif. Fred Harvey Fine Arts Collection.

FACING, TOP RIGHT: VIRGINIA ROMERO, TAOS. *Bowl,* 1978, 7.5 x 12.25. When advisor Marie Reyna, Taos, selected this bowl for exhibition, she said, "The elasticity of the clay adds to its versatility, and many Northern Pueblo potters enjoy working with micaceous clay. It's just a beautiful, natural clay that speaks for itself. The potter brings out the shape of the work, but nature itself works with you to produce a beautiful, unique piece of pottery."

FACING, BOTTOM LEFT: ATTRIBUTED TO SARA FINA TAFOYA (C. 1863-1949), SANTA CLARA. *Jar,* 1905, 11 x 14.5. The indented bear paw design has long been considered a Santa Clara trademark. No other pueblo uses it. Yet, even though most people consider it traditional, the design apparently has been in use only since about 1900. It was possible for Sara Fina Tafoya's great-grandson, Nathan Youngblood, to identify this jar as Tafoya's work based on the shape of the bear paw design. Fred Harvey Fine Arts Collection.

Tito Naranjo, Santa Clara, and his mother, Rose Naranjo, Santa Clara, 2004. Walter BigBee, photographer.

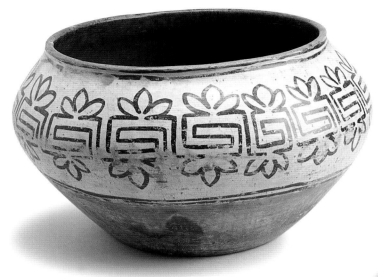

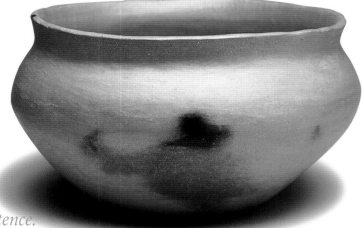

"This pottery is full of meaning for me. This is our existence. Without this, I don't know from where our money would come. This brings us money, but it also commands respect. Respect. From this work our life is brought forth. Everybody here makes pottery. Pottery is our life, it is life-giving."

MADELINE NARANJO, SANTA CLARA

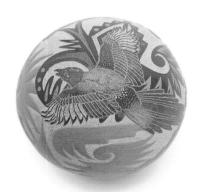

JOSEPH LONEWOLF (B. 1932), SANTA CLARA. *Pottery,* 1978, 2.75 x 2.75. In the late 1960s, Joseph Lonewolf, his father, Camilio Sunflower Tafoya, and his sister, Grace Medicine Flower, began using the sgraffito technique to lightly scratch designs in their pottery. Lonewolf often depicts wildlife from New Mexico and Colorado. Gift of Don and Jean Harrold.

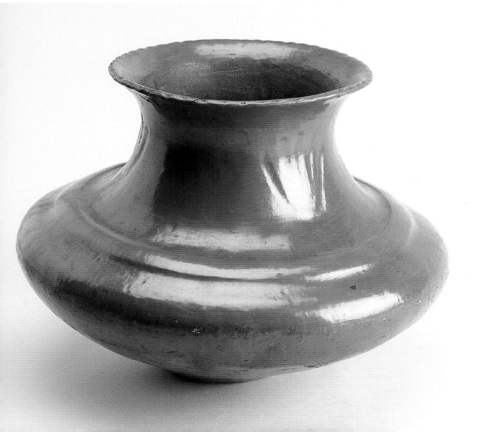

LORENCITA A. BIRD (1917-1995), SAN JUAN. *Manta,* 1985, 46 x 55. Lorencita Bird was a skilled textile artist who researched and generously taught the traditions of pueblo weaving and embroidery to many students. The manta features a butterfly—a symbol of renewal and spring.

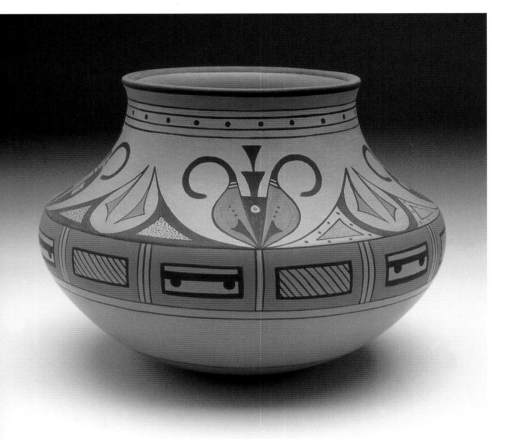

CAVAN GONZALES (B. 1970), SAN ILDEFONSO. *Jar,* 1994, 10.125 x 13.25. Cavan Gonzales is the oldest of his siblings, as was his mother, Barbara Gonzales, his grandmother, Anita Martinez, and his great-grandfather, Adam Martinez, son of Maria and Julian Martinez. Gonzales has revived the polychrome style of his great-great-grandparents while developing his own style. About this jar, he said, "This is a polychrome jar made of clay materials from my pueblo. The tan that is utilized is a very old source of clay. The designs are a squash blossom and leaf designs that shoot upward. On the belly, I have a belt design going around the entire piece. The black that is utilized is a mixture of bee plant with clays from my local area, and that gives them that light grayish tone. I like using soft colors on my polychromes."

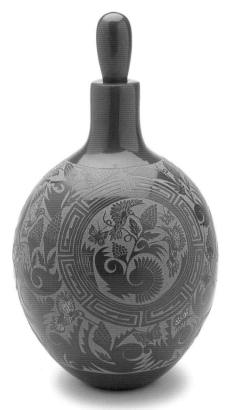

GRACE MEDICINE FLOWER (B. 1938), SANTA CLARA. *Jar,* 1991, 14 x 7. Delicate flowers and hummingbirds are etched into the surface of this jar. Gift of Rita and John Rye.

"All these things that we do, drum making, pottery making, those are life skills. They're needed within our communities for traditional things. You're able to make a few more and sell it to support your family, but the art is really our life. We didn't do those things to put them in galleries; we did those things because we needed to keep warm. We needed things to eat out of. Indian way is art. Our life is art."

MARIE REYNA, TAOS

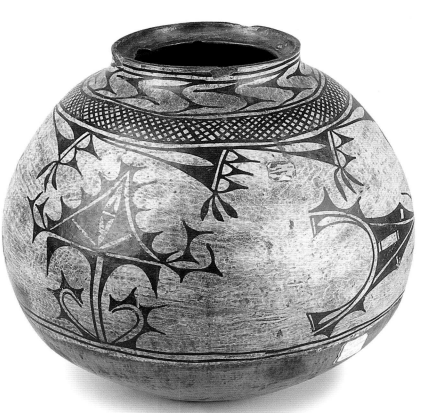

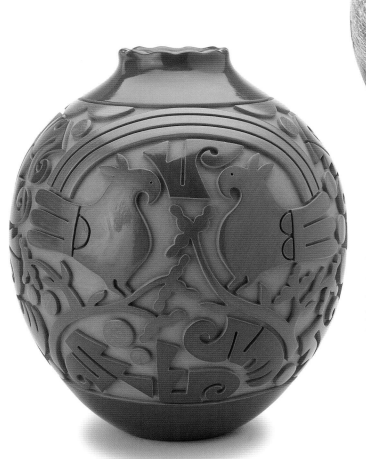

TAMMY GARCIA (B. 1969), SANTA CLARA. *Jar,* 1995, 13.5 x 12. On one side of this jar, Tammy Garcia featured a pueblo-style parrot design similar to those seen on early Acoma pottery, and a complex abstract design is on the opposite side. Birds have long been important to Pueblo life and ceremony.

SAN ILDEFONSO. *Jar,* c. 1850, 15.25 x 17.25. This jar has feather designs hanging from the rim and a central cloud motif with rain falling from the cloud. Vegetation nourished by the rain can be seen at the corners of the cloud. Fred Harvey Fine Arts Collection.

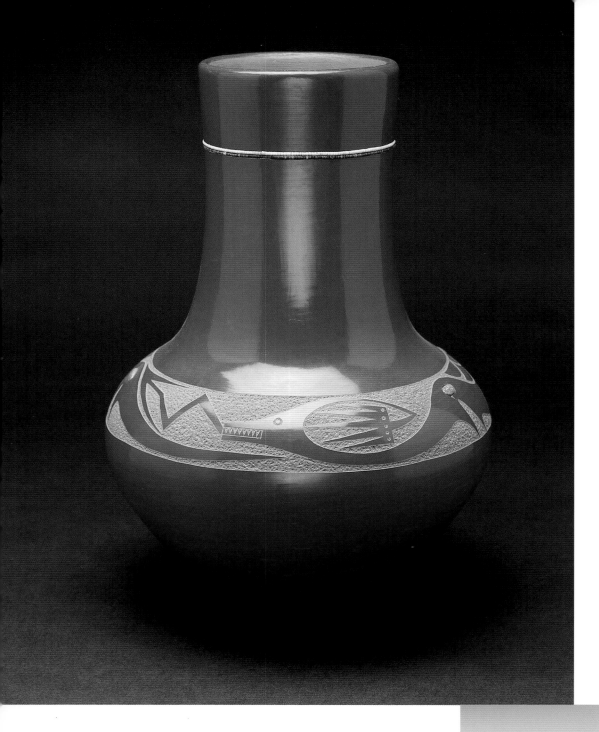

MARIA MARTINEZ (1887-1980)
AND TONY DA (B. 1940), SAN
ILDEFONSO. *Jar*, c. 1972, 13 x 9. In
the late 1960s, Tony Da and his father,
Popovi Da, introduced a number of
pottery techniques including
sgraffito—finely scratching a design
into the clay surface—as well as
setting turquoise and other stones into
the pottery. Tony Da often fired his
pottery under the guidance of his
grandmother, Maria Martinez. The
design that encircles the jar is an
avanyu or water serpent, and clouds
hang over the serpent. Gift of Mr.
James T. Bialac.

NANCY YOUNGBLOOD
(B. 1955), SANTA CLARA.
Jar, 1987, 4 x 5.75. Known for her
carved-rib and carved-swirl jars,
Nancy Youngblood often
incorporates seashell shapes into
her pottery designs. Youngblood's
first pieces were miniature vessels,
and her grandmother, Margaret
Tafoya, encouraged her by
purchasing examples of early works.
Gift of Dr. Eric Tack.

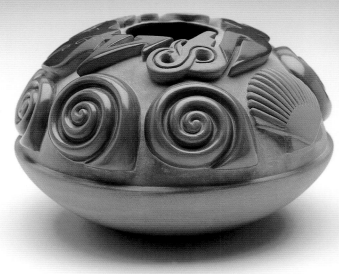

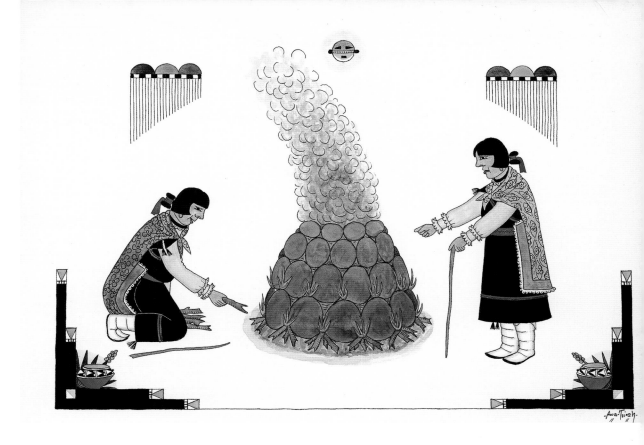

AWA TSIREH (1898-1955), SAN
ILDEFONSO. *Firing Pottery,* n.d., 11 x 14.
Gift of Mr. and Mrs. Henry S. Galbraith.

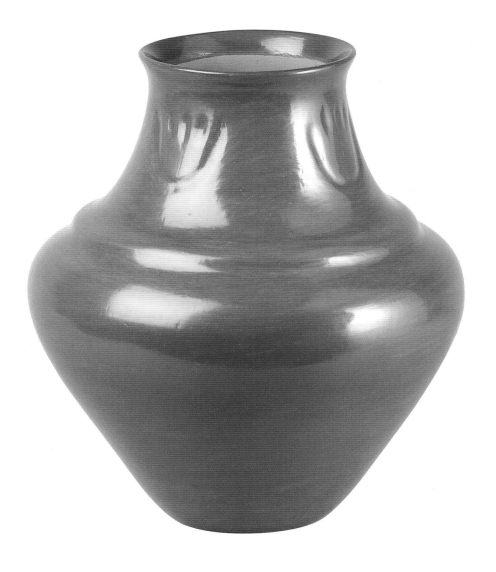

MARGARET TAFOYA (1904-2001),
SANTA CLARA. *Jar,* c. 1973, 15 x 12.
The bear paw references a story from
Santa Clara Pueblo in which a bear leads
the people to water.

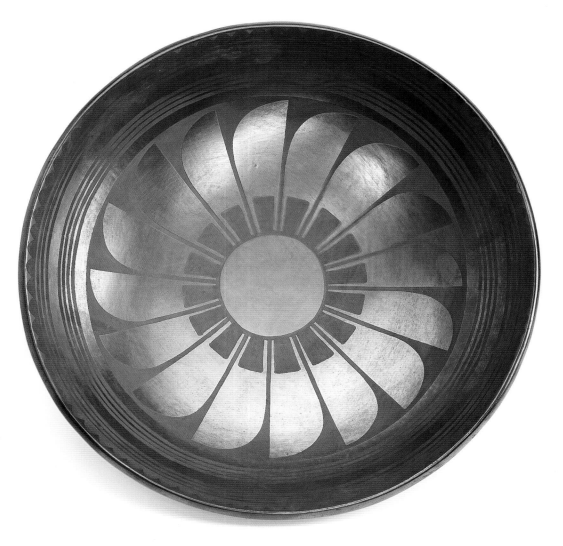

MARIA MARTINEZ (1887-1980) AND JULIAN MARTINEZ (1885-1943), SAN ILDEFONSO. *Plate,* c. 1925, 3 x 14. One of the earliest designs painted by Julian Martinez on the pottery made by Maria Martinez was the feather pattern the couple had seen on ancestral Mimbres pottery. Gift of Madeline and Russell Warren.

BELOW LEFT: SUSAN FOLWELL (B. 1970), SANTA CLARA. *Plate,* 2001, 2.5 x 11.25. On this plate, contemporary potter Susan Folwell references popular literature through designs inspired by the Harry Potter books.

BELOW RIGHT: VIRGINIA EBELACKER (B. 1925), SANTA CLARA. *Jar,* c. 1970, 7.75 x 14.5. Virginia Ebelacker, the eldest daughter of Margaret Tafoya, received an honorable mention award for this carved and highly polished jar at the 1971 Scottsdale National Art Exhibition. Ebelacker's grandmother, Sara Fina Tafoya, was the first known potter to carve her pottery beginning around 1922. Gift of Mr. Edward Jacobson.

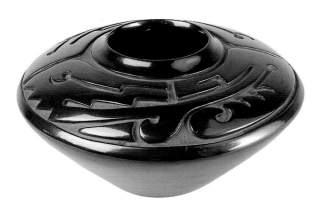

TESUQUE. *Rain god,* 1890, 12 x 6 x 6. This early example of a "rain god" was made before the mass marketing of these figures. Santa Fe merchant Jake Gold sold them to stores across the country between 1900 and 1940. Gift of Giovanni Bolla.

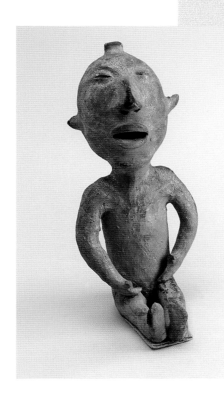

SAN ILDEFONSO. *Wedding vase,* 1890-1920, 10.5 x 7.5. "I love this wedding vase; the mouths are like birds, you can see a little beak on either side. And then it has a nice flower design. You get the idea that it's nurturing and watering the flowers, the plants. It has a butterfly on there coming to get the nectar. I love the way that's zooming in. It also has a surface on the bottom that's polished, and it's not dye. You can tell it's rubbed with a stone. I just love it! Springtime!" Kathy Sanchez, San Ildefonso, great-granddaughter of Maria Martinez. Fred Harvey Fine Arts Collection.

Southern Pueblos

SOUTHERN PUEBLOS have experienced turbulence throughout their history in larger measure than their neighbors to the north. During the period surrounding the Pueblo Revolt and reoccupation, the Southern Pueblos were the first to feel the pain of unsuccessful forays by the Spanish military. Home life changed again in the 1880s with the arrival of the railroad near Santo Domingo, Laguna and Isleta bringing tourists to Albuquerque.

Following a practice from ancestral times, some pueblos focused more on pottery than others. The people of Isleta, San Felipe, Santa Ana and Santo Domingo made pottery primarily for their own use. Zia people made pottery both for their use and that of Jemez. As manufactured containers became available, some pueblo pottery production declined. At the same time, some potters at Cochiti and Isleta shifted to production of tourist wares. Today, individual potters have created distinctive ceramics that are prized by collectors. Helen Cordero was among the first potters singled out for her Storytellers.

Agnes Dill, Isleta, 2004. Walter BigBee, photographer.

SANTO DOMINGO. *Jar,* 1870-1890, 17.5 x 23. This jar was made at a time when large storage jars still had an important household use. Fred Harvey Fine Arts Collection.

HELEN CORDERO (1915-1994), COCHITI. *Storyteller,* 1969, 13 x 7 x 9. Helen Cordero started a resurgence of figurative pottery following the creation of her first storyteller figure in 1964. Her figures are distinctive not only for their whimsical nature, but also for the details of the painted clothing and jewelry. Gift of Mr. and Mrs. William Gilbert.

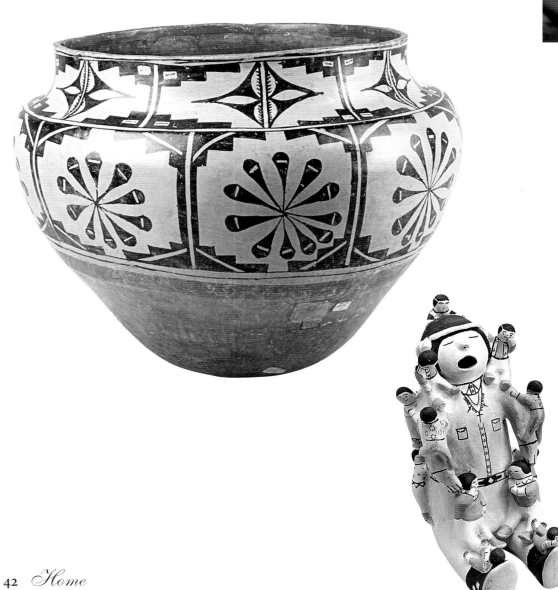

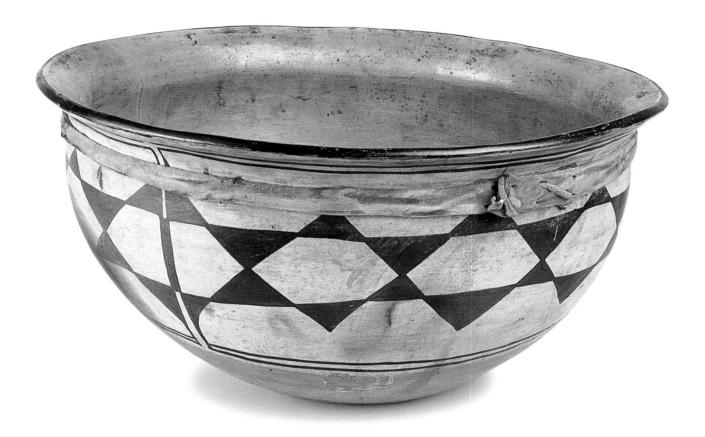

MONICA SILVA, SANTO DOMINGO. *Bowl,* early 1900s, 9.25 x 17.25. Between 1950 and 1952, Santo Domingo jeweler Angie Reano lived with her grandmother, Monica Silva. She recalls the Fred Harvey Company ordering pottery lamp bases. They would load up the back of a truck with an order of lamp bases, and Reano would ride in the back on the long drive to the Grand Canyon. Fred Harvey Fine Arts Collection.

"I remember as a child that our Pueblo women sold crafts in front of the Alvarado Hotel and the Albuquerque railroad station. Some lived at the station in adobe homes made for them. We used to go visit them when I was a little girl. Their crafts produced an income for the families. The passengers liked to have souvenirs. Isleta was the main seller, and then probably Laguna, when the train stopped at Laguna. When the railroad vanished, it made it a little hard for the people who went and sold." AGNES DILL, ISLETA

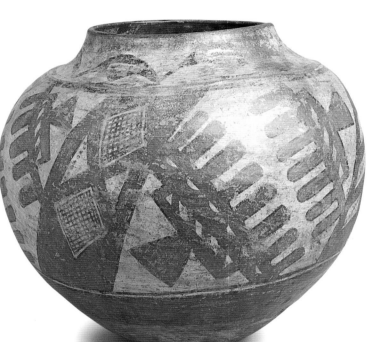

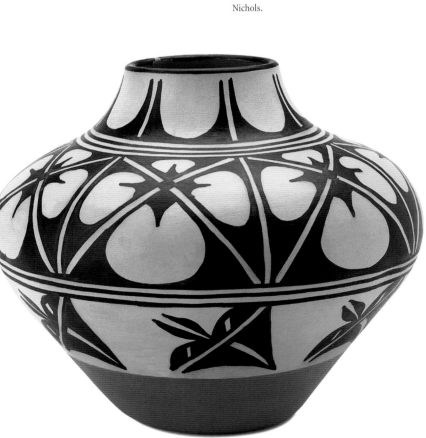

SANTO DOMINGO. *Necklace,* 1950s-1960s, 14 x 1.75. Santo Domingo jeweler Angie Reano thought this necklace was made by either Domingo Abeita or Ralph Pacheco. It uses hand-drilled shell beads, jet and turquoise. The necklace shows a continuation of the mosaic tradition and is done in a style that was imitated for tourists in plastic and gypsum, when materials became scarce or unaffordable from the 1930s to the late 1950s. Gift of Mareen Allen Nichols.

SANTA ANA. *Jar,* c. 1890, 15.5 x 16. Acquired from trader Frederick Volz by the Fred Harvey Company, this jar's bold design is distinctive of Santa Ana jars of this time period. Fred Harvey Fine Arts Collection.

ROBERT TENORIO (B. 1950), SANTO DOMINGO. *Jar,* 2001, 9 x 11. Robert Tenorio is inspired by the older traditional ceramics of Santo Domingo. Gift of the Artist in honor of the Heard Museum Volunteers.

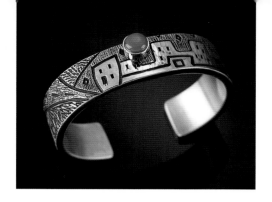

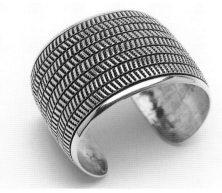

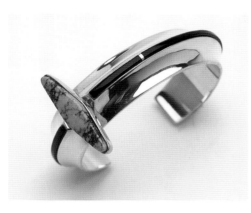

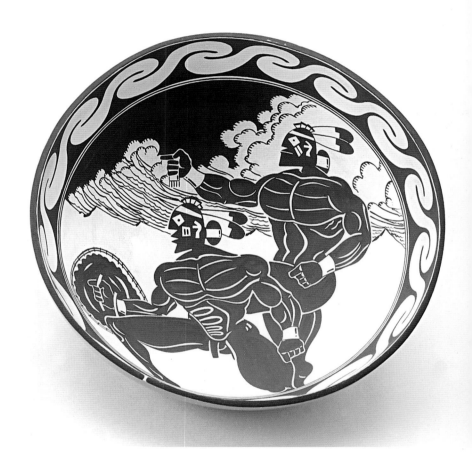

JARED CHAVEZ (B. 1982), SAN FELIPE/HOPI-
TEWA/NAVAJO. *Bracelet,* 2004, 2 x 2.5 x .625. Jared Chavez
learned traditional jewelry techniques from his father, Richard
Chavez, but he has developed his own distinctive style focusing on
detailed stamped designs. The bracelet references pueblo homes
and was created when Jared was home on break from George
Washington University in Washington, D.C.

CIPPY CRAZY HORSE (B. 1946), COCHITI. *Bracelet,* 2001,
2.25 x 1.75 x 3.25. Cippy Crazy Horse was inspired by the jewelry
of his father, Joe H. Quintana, and the early Pueblo silversmiths.

RICHARD CHAVEZ (B. 1949), SAN FELIPE. *Bracelet,* 1990s.
2.75 x 1.25 x 2. Gift of Ruth and Robert Vogele.

DIEGO ROMERO (B. 1964), COCHITI. *Bowl,* 2000,
6.75 x 12. Diego Romero has created two characters he calls
the Chango Brothers. They are shown here as the Twin War
Gods. Other depictions of them involve contemporary
themes and social commentary.

Western Pueblos

"In your home, you always have one of each: a stew bowl, a water jar, a canteen, a corn meal bowl and a dough bowl." MILFORD NAHOHAI, ZUNI

THE WESTERN PUEBLO LANDS are on trade routes that date from ancestral times through today's interstate. Of the three Western Pueblos in New Mexico, Zuni has inhabited its present homeland since about A.D. 700. Acoma's mesa-top home community was established before A.D. 1000. By these standards, Laguna is comparatively new. It was established between 1697 and 1699 following the Spanish reconquest by refugees from some of the Southern Pueblos, although ancestors of Laguna people lived in the area long before then.

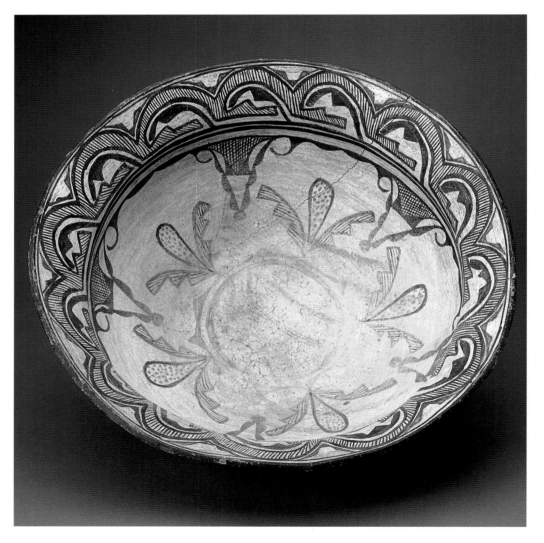

FACING: LUCY M. LEWIS (C. 1890-1992), ACOMA. *Pitcher,* 1960, 7.5 x 7. This pitcher is an example of Lucy Lewis' revival of shapes and designs from ancestral pottery. In this instance, she has revived the shape and design of a Tularosa black-on-white pitcher that has a swirled water design and fine lines, characteristics that Christine Sims of Acoma associates with rain. Fred Harvey Fine Arts Collection.

ZUNI. *Bowl,* late 1800s, 7.25 x 17. Signs of wear on the interior base of this bowl indicate that it was probably used as a serving dish. Fred Harvey Fine Arts Collection.

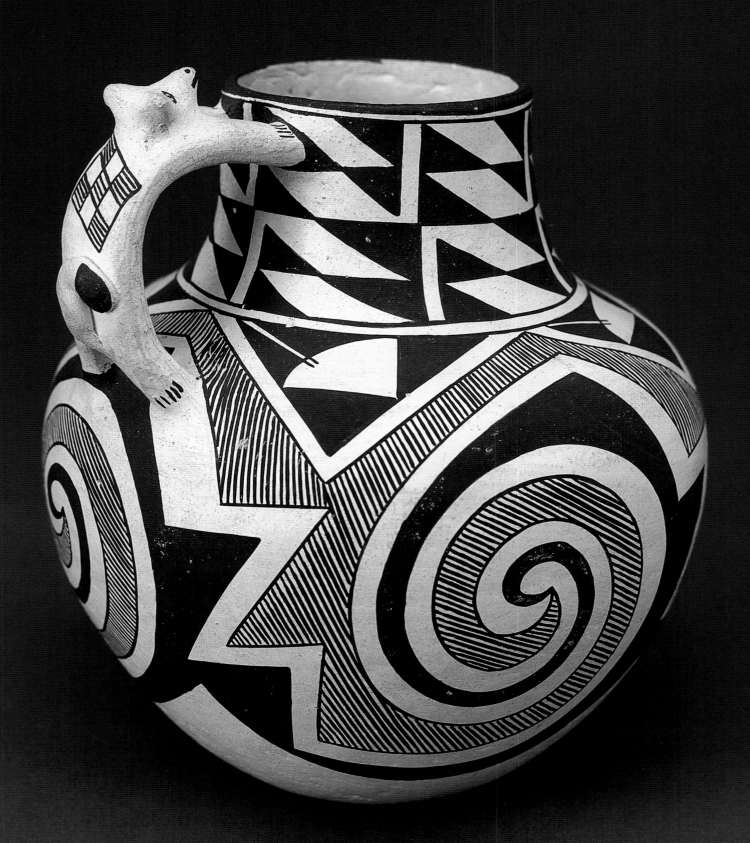

Located away from the Rio Grande, these Pueblos traditionally practiced dry land farming and ditch irrigation. In historic times, the railroad passed through Laguna and Acoma lands. With the governor of Laguna's approval, the railroad agreed to employ as many people from the pueblo as wanted to work. Into the 20th century, through strikes and world wars, Laguna people were loyal railroad employees, working as far from home as Richmond, California.

"My father was a railroad man, so I had to learn how to make lunches with my mother for him to take daily to work on the railroad." FLORENCE YEPA, LAGUNA/JEMEZ

"When the automobiles started to come through, that was the first time that the people actually got off the road. When they were on the trains, they didn't stop except at the designated depots, but once U.S. 66 came through, people started getting off and wandering into Native communities to see things. We have the lava beds, and people would take these little lava rocks and build little shelters, and the women would sit under those shelters right by the Old Highway 66 and sell their pottery." THERESA PASQUAL, ACOMA

CARMEL LEWIS HASKAYA (B. 1947), ACOMA. *Jar*, 1996, 14.5 x 5.5. This jar was inspired by similar pieces made by ancestral potters of Chaco that the artist saw at the museum at Chaco Culture National Historic Park.

ACOMA, LAGUNA AND ZUNI POTTERY In all the pueblos, wage labor in government or tribal enterprises or off-reservation employment is the key source of income. Still, in the economies of the Acoma people, pottery occupies a significant place. In the early 1900s at Laguna, pottery making declined as railroad jobs became available and income from pottery production was less important. It was not until the 1970s that a revival of pottery making began. Beyond economic support for families, pottery plays a role in the ceremonies of home. Pottery may be used in an initiation ceremony or in other ceremonies as a container for water or cornmeal or to hold water that accompanies a person on a final journey home. Both Acoma and Zuni potters talk of how much sweeter water tastes when it comes from a jar fired in the traditional way. Painted pottery with designs of rain, clouds and rainbows are a maker's prayer for a good life.

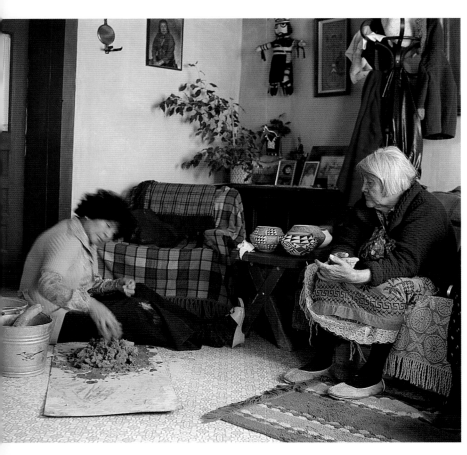

Dolores Lewis Garcia and Lucy Lewis, Acoma, mixing clay, c. 1970. Susan Peterson, photographer.

ZUNI. *Kiapkwa polychrome jar,* 1820-1840, 13.5 x 14.5. Precise, careful painting is distinctive of this period of Zuni pottery and can be seen in the fine-line hatching on the design of this jar. Fred Harvey Fine Arts Collection.

JOSEPHINE NAHOHAI (B. 1912), RANDY NAHOHAI (B. 1957) AND MILFORD NAHOHAI (B. 1953), ZUNI. *Jar,* 1983, 8.25 x 9.75. Speaking for the family, Milford Nahohai said, "This is a pot that we all did. Mom made the pot, Randy designed it, and I painted it. The design that we used on this pot is called the rainbird design, and it shows the movement of clouds as they're coming in. This is the very first pot that I ever did; it started my pottery career. When Randy penciled in the design for me, he made it very elaborate, but eventually I got finished with it and now it has a home at the Heard."

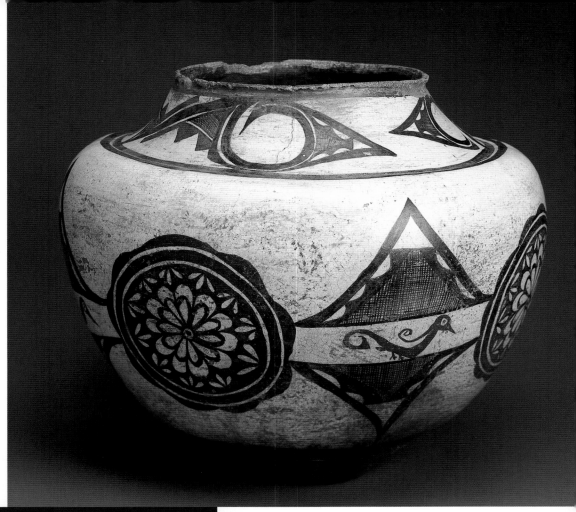

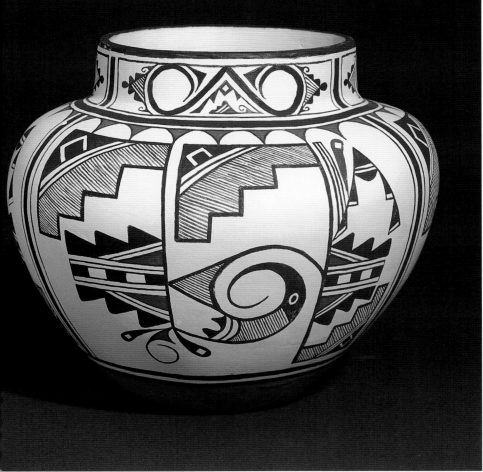

"A lot of our potters work at the kitchen table; when dinner comes, they move their pottery, their clay, and everybody sits down to a meal. Once dinner is done, the potter brings back her work, and she continues making pottery."

THERESA PASQUAL, ACOMA

ZUNI JEWELRY Ancestral Zuni jewelry was made of stone and shell. Around 1872, Atsidi Chon, a Navajo, is thought to have taught silversmithing to La:niyadhi at Zuni. Because jewelry making is expensive, traders such as C.G. Wallace provided materials and tools to jewelers in return for payment by the piece or credit at the trader's store.

Since the 1920s, jewelry has been an economic mainstay at Zuni. Jewelers usually work in the home, and family members have worked together. As a child, Veronica Poblano remembers cranking a buffing wheel for her father, Leo Poblano's, jewelry. By the 1930s, Zuni jewelry had a distinctive look featuring superb lapidary work with silver as a setting or background to the stone and shell. Jewelers created styles such as needlepoint that were distinctively Zuni. By the 1940s, power tools let jewelers further refine and detail the jewelry. Today, styles that were innovative in the 1940s have become classics. Contemporary jewelers are developing their own designs with new materials inspired by the wider world of ornament.

"Although Zuni is still a very close community, having relationships was critical back in my father's day. We shared crops, food—everything. Jewelers worked together. My father collaborated with a number of different jewelers." DAN SIMPLICIO, JR., ZUNI

WARREN ONDELACY (1898-1970s), ZUNI. *Cluster bracelet,* 1930s-1950s, 3.75 x 2.25. Warren Ondelacy is known for the cluster jewelry he made. This bracelet could easily be seen across a plaza during a gathering of people. Gift of Mr. C.G. Wallace.

EDITH TSABETSAYE (B. 1940), ZUNI. *Bracelet,* 1998, 2.25 x 2.625 x 1.89. After mastering the petit point technique, Edith Tsabetsaye began making the narrower and more finely tapered needlepoint technique. Her needlepoint now includes stones that are curved or raised to make them more visible.

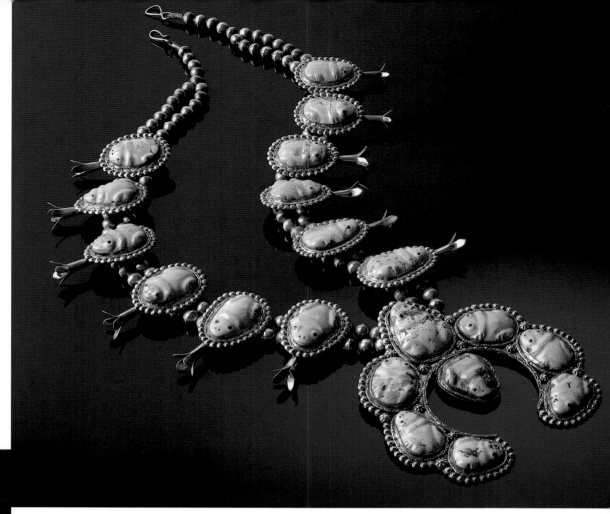

LEEKYA DEYUSE (1889-1966), ZUNI. *Necklace*, 1939, 19 x 4.75. Known by first name only, Leekya became famous for his fetish jewelry and carvings. Leekya was employed as a workman at Hawiku Pueblo, where he viewed carvings as they were recovered by the archaeological field crew. He was known to study a stone for hours until he could visualize the figure in the stone before carving. [Deborah Slaney, *Blue Gem, White Metal*, 1998.] Gift of Mr. C.G. Wallace.

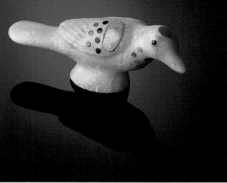

LEO POBLANO (1905-1959), ZUNI. *Bird*, 1939-1959, 2.25 x 4. Leo Poblano was one of the first carvers to use dot inlay as decorative elements in his carvings such as on the wings of birds or the backs of frogs. According to Poblano's daughter, Veronica, the dot inlay and large inlay together are distinctive of her father's work. "He used to pick up rocks at his ranch in Nutria. He rarely had enough material to work with, so he would go hunt for different rocks for his carvings. He was known for doing elaborate birds." Gift of Mr. C.G. Wallace.

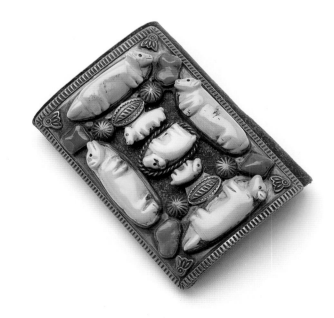

LEEKYA DEYUSE (1889-1966), ZUNI. *Bow guard*, 1948, 5 x 3.5. Gift of Mr. C.G. Wallace.

EDNA LEKI (B. ABOUT 1930), ZUNI.
Necklace, 1960s, 11.5 x 1. Edna Leki is the daughter
of skilled carver Teddy Weahkee, who inspired her to
make carved jewelry. Gift of Mareen Allen Nichols.

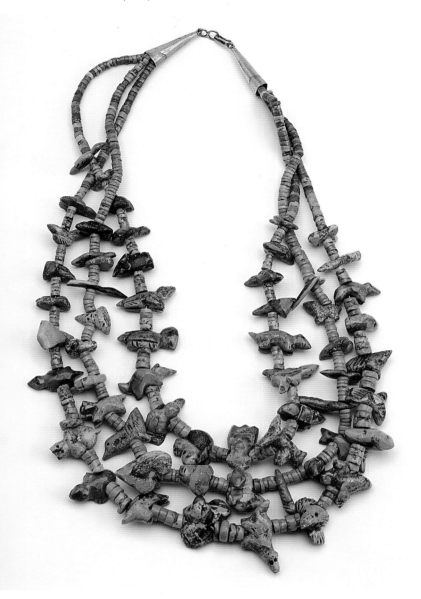

Dan Simplicio, Jr., Zuni, 2004.
Craig Smith, photographer.

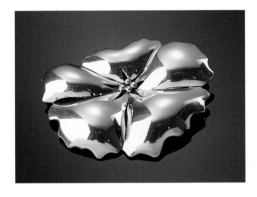

CHRISTINA EUSTACE (B. 1954), COCHITI/ZUNI.
Pin, 1983, 1.5 x 1.75. Christina Eustace interprets
themes of nature—including flowers, insects and rain
imagery—using non-traditional jewelry making
methods. Gift of Jeanie and Joseph Harlan.

ACOMA. *Manta,* 1850-1860, 46.89
x 56.34. Embroidered Acoma mantas
combine ancestral design elements with
floral motifs that are a heritage from the
Spanish. The red yarns come from
raveled commercial cloth. Fred Harvey
Fine Arts Collection.

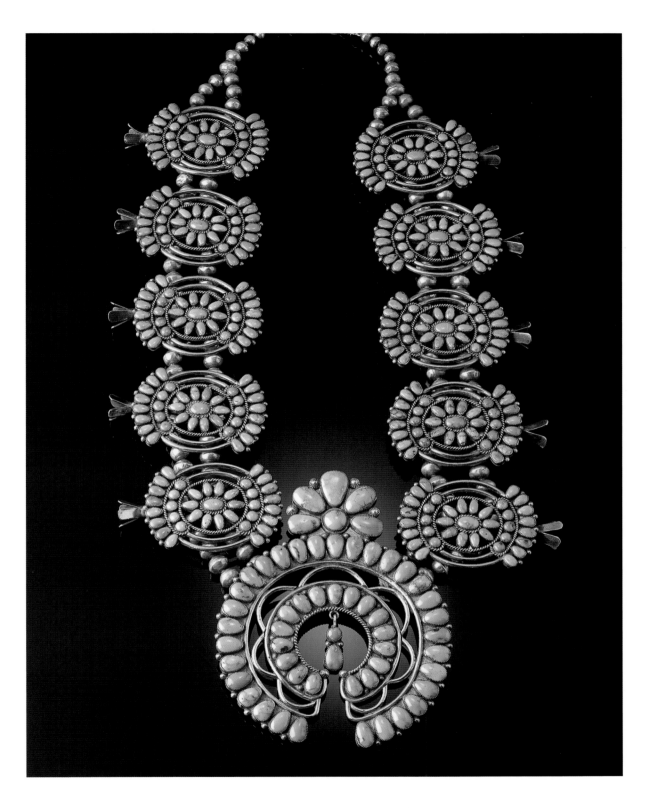

ZUNI. *Necklace,* early 1940s, 18.5 x 10. According to Dan Simplicio, Jr., much of the large-format Zuni jewelry was made to be worn in ceremony by participants and spectators, and it also could be seen by the ancestors looking down, showing that people are well and surrounded with beautiful things. Fred Harvey Fine Arts Collection.

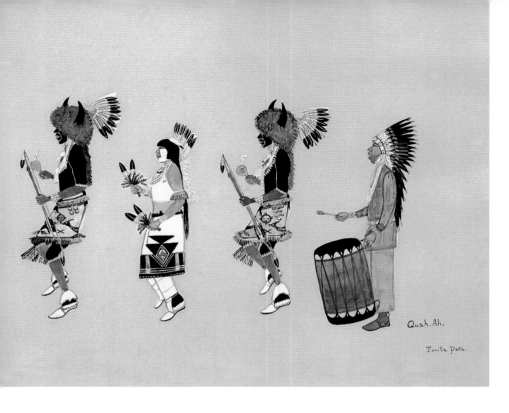

Quah.Ah.

Tonita Peña.

"The Pueblo men taught me that we had a kinship with the animals because they were P'o kanu. They came out of the lake of origin with us. That's how they taught us, and so I still have a sense of kinship with the animals—bears, deer, grouse, rabbits, rats and hawks, eagles." TITO NARANJO, SANTA CLARA

ANIMAL DANCES OF WINTER Animal dances are usually held in winter, a time when the most important precipitation, snow, comes to pueblo homelands. As with all ceremony, they are a prayer in which the whole community participates and when people now living in other communities often return home. In the animal dances, people are praying for the moisture necessary for all life. The ceremonies also are a tribute to the animals that traditionally provided food and clothing.

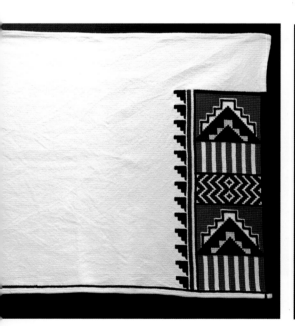

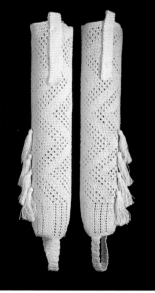

TOP: TONITA PEÑA (1893-1949), SAN ILDEFONSO. *Buffalo Dancer,* pre-1942, 11 x 14. The Buffalo Dance was one of the ceremonies Tonita Peña frequently depicted, always with a few figures representing many. Peña's son, Joe Herrera, has said that a Buffalo Dance at Cochiti would include six to eight drummers from the drum society and 40 to 50 singers. Peña's depictions of clothing worn in ceremony are usually very detailed and precise.

FAR LEFT: FLORENCE YEPA (B. 1949), LAGUNA/JEMEZ. *Kilt,* 2002, 20 x 43.75. This kilt has a classic design in a newer style of cross-stitch. According to Florence Yepa, it is worn mainly at harvest dances and at social dances. It is worn as a kilt by men and across the shoulders of women. Speaking of the kilt and clothing worn in ceremony, Yepa said, "Every article of clothing is handmade, everything takes time to have it just the way it should be. There are certain colors, certain dresses, certain things that we wear to put the dance together, and it all represents something. On the kilt are the kiva steps, the rain and the lightning. The red color represents the sky; the green represents the earth. It's very beautiful, how we have to know the stories of all the clothing that we wear for our ceremonial dances."

LEFT: CAROL VELARDE-BREWER (B. 1949), SANTA CLARA. *Leggings,* 2004, 29.5 x 6. These are worn for the Deer Dance at Santa Clara.

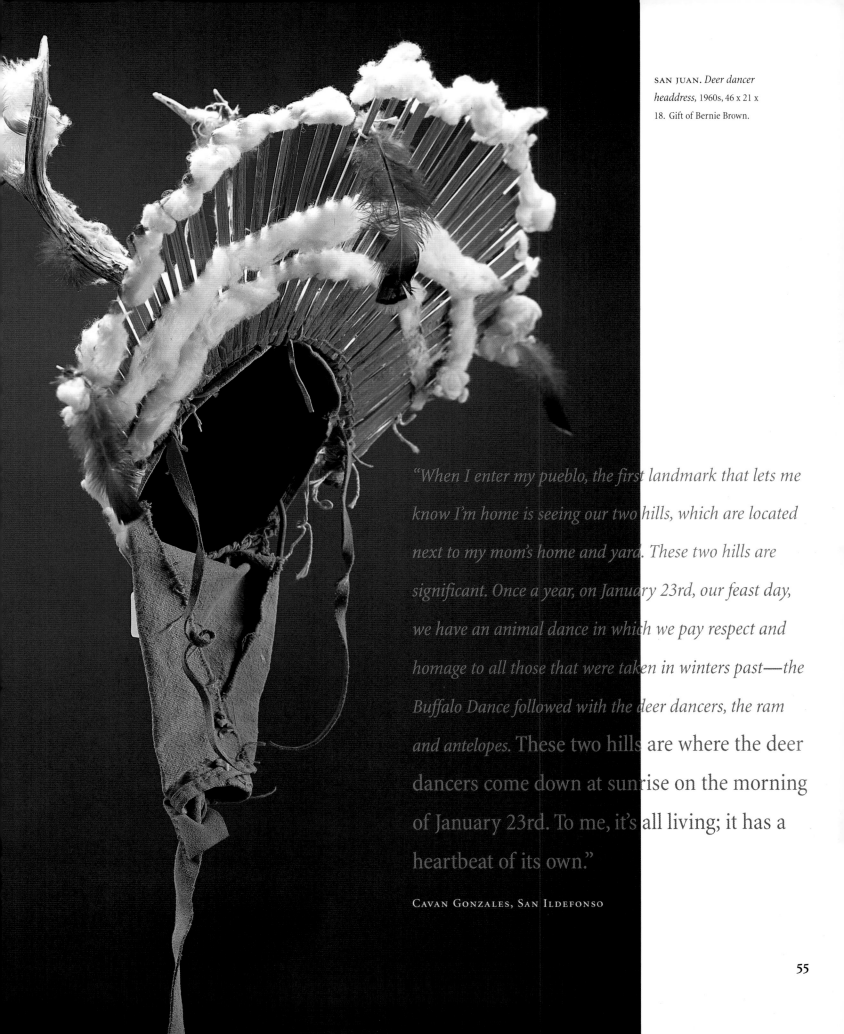

SAN JUAN. *Deer dancer headdress*, 1960s, 46 x 21 x 18. Gift of Bernie Brown.

"When I enter my pueblo, the first landmark that lets me know I'm home is seeing our two hills, which are located next to my mom's home and yard. These two hills are significant. Once a year, on January 23rd, our feast day, we have an animal dance in which we pay respect and homage to all those that were taken in winters past—the Buffalo Dance followed with the deer dancers, the ram and antelopes. These two hills are where the deer dancers come down at sunrise on the morning of January 23rd. To me, it's all living; it has a heartbeat of its own."

CAVAN GONZALES, SAN ILDEFONSO

55

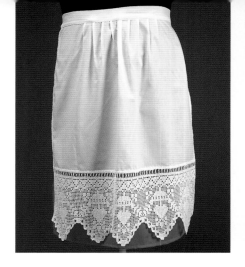

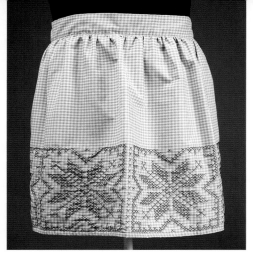

PUEBLO OVENS Many pueblo homes have outdoor beehive-shaped ovens. Sometimes a home may have several ovens. They are used for special occasion baking such as feast days. The ovens, called hornos, were introduced by the Spanish. The first oven recorded was at San Ildefonso in 1591. Prior to the Spanish arrival in pueblo homelands, corn was the principal grain food. The Spanish introduced wheat and the recipe for leavened bread. While a corn tortilla or flat bread could be baked over a hearth fire, in the fire's ashes or on a wood stove, bread loaves need an oven. Baking multiple loaves is the only way to use the horno efficiently. The preparation of dough for these multiple loaves requires larger bowls than had been needed before. Despite the apparently early introduction of the oven, dough bowls most commonly date to the last half of the 19th century, with bowls from Santo Domingo, Zia and Zuni being the most common.

When firing the oven, it takes skill to know when the oven is the right temperature. Grains of oats, wheat or cornhusks attached at the stem may be tossed into the oven to see how quickly and evenly they brown. If the oven is too hot, water is used to cool it down. When the right temperature is reached, the bread is put in using long-handled wooden paddles, and the oven door is put in place.

Ovens are more than places in which to cook food. Rachele Agoyo remembers that her grandmother baked certain rocks in the oven before grinding them to make paint for the house walls. On a cold February day, her grandmother's outdoor oven was the place the men gathered around while Rachele was being born. All the way out by the oven they heard her loud cry, and there, by the oven, decided on her name.

LUPITA A. LUCERO (B. 1947), ISLETA. *Apron,* 2004, 26.5 x 22.5. Isleta aprons are traditionally white cloth with a crocheted border over a red lining.

MICHELLE SANDOVAL, SAN JUAN. *Apron,* 2004, 19.75 x 78.75. Cross-stitch on gingham is a popular apron design. Both this apron and the Isleta apron are decorative and are worn at a gathering when people are dressed up, not when the preparations are being made.

SAN JUAN. *Bowl,* 1880-1900, 7.75 x 14.

COCHITI. *Bowl,* c. 1880, 10.75 x 22. Cochiti is unusual among the pueblos in having long used moisture symbols —clouds, rain and lightning—on pots made for everyday use. Most other pueblos restrict such designs to ceremonial pieces, which are seldom seen by outsiders. Fred Harvey Fine Arts Collection.

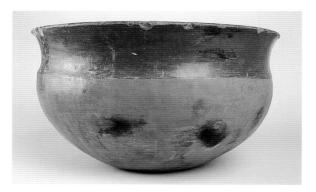

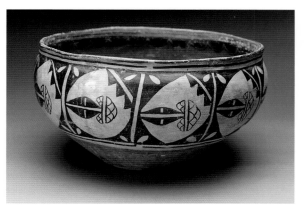

"My favorite food was raisin cinnamon bread. That's traditionally baked in the Zuni hornos. It was a rarity that they would make, usually on special occasions. One of my biggest tests was when I got initiated. We went through a four-day fast where we couldn't eat any animal fat or food fats or anything like that. That type of bread used shortening, and it was restricted from our diet. And I just saw loaves and loaves of it. There was so much of it being made that I thought I would really have a good supply of that bread. As it turned out, at the end of my fast, all that bread was actually going to be given to my godfather who sponsored my initiation, so I got very little of it. I was always disappointed about that, that even when I thought that I had it in my hands, it got away from me."

DAN SIMPLICIO, JR., ZUNI

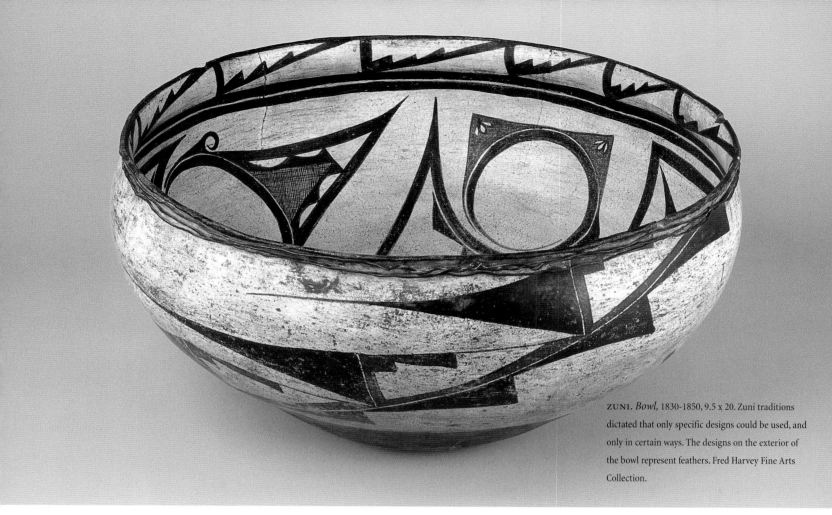

ZUNI. *Bowl,* 1830-1850, 9.5 x 20. Zuni traditions dictated that only specific designs could be used, and only in certain ways. The designs on the exterior of the bowl represent feathers. Fred Harvey Fine Arts Collection.

"I really like my mom's oven bread. You can recognize the taste of bread that comes from different families and households. If you're dancing and participating in a ceremony, you can tell where the baskets of food come from. You have a lot of food that comes from all the families."

CAVAN GONZALES, SAN ILDEFONSO

SANTO DOMINGO. *Bowl,* 1850-1900, 10 x 19.

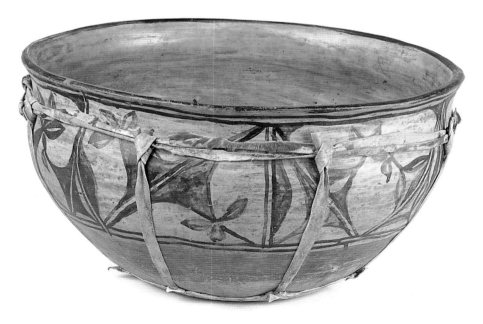

"When I think of home, I always picture the mesas. *We live out in the desert. People think that there's nothing to see out there, but there are lots of beautiful colors, wide-open spaces and blue skies. I used to live in California, and they didn't believe me that there was such a thing as a blue, clear sky, but there is.*" RUBY CHIMERICA, HOPI

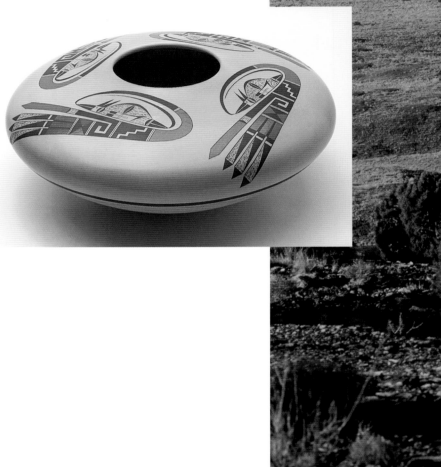

3 Home on the Mesas

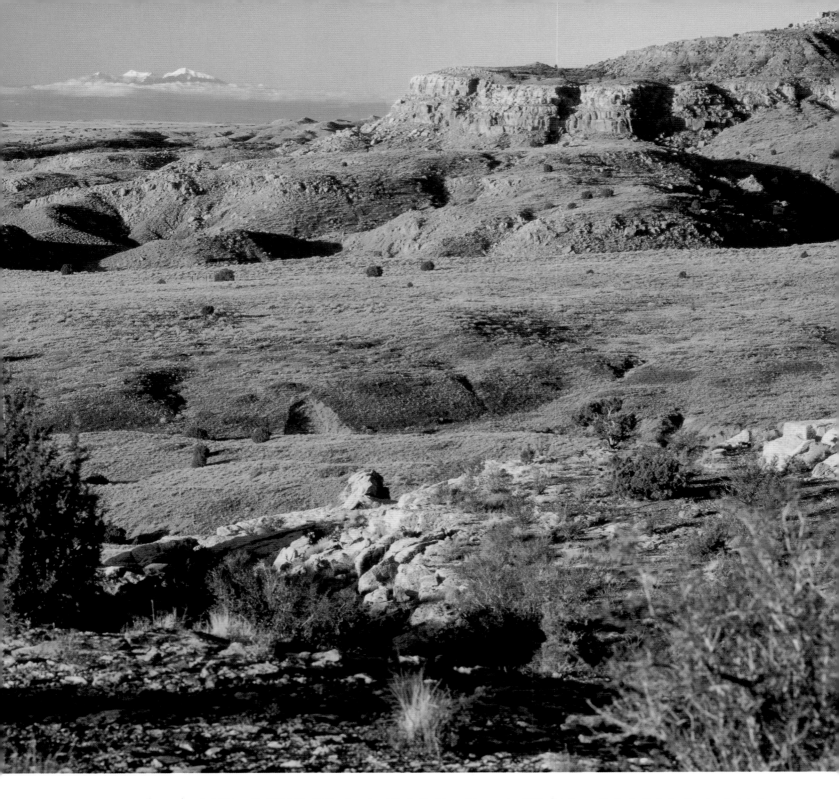

STEVE LUCAS (B. 1955), HOPI-TEWA. *Jar*, 2001, 6.75 x 16. Steve Lucas' aunt, Dextra Quotskuyva Nampeyo, taught him how to make these large-diameter, low-shoulder jars. The designs on this jar are derived from pottery by Lucas' great-great-grandmother, Nampeyo. Gift of the family of Marcia L. Katterhenry in loving memory.

POLINGAYSI QÖYAWAYMA (1892-1990), HOPI. *Canteen*, 1966, 10 x 10.5 x 7.5. Bequest of Polingaysi Elizabeth Qöyawayma.

Hopiland with the San Francisco Peaks in the background, 1994. Owen Seumptewa, photographer.

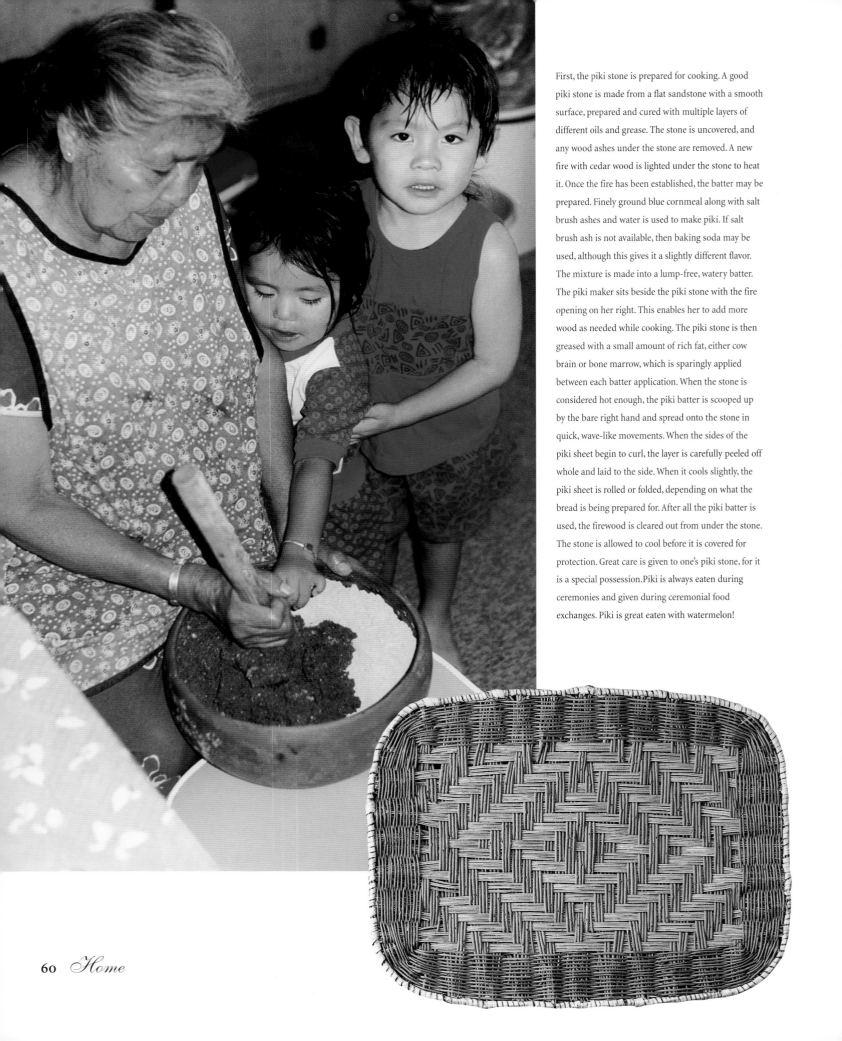

First, the piki stone is prepared for cooking. A good piki stone is made from a flat sandstone with a smooth surface, prepared and cured with multiple layers of different oils and grease. The stone is uncovered, and any wood ashes under the stone are removed. A new fire with cedar wood is lighted under the stone to heat it. Once the fire has been established, the batter may be prepared. Finely ground blue cornmeal along with salt brush ashes and water is used to make piki. If salt brush ash is not available, then baking soda may be used, although this gives it a slightly different flavor. The mixture is made into a lump-free, watery batter. The piki maker sits beside the piki stone with the fire opening on her right. This enables her to add more wood as needed while cooking. The piki stone is then greased with a small amount of rich fat, either cow brain or bone marrow, which is sparingly applied between each batter application. When the stone is considered hot enough, the piki batter is scooped up by the bare right hand and spread onto the stone in quick, wave-like movements. When the sides of the piki sheet begin to curl, the layer is carefully peeled off whole and laid to the side. When it cools slightly, the piki sheet is rolled or folded, depending on what the bread is being prepared for. After all the piki batter is used, the firewood is cleared out from under the stone. The stone is allowed to cool before it is covered for protection. Great care is given to one's piki stone, for it is a special possession. Piki is always eaten during ceremonies and given during ceremonial food exchanges. Piki is great eaten with watermelon!

HOME FOR THE HOPI PEOPLE is 12 mesa-top villages in northeastern Arizona, but home is also the place of the Katsinam on the San Francisco Peaks. The villages are on three smaller mesas that reach out from 60-mile-wide Black Mesa. The Hopi arrived at their present mesa-top homes by at least A.D. 1000. Migration stories tell of clans gathering from every direction. Ancestral people who lived in the area are referred to by the Hopi as Hisatsinom, or People of Long Ago, and as Kayenta Anasazi by archaeologists. That the Hopi have traditionally been farmers speaks to their skills and knowledge of a land that receives less than 10 inches of precipitation in a good year. They grow corn, squash, melons, beans and fruit trees, and of these, corn is the most important. Corn is more than a staple food; it is deeply entwined with a way of life, a value system and beliefs. Virtues of humility, respect, caring for others and caring for the earth all play a part in farming and the Hopi way of living on the earth.

"For me, being a Hopi woman means to welcome people to your home, tell them to come in and sit down. Feed people if you have food or offer whatever you have." KAREN KAHE CHARLEY, HOPI

HOME COOKING

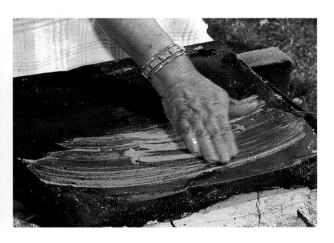

Hopi woman making piki, 2002. Craig Smith, photographer.

FACING: Lula Joshongeva, Alyssa Begay and Cameron Sinquah mixing piki, 1993. Gloria Lomahaftewa, photographer.

FACING: IMOGENE POLINGYUMPTEWA, HOPI. *Piki tray,* 1972, 21 x 16 x 1.5. Trays such as this are an important part of the bride's gift to the groom's family. When given, it would be stacked with piki bread.

"Our grandmother was a good cook. She made biscuits and blue cornmeal sweet tamales. When they would butcher a sheep, they'd cook all the insides, which are very good—blood sausage and intestines are good. Ground corn is added to the intestines and poured onto the cleaned stomach and boiled. That's how they cook it. After it is cooked, it is cut and eaten." MARCELLA KAHE, HOPI

"My grandmother was a real traditional Hopi. She would always have something Hopi cooking, whether it was beans with an herb or mutton or rabbits. I would smell the different herbs when I came to her house or the different kinds of tea that we'd drink as well as the cedar that is burned or boiled as a drink—my grandmother used to drink that a lot." RUBY CHIMERICA, HOPI

PIKI Every year, Hopi farmers plant their fields of blue corn, white corn, multi-colored corn and sweet corn. Each type of corn has a specific purpose in Hopi lifeways. In drought years, farmers find it difficult to harvest a successful crop. Additionally, animals such as rabbits, prairie dogs and crows seek food and raid the fields before the corn has fully matured for harvesting.

Piki is made from blue corn that has been ground into cornmeal and uniquely prepared into bread. Once made by all Pueblo people, today it is more commonly made at Hopi. Hopis eat it during ceremonies, everyday meals and as a snack, making it an important food for the Hopi, while for other tribes it is considered a delicacy. A girl is first taught to make piki during her corn-grinding ceremony, also known as a girl's puberty ceremony.

Traditionally, corn was handground on grinding stones to prepare cornmeal. Today, Hopi women grind their corn with an electric meal grinder, which makes it easier to achieve the fineness needed. Only if they do not have access to an electric one will they grind by hand. The exception is during the corn-grinding ceremony, when all the meal grinding is done on stones.

"In the wintertime, the smells of smoke that come from the chimneys and the kivas, and the smell of the tobacco coming from the kivas during all the ceremonies, reminds me of home."

KAREN KAHE CHARLEY, HOPI

"The smell of cedar burning reminds me of home, as does the smell of sheep dung when they are firing pottery. Also, the smell of animals, primarily horses and cattle—I could be at a fair in South Carolina and that smell reminds me of home."

ALBERT SINQUAH, SR., HOPI-TEWA

"In the springtime, the smell of the flowers and this herb called tu'itsma reminds me of home because it makes me think of all the meats and the feasting that our people use these herbs for. You can smell the spearmint in the spring, and you can eat that year-round with beans or potatoes or dry it and use it for tea. I really would not trade my home for any other place."

RUBY CHIMERICA, HOPI

LANGUAGE The cycle of ceremonies that sustains the Hopi is tied to the seasons and agricultural activities of the season. In the ceremonies, songs are sung, speeches are given and lessons are taught—all in the Hopi language. This makes understanding the language important to understanding the full meaning of being Hopi. As with other Native groups, people who were sent away to school and people who married someone who spoke another language have had to struggle to learn Hopi. Concern about teaching the Hopi language to young people has led to the development of two paths of teaching. One provides materials and support for parents who want to teach the language in the home, while another school-based program can be found in schools that are now located at Hopi.

"I think that we would get along better as a people if we really could talk the Hopi language together. Some English words seem harsh, even if you really don't mean that. In Hopi, it's soft and it really means something."

KAREN KAHE CHARLEY, HOPI

"For me, the language is very important because when I hear the songs that the Katsinas sing, a lot of songs are telling us how we should be as people, how we should treat each other, how we should treat the area that we live in and how we are going to get blessed if we become the humble people that we should be."

RUBY CHIMERICA, HOPI

Karen Kahe Charley and Marcella Kahe, 2004. Craig Smith, photographer.

"Our clan is pretty small; it's the whole family, my sisters and my aunts and their kids. We're all related together by blood, and that just makes us a big family." KAREN KAHE CHARLEY, HOPI

Ruby Chimerica, Hopi, 2004. Terrol Dew Johnson, photographer.

MYRTLE YOUNG, HOPI-TEWA. *Piki bowl,* 1960-1970, 5.3 x 12. "These functional bowls are not made much anymore. Now, pottery is made for the market. You can tell it is a piki bowl by the recurved rim. It is made so that when your hand scoops piki batter out, you get the right amount." Mark Tahbo, Hopi-Tewa. Gift from the Estate of Herman and Claire Blum.

"It's really difficult to draw a line when it comes to immediate family and clan because the Anglo society emphasizes family being mother, father, children. But I grew up with the family, the grandparents, aunts and uncles, all being very important because they had specific and major roles in your upbringing. The uncles were the persons who corrected you, taught you what you should be, and aunts protected you. The aunts were the loving part of your upbringing."
ALBERT SINQUAH, SR., HOPI-TEWA

"As an educator, I see the positive change from Hopi High School being built. More youngsters are around the culture all year, not just in summer when they come home from boarding school."
ALBERT SINQUAH, SR., HOPI-TEWA

There are 34 living clans at Hopi. In some smaller clans, the difference between family and clan is indistinct and in many respects, the entire clan is considered family. Some clans are linked through migration stories of their travels together. Each clan has a common ancestor, and descendants are linked through the female line. Aunts and uncles have important and specific family roles at Hopi.

While the difference between family and clan blurs, the 12 village communities at Hopi are distinct and independent. Some communities are quite old. People have been living at Oraivi since at least A.D. 1150, making it the oldest continuously inhabited community in the United States. At Paaqavi, people have been planting gardens on terraces since about A.D. 1200. One of the villages, Hanoki, was settled by immigrants from the Tewa communities of New Mexico fleeing the unrest that followed the return of the Spanish to their homeland in 1692. They were invited by the Hopis to help defend their people and crops from enemy tribes.

Today, in many respects, the village communities are independent. In recent decades, governance changed with the creation of an elected tribal council, providing central government for matters that affect all Hopi.

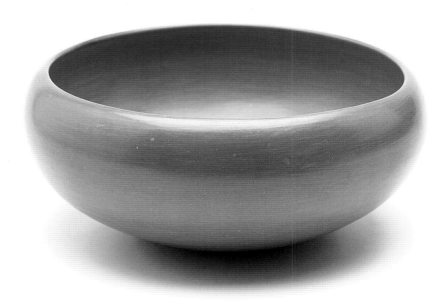

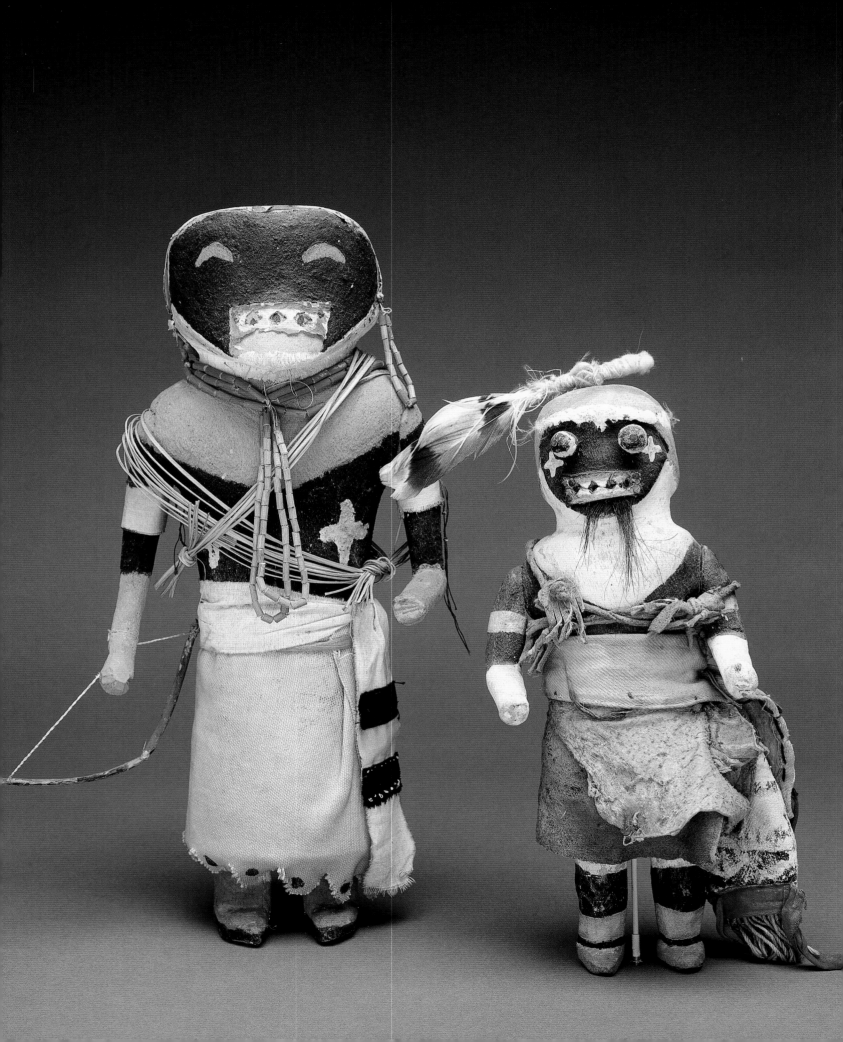

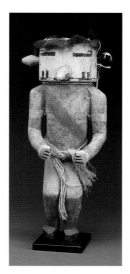

"We see ourselves as caretakers of that piece of the earth that we use. We also have respect for the heaven, the stars, the moon, the sun, and nature itself, the clouds, rain, snow. What makes us whole is to recognize and respect all these things and their seasons. *. . . we live on a definite calendar, our planting season, our Katsina season, our Home Dance, are all dictated to us by Mother Nature."* ALBERT SINQUAH, SR., HOPI-TEWA

HOPI KATSINAS/KATSINAM Katsinas are the spirit messengers of the universe representing all things in the natural world as well as Hopi ancestors. After death, a Hopi continues a spiritual existence as a life-sustaining Katsina. When Katsinas appear as rain clouds, they bring prayers for nourishment of the earth, moisture and a long life for all mankind.

The cultural and religious belief of Hopi people is that Katsinam bring the ti'tihu (katsina dolls) in their likeness as gifts for the young girls. Each gift represents a prayer-wish for good health, growth and fertility. With this daily reminder in the home, young girls remember the Katsinam and their teachings. Male family members may assist in the learning process by casually singing bits of Katsina songs within the home to remind others of the prayer-songs shared.

The first tihu given to babies is Hahai'i wuhti (Mother of the Katsinam). Male babies also receive Hahai'i wuhti, along with other gifts. When a young girl receives a tihu, she is either allowed to play with it or it is hung on the wall as a reminder of the Katsinam. Girls receive them from the time they are born until they are initiated into Katsina society. They may receive a tihu during Powamuya (Bean Dance) and Niman Ceremony (Home Dance).

Katsina dolls are carved from cottonwood roots, which embody a spiritual prayer for moisture and growth. Each carving represents a specific Katsina spirit. Outside interest in Katsinam and carved figures began in the late 1800s. Since that time, katsina doll carvings have become a popular item in the cultural art market. Carving styles of katsina dolls have changed over the years from simple, natural-colored representations of Katsinam to complicated, stylized sculpture. Buyers requested that carvers sign the dolls with a distinguishing mark. Carvers now sign their carvings either with a name, initials or a clan symbol. To Hopis, the carvings themselves are signatures of the carver. Katsina doll carvers are constantly seeking innovative ways to present Katsinam: in ceremonial groupings, in storytelling scenes or in an action pose appropriate to the Katsina being represented.

Other ceremonial figures that are not Katsinam are also represented through carvings. Popular non-Katsina figures are male buffalo dancers, butterfly maidens, sacred clowns and mythological beings.

HOPI CEREMONIAL CYCLE The religion of the Hopi people is a complex, holistic belief system referred to as "being Hopi." Religious ceremonies, including prayers and songs, are all a part of a completely defined and orderly ritual cycle. Each ceremony has a specific purpose. The central theme throughout Hopi ceremonies is prayer for a lasting and harmonious balance in the universe for all life as well as the nourishment of corn, "mother corn," the food of life.

The Hopi religious cycle is initiated in November during Wuwusimt. Winter solstice marks the beginning of the new year with prayers for all life and the world. Katsina ceremonies are an important part of this ceremonial cycle, to which half the year is committed. The Katsinam first appear in the Hopi villages in January and are seen at intervals until they return to their homes in July. Katsinam are the spirit messengers of the universe, bringing prayers for nourishment of the earth, moisture and a long life for all mankind. Renewal ceremonies are completed each year to maintain the balance of harmony and nourishment for all life.

SOYALUNG CEREMONY Soyalung, the Winter Solstice Ceremony, signifies the beginning of the sun's journey to its summer house. The days begin to grow longer, and preparations begin for the planting season. Prayers are conducted for universal life renewal to ensure a long, healthy, nourishing life as well as bountiful crops. Ahöla is the first ceremonial figure to appear in the village to symbolically open the village's doors. He makes ceremonial markings by each doorway to welcome the return of the Katsinam. Other Katsinam who conduct specific rituals eventually accompany Ahöla to assist in this important beginning.

POWAMUYA/BEAN DANCE With the entrances of the ceremonial kiva chambers opened by Ahöla, Katsina ceremonies may commence. For four days before Powamuya, the Whipper Katsinam, powerful spirit beings, begin returning to the villages in the evening. They check to see if the people are living according to the Hopi way.

At sunrise on the day of Powamuya, two Qöqöqli appear in the village with their baskets full of bean sprout bundles and gifts for the children. Each household matriarch receives a miraculous bundle of fresh bean sprouts with bits of earth still clinging to its roots. The children receive special

FACING: LEFT, JIM FRED (B. 1945), HOPI. *Angwusnasomtaqa,* 1984, 17.75; RIGHT, HOPI. *Angwusnasomtaqa,* c. 1900, 9.75. Crow Mother is the Katsina mother.

"Now we have finished the day. Now the time has come, the sun has reached its place and I am tired, and you too may be tired. When you go home and get to your parents and sisters and the rest of your relatives who are waiting for you, tell them all the words that I am going to tell you. Tell them that they should not wait, but let them come at once and bring rain to our fields. We may have just a few crops in our fields, but when you bring the rain they will grow up and become strong. Now go back home happily, but do not forget us. Come to visit us as rain. *That is all."*

FROM THE KATSINA CHIEF'S SPEECH TO THE KATSINAM AT THE END OF THE NIMAN OR GOING-HOME CEREMONY.

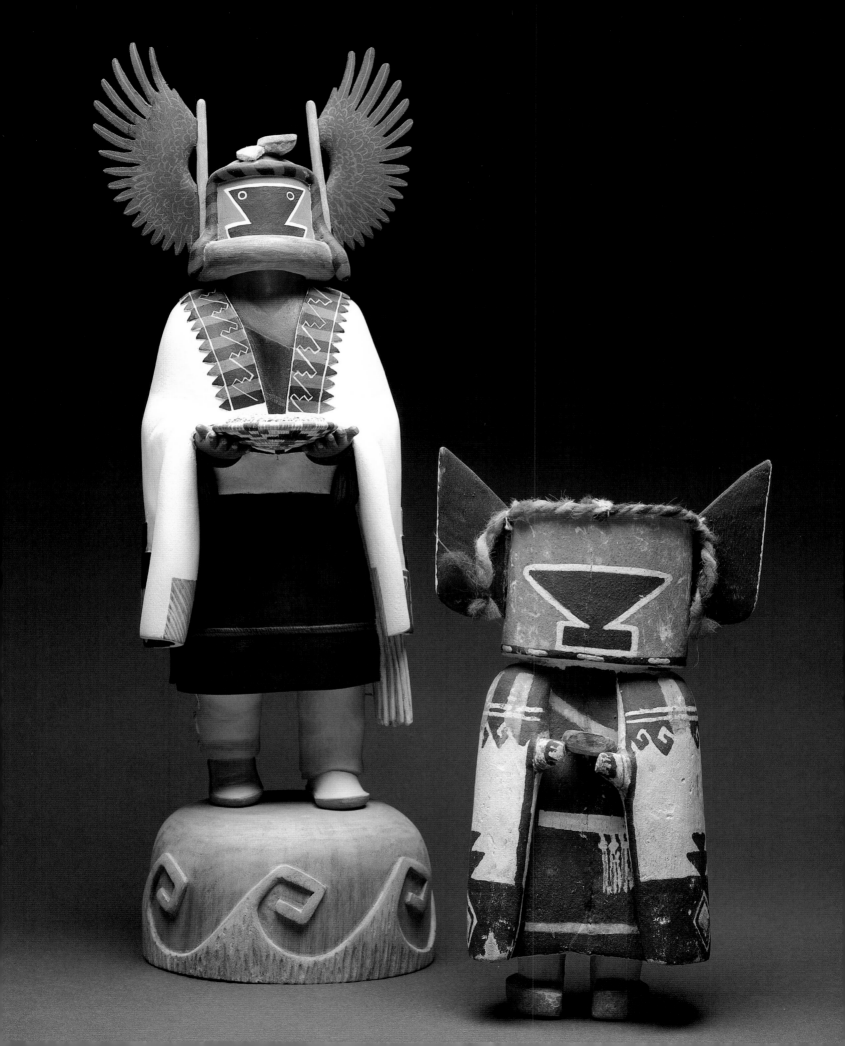

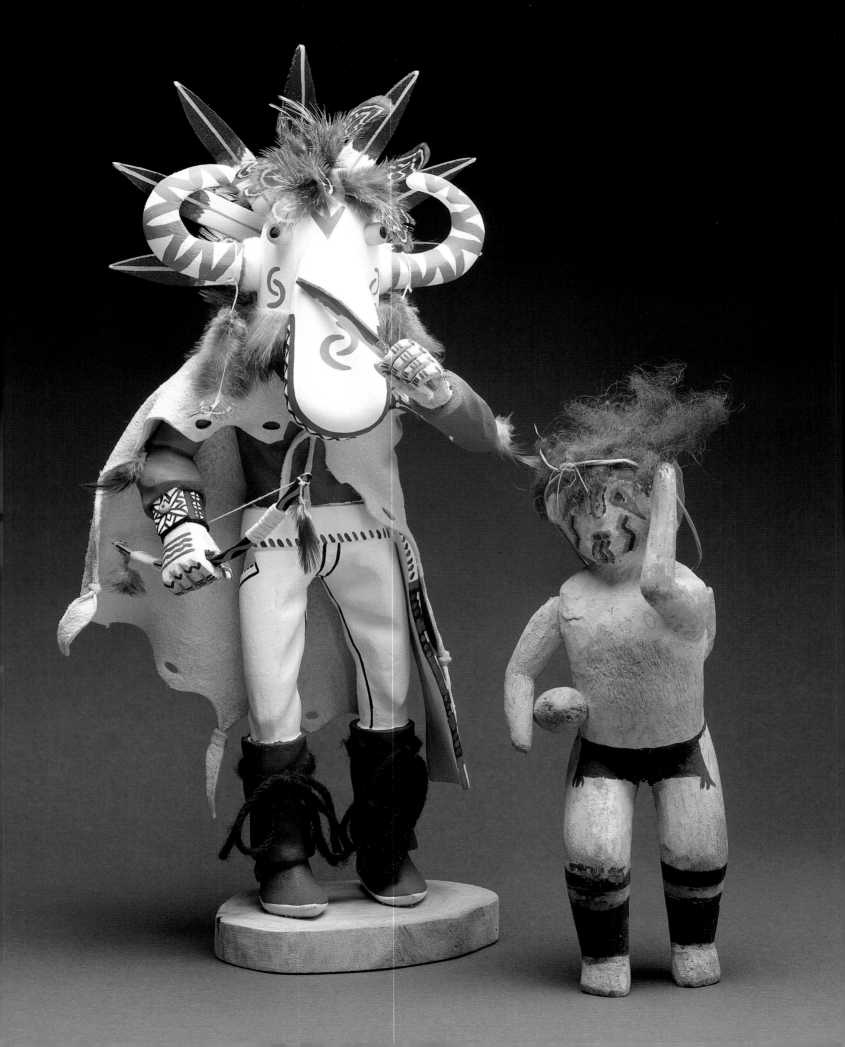

gifts. The boys receive brightly painted gourd rattles, lightning sticks and possibly a new pair of moccasins. The girls receive katsina dolls, masumpi (dancing wands) and maybe a basket plaque. These wonderful gifts from the Katsinam tell the children they are special and encourage them to behave properly in the Hopi way. Children between the ages of 9 and 15 are initiated into Katsina society during Powamuya. They receive religious teachings about being Hopi and purification of life.

At night, when the Powamuya Katsinam are in the kiva, only those who have completed the Katsina initiation may see the dance. These colorful Katsinam bring special prayers through their songs for a renewed year.

SOYOKO Powamuya continues the purification of life with the So'so'yoktu, Ogre Katsina spirits. So'yok'wuhti (Ogre Woman) appears in the village, stopping at each home where she selfishly demands food that will take skill and many hours to make. She also checks to see if people are living the Hopi ways.

When the So'yok'wuhti returns a few days later to the village, she brings her Ogre family, each of whom has a frightening appearance. She tells the people their lives will be spared only if they meet her challenging demands, otherwise she will take the children to eat, especially the naughty ones. As the So'so'yoktu arrive at each home, all the children inside cry in terror, knowing they have misbehaved sometime during the year. They give their food to So'yok'wuhti, promising to be good and to behave properly. No one escapes her—even the men at the kiva are disciplined and give her their game animal meat. After the So'yok'wuhti visits each home and kiva, checking and testing the behavior of the people, special blessings are provided during festivities. Purification is now complete within the village.

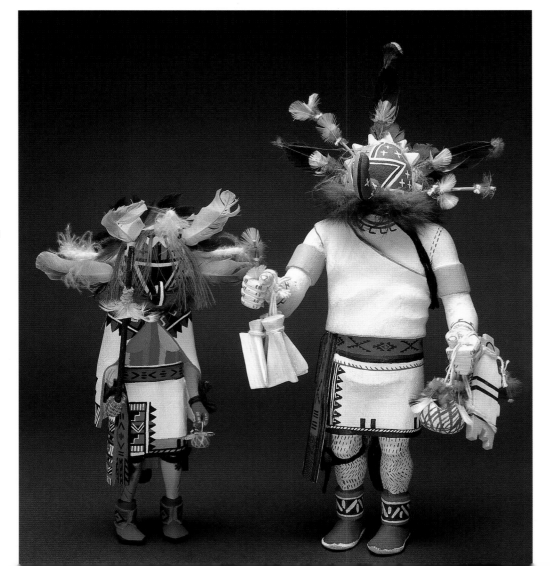

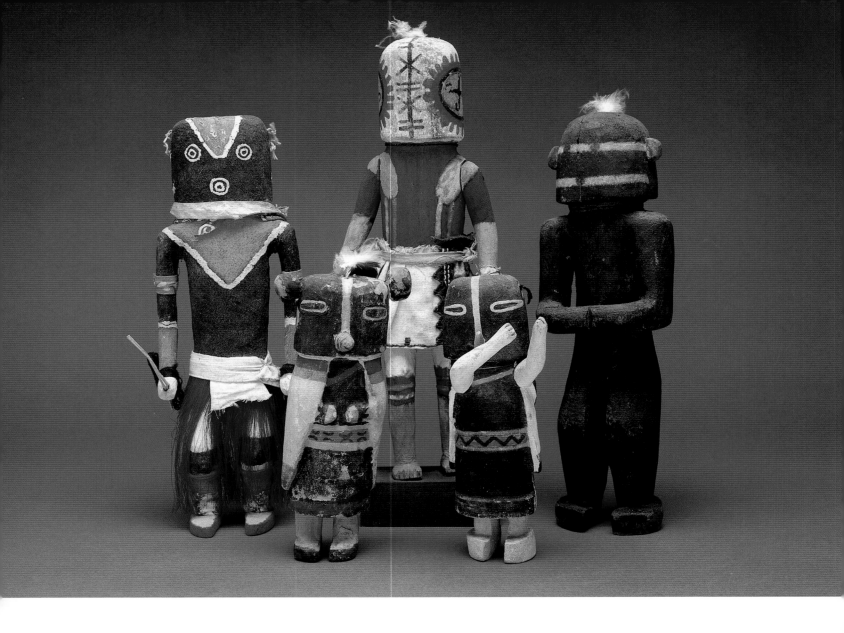

RACER KATSINAM In early spring, the Racer or Runner Katsinam appear in the plazas of the villages, challenging the men and boys to short-distance races the length of the plaza. The Koyemsi (Mudhead Katsina), who serves as the leader of the Racer Katsinam, announces that they have brought blessings for a strong and healthy life. They wish to test the strength of the men and boys of the village.

There are many different types of Racer Katsinam, each with a specialty or unique quality. For example, when the Chili Racer wins a race, it smears hot chili on people it defeated. Everything is done in good fun, with no one really losing. Each man or boy who participates in a race receives a food gift from the Katsinam at the end. After all the food has been given out, the Racer Katsinam are blessed by the village Kikmongwi (Village Chief) with sacred cornmeal and then sent away with prayers for rain.

NIGHT KATSINA DANCES March is called Osomuya. In this month, night Katsina ceremonies take place in the kiva (ceremonial chambers) in the Hopi villages. A pair of Kokoyemsit (Mudhead Katsinam) announces the coming of the Katsina night dances and when they will begin. Many kinds of Katsinam appear during this time, bringing gifts for the people such as piki bread and sweet corn that represent bountiful crops and renewal of life.

FROM RIGHT, HOPI. *Sivutotovi*, 1900-1920, 11; *Kokopölmana*, pre-1901, 7.67; *Aykatsina*, c. 1901, 13.26; *Kokopölmana*, 1930s-1940s, 7; and *Sivukwewtaqa*, c. 1901, 13.6. The Black Fly Racer on the right, Sivutotovi, carries a yucca whip to lash his opponents. The whip feels like the sting of a fly. The Kokopölmana intercept opponents and make gestures of copulation that reference procreation. The head of the Aykatsina is a rattle, with a design on each side of his head that represents the world. Gifts of Senator Barry Goldwater and The Fred Harvey Fine Arts Collection.

As the ever-watchful spirit beings and invisible forces of life, the Katsinam listen for humble prayers and meditations of the people and then provide ceremonial prayer-songs to bring rain and encourage growth.

Time disappears into the evening when the Katsinam sing during the night dances. Their songs are a cloudburst of music, showering everyone and absorbing them into the songs' beauty, creating wholeness to the universe that is felt by all.

DAY KATSINA DANCES Spring is the beginning of planting time. The different colors of corn, all sacred in the cycle of life, are planted. This is when the prayer-songs of the Katsinam are most needed to encourage clouds to come and bring rain to help nurture the young plants in the fields below the mesas.

In the plaza, the Katsinam accept the warm welcome by the Katsin'mongwi and sing many different prayers for rain, good health, bountiful crops and long life for all. At midday, the women of the village provide them with specially prepared sacred foods. The Katsinam also bring gifts of food to share with the people who bless them with sacred cornmeal. A wonderful feeling is left in the village through the memories of the beautiful songs.

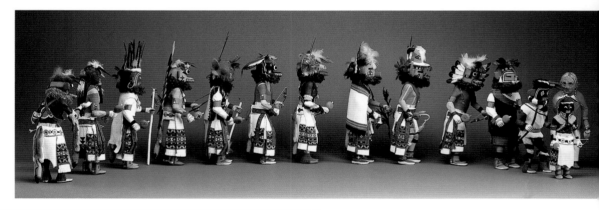

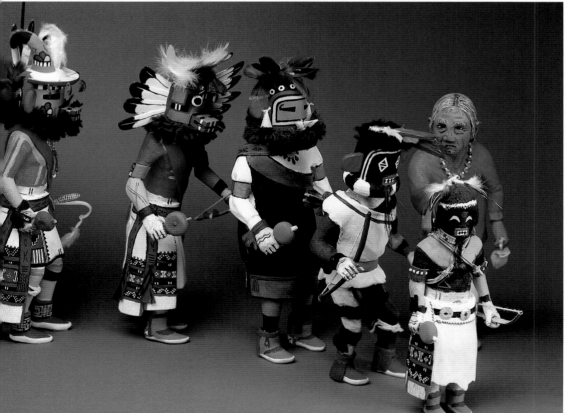

ROBERT QUOTSKUYVA, HOPI. *Katsina set from a Mixed Katsina dance,* 1984. Robert Quotskuyva, a superb carver, carved this group of katsinam representative of a Mixed Katsinam dance that would take place in a village plaza. The elder man takes care of the Katsinam and encourages them in their singing.

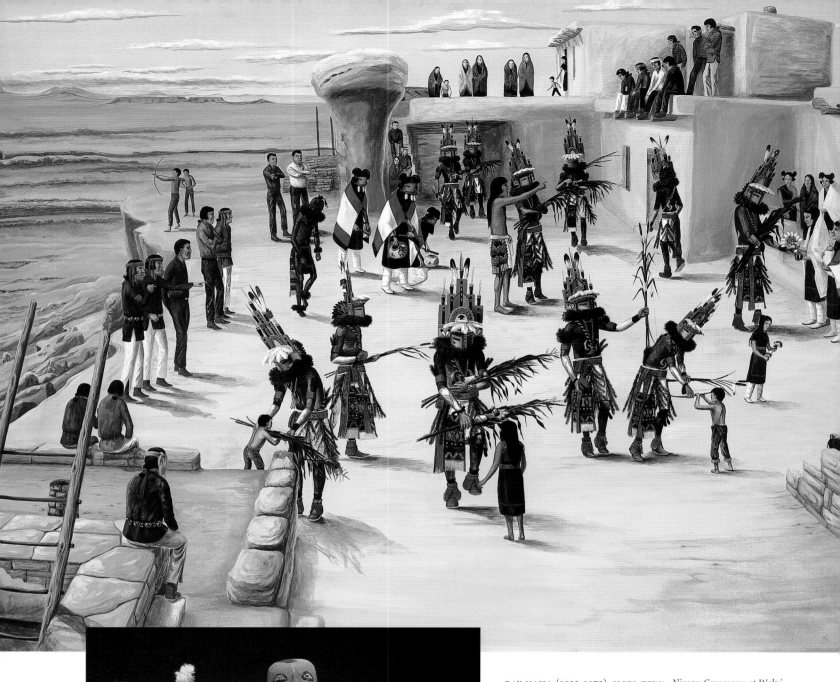

RAY NAHA (1933-1975), HOPI-TEWA. *Niman Ceremony at Walpi Village,* c. 1965, 41 x 61. During this ceremony, the Niman Katsinam present gifts as prayers for health and prosperity to Hopi children before returning to their homes in the San Francisco Peaks. Gifts include bows and arrows for boys and katsina dolls for girls. The gifts are tied to cattails, which are water plants. The Niman Katsinam also carry corn and watermelon, symbolizing successful prayers for rain. The figure in a kilt with his hair worn long takes care of the Katsinam. He is shoeless because he is praying for rain. When he explained this painting, Clifford Lomahaftewa, Hopi, said, "If he sees clouds, he will put his shoes on. Otherwise, he will stay barefoot."

HOPI. FROM RIGHT, *Tsuku,* 1910-1940, 10; *Koyaala,* 1900, 6; *Tsuku,* early 1900s, 12; *Koyaala,* c. 1901, 7.5; and *Koyaala,* c. 1969, 12. Gifts of Senator Barry Goldwater, Byron Harvey III and The Fred Harvey Fine Arts Collection.

CEREMONIAL FIGURES The Tsutskut (Hopi clowns) maintain important ceremonial roles during the plaza dances. They are not Katsinam but are a type of sacred priests. The Tsutskut vary in appearance from one village to the other. They mimic inappropriate behavior, which is called being qahopi (un-Hopi). These acts are a way of providing lessons and advice.

Throughout the day, the clowns are honored with gifts of food from the women of the village. The Tsutskut are warned by the Owl Katsina and Crow Katsina of potential punishment for their inappropriate behavior and asked to consider changing their ways. Finally, the Owl Katsina leads the Kipok Katsinam (Raider Katsinam) into the plaza to punish the clowns, which is symbolic of purification for all Hopi people and a lesson in the consequences of being qahopi (un-Hopi).

NIMAN CEREMONY The Niman Katsina Ceremony occurs at midsummer. The majestic Niman Katsina and serene Katsinmana appear at early sunrise during the freshness of the cool morning. The Katsinam arrive bringing gifts of corn stalks and melons for everyone. Girls receive special gifts of katsina dolls, and boys receive bows and arrows. Later in the day, the Katsinam bring colorful gifts tied to cattail stalks.

Niman Katsinam prayer-songs provide blessings for the bountiful crops of a rich harvest, with everyone participating in this concert of prayers. At day's end, the Katsin'mongwi (Katsina Chief) will thank the Katsinam for their blessings and ask them to take the prayers of the Hopi to their spiritual home. Life is again purified.

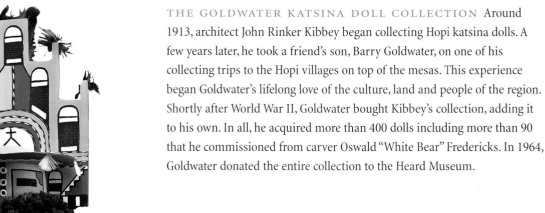

THE GOLDWATER KATSINA DOLL COLLECTION Around 1913, architect John Rinker Kibbey began collecting Hopi katsina dolls. A few years later, he took a friend's son, Barry Goldwater, on one of his collecting trips to the Hopi villages on top of the mesas. This experience began Goldwater's lifelong love of the culture, land and people of the region. Shortly after World War II, Goldwater bought Kibbey's collection, adding it to his own. In all, he acquired more than 400 dolls including more than 90 that he commissioned from carver Oswald "White Bear" Fredericks. In 1964, Goldwater donated the entire collection to the Heard Museum.

"My fondest wish for the future of this collection is that students of all ages will be able to visit and study it and emerge with a full understanding of what the Katsina means." SENATOR BARRY M. GOLDWATER

TINO YOUVELLA, HOPI. *Niman katsina,* c. 1983, 20.5. The Niman Katsina is the last Katsina to appear in the village before all the Katsinam return to their mountain-top homes. Niman Katsina's headdress and the feathers on top represent clouds. Cloud designs can also be seen on the embroidered kilt.

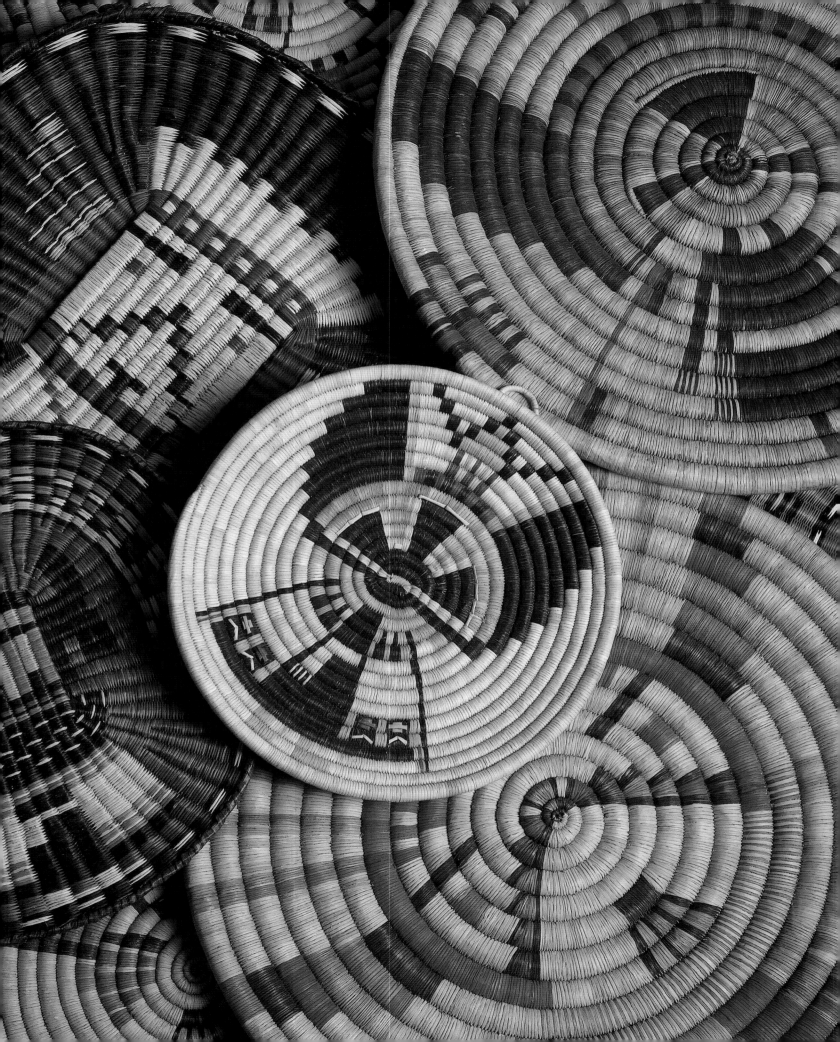

FACING: HOPI. *Baskets,* early
1900s-1970. These are examples of
the many baskets given to the groom
and his family by the bride and her
family upon completion of the
wedding ceremony.

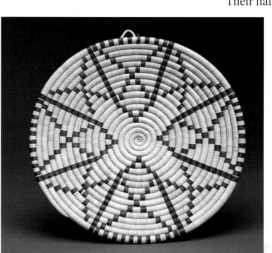

BETH LUKE, HOPI. *Basket,*
c. 1970, 2 x 14. Weavers who live in
Second Mesa villages are known for
weaving coiled basketry plaques. Hopi
basketweaver Elfreda Holmes selected
this basket as an example of the type
that would be given by the bride to the
groom. Gift of Mr. and Mrs. Byron
Harvey III.

MARVIN POOYOUMA AND MIKE
GASHWAZRA, HOPI. *Belt, sash
and kilt,* 1983, 87 x 3.5, 54.5 x 10.28
and 57 x 23.75. The belt, embroidered
sash and kilt are worn in many
ceremonies. On the sash, the paired
vertical lines with hooks represent a
dragonfly, which is associated with
water, and the red lozenge shapes are
flowers. The red side borders show the
sash is from the Third Mesa village of
Oraivi. On the kilt, the terraced
designs are clouds, the green is the
earth and red vertical lines are the
sun's rays.

THE HOPI WEDDING In a traditional Hopi wedding, months of ritual exchanges between the families of the bride and groom take place before the wedding is complete.

A central event in the whole wedding process occurs when the bride goes to her groom's mother's house. Her hair is worn in a set of poli'ini, or butterfly hair whorls, which is the customary style of unmarried women. For three days, she grinds corn. Before sunrise on the fourth day, her hair is taken down, and she and her groom have their hair individually washed by their future mothers-in-law. Their hair is then washed together in a single bowl to symbolize that they are now one.

Then the couple walks along the east side of the village toward the rising sun. Holding a pinch of cornmeal to their lips, each offers a prayer for prosperity and a long life together. On completion of their prayers, they sprinkle the meal toward the rising sun. They return to the house as man and wife.

In the days following their wedding, the couple remains at the groom's mother's home while he and his male relatives complete the weaving of the bride's wedding robes. When they are finished, she is dressed by her husband's family and wears her robes on a ritual journey to her mother's house, where the couple will reside.

Today, couples may wait a few years after their civil marriage ceremony to complete the traditional wedding. If children have been born before the Hopi wedding ceremony, they also will receive Hopi traditional woven clothing.

The tassel of the wedding robe is called qaao-corn. The feather on the robe is a prayer-wish for the health and happiness of the bride and her children to come. The embroidered line symbolizes the life-giving bloodline—or umbilical cord—from mother to baby.

Two white robes are woven for the bride. For the bride's journey home, one is worn and the other is rolled in a reed mat, which she holds in her arms. Traditionally, all of the wedding garments were rolled in this mat for storage. One of the bride's robes is kept until she dies, when she will be buried in it.

Women who have completed their traditional Hopi wedding in the months previous to Niman Ceremony are presented to the Katsinam in their new wedding robes. Dressed in her robes, each new bride receives a special elaborate katsina doll from the Katsinam that represents special blessings for motherhood. If she has children, they too will wear their new Hopi clothing and accompany their mother. The children also will receive special gifts from the Katsinam.

HOPI WEAVING Hopi textiles are worn today, as they were in the past, in Hopi ceremonies. Traditionally, weaving was done by Hopi men and comes from a complex ancestral tradition of woven cotton. With the introduction of Spanish sheep, weavers added wool to their tool kits. Because weaving was done to produce ceremonial garments, it continued even when the introduction of machine-made cloth and the adoption of western-style clothing meant everyday garments did not need to be woven. Children removed from home and taken to boarding schools had their traditional clothing destroyed and replaced with uniforms. For a time in the late 1800s, Hopi weaving was an important trade item to the New Mexico pueblos, where the cloth would be embroidered in the manner appropriate to the purchaser's pueblo. Today, the time-consuming aspect of weaving means that more ceremonial garments are hand-embroidered by women on machine-made cloth. However, a few younger men continue the weaving tradition.

HOPI. *Blanket,* c. 1975, 62.5 x 46. Traditional Hopi weddings take time to plan. A wedding requires corn from two harvests and the weaving of wedding clothing as well as other resources. If a couple starts a family before the traditional Hopi wedding, gifts are given to their children. A plaid blanket such as this would be given to the bride's son.

HOPI. *Dress,* 1961, 37.5 x 38. The addition of the taffeta ribbon ruffle indicates that this dress was probably worn during a summer social dance. The bride's daughter would be given a dress without a decorative ribbon by the groom's family for the traditional Hopi wedding ceremony. This dress was purchased from the Porter Timeche family.

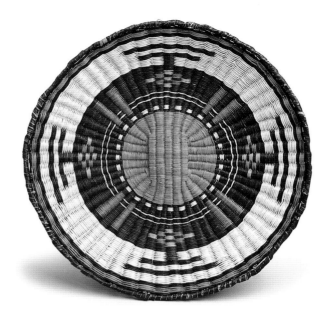 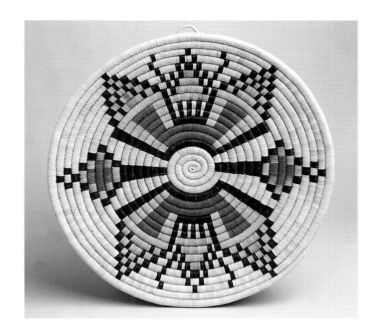

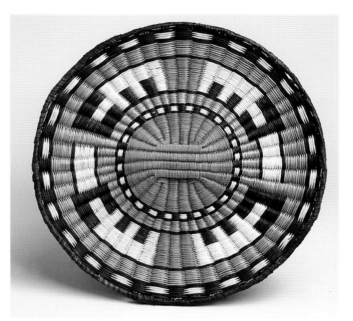

CLOCKWISE FROM UPPER LEFT: HOPI. *Basket*, c. 1970, 1.25 x 13.25. The design on this basket is one that would be used on an embroidered wedding robe, making it an especially suitable design to place on a basket that is given as part of the wedding gift. Gift of Mr. and Mrs. Byron Harvey III.

MARTHA KOOYAHOEMA, HOPI. *Basket,* c. 1967, 2 x 15.25. This basket design features colorful summer clouds, with lightning streaking outward from the central clouds. Gift of Mr. and Mrs. Byron Harvey III.

ROBERTA NAMINGHA (1932-2004), HOPI. *Basket,* c. 1969, 1.25 x 13.5. A Crow Mother Katsina is surrounded by rain clouds on this plaque. Gift of Mr. and Mrs. Byron Harvey III.

HOPI. *Basket,* c. 1970, .75 x 9. This wicker plaque was made by a woman from the Third Mesa village of Oraivi. It has a design of two rabbit sticks, which are hunting weapons. Gift of Mr. and Mrs. Byron Harvey III.

HOPI POTTERY Today, individual Hopi potters are widely appreciated by collectors of Native art. Historically, Hopi pottery was utilitarian and produced on all three Hopi mesas. From the 14th through the 16th centuries, black-on-yellow pottery of the Hopi region was one of the most widely traded ceramics of its time. By the 1900s, utilitarian Hopi pottery production had declined as metal containers became more widely available. Pottery revived as an art form when potters at First Mesa, led by Nampeyo, developed styles based on pottery fragments found at the ancient site of Sikyatki. One of the first artists to be known by name, Nampeyo was the first of a family dynasty of potters. For years, the Nampeyo family and other families made First Mesa the exclusive pottery making center, and it remains a center for traditional pottery today. As the collector market has developed, men are pursuing what was once a woman's art, and potters are pursuing innovations in both form and surface treatment.

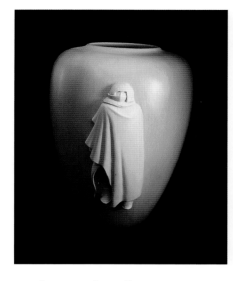

AL QÖYAWAYMA (B. 1938), HOPI. *Jar,* 1980, 11.25 x 8.5. Al Qöyawayma used the techniques of working with the clay learned from his aunt, Polingaysi Qöyawayma, but the design was of his own creation. Gift of Jerry and Lois Jacka.

HOPI. *Jar,* 1905-1910, 10.5 x 15.5. Potter Mark Tahbo commented on the unusual design below the rim on this jar. Instead of featuring abstract bird feathers or beaks, the entire bird is depicted. Fred Harvey Fine Arts Collection.

ANNIE NAMPEYO (C. 1884-1968) OR DAISY NAMPEYO (1910-1994), HOPI-TEWA. *Jar,* 1920s, 7.25 x 14. Originally purchased as the work of Nampeyo (c. 1862-1942), this jar may have been made by her daughter, Annie Nampeyo, or by Annie's daughter, Daisy Nampeyo. Abstract designs of bird feathers were painted on the jar.

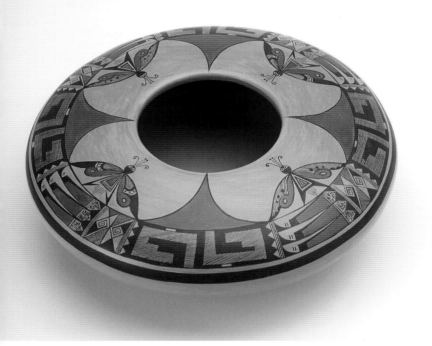

"Sometimes when I work on a pot and I've really worked hard on it and I want to go to the next step, my mom comes and she inspects it and tells me, 'No, it's not ready for the next step. You take it back and do it over again.' She wouldn't say that to anybody else except me."

KAREN KAHE CHARLEY, HOPI

DEXTRA QUOTSKUYVA NAMPEYO (B. 1928), HOPI-TEWA. *Jar,* 1967, 3.75 x 11. Dextra Quotskuyva Nampeyo is known to paint complex patterns inspired by the pottery of her great-grandmother, Nampeyo.

GRACE CHAPELLA (1874-1980), HOPI-TEWA. *Bowl,* c. 1967, 8.5 x 15. Potter Mark Tahbo has described the designs on his great-grandmother's jar as being a type of landscape. Grace Chapella depicted the three Hopi mesas, with "x" elements denoting the fields below the mesas. The curved, wave-like element is a stylized water pattern. The black columns represent the buttes seen from First Mesa looking south toward the Navajo Nation around Seba Dalkai. The butterfly motif is a figure that Chapella derived from the Sikyatki bowls she saw being excavated that had a moth design on them. Chapella made her butterfly with curled antennas surrounded with dots of pollen, representing germination or fertility. Her butterflies have a heartline ending in an arrow-shaped heart. Gift of Mrs. Scott L. Libby, Jr.

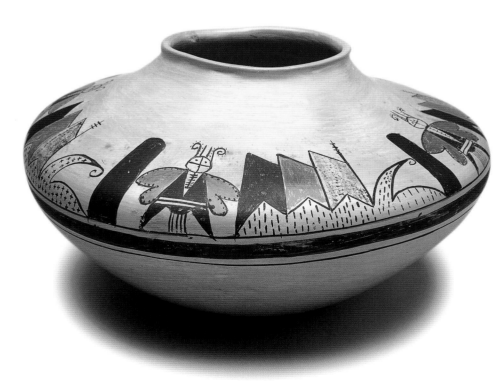

"As far as I am concerned, it is the Katsinas who are giving us the wealth of ideas and talent we have."

CHARLES LOLOMA, HOPI

CHARLES LOLOMA (1921-1991), HOPI. *Bracelet*, c. 1975, 2.75 x 3.25 x 1. The lapis lazuli and gold used in this bracelet were revolutionary materials in Native American jewelry at the time it was created. The sculptural outline of the stones are reminiscent of the mesa tops near Charles Loloma's home in Northern Arizona. Gift of Mareen Allen Nichols.

FACING: MORRIS ROBINSON (1900-1987), HOPI. *Necklace*, 1950s, 13.75 x 3.25. In this necklace, Morris Robinson used the overlay technique to create feather designs traditionally found on Hopi pottery. Gift of Mareen Allen Nichols.

HOPI JEWELRY Two major developments in Hopi jewelry have brought it to the distinctive and highly regarded place it holds today. The first development was the creation of the overlay style. Overlay means a thin sheet of silver with a fine design cut in it is laid onto a solid piece of sheet silver. The cutout design is blackened for accent. Efforts to develop a style unique to Hopi were begun by Mary Russell Colton, a founder of the Museum of Northern Arizona. When Hopi veterans of World War II returned home, a GI training program led by Paul Saufkie and Fred Kabotie offered 18 months of training in jewelry making. It opened a career path that could be pursued at home.

The second major development in Hopi jewelry was the innovative work of Charles Loloma. Loloma combined stones and wood in elegant shapes. His jewelry presented an entirely original vision that broke from the conventions of Indian jewelry. The result has inspired subsequent generations of jewelers far beyond Hopi. At Hopi, community efforts aimed at inspiring further innovation continue.

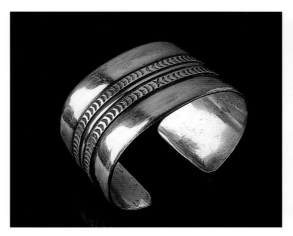

MORRIS ROBINSON (1900-1987), HOPI. *Bracelet*, late 1930s-early 1940s, 2 x 2.67 x 1.5. The clean, unencumbered lines of this bracelet are characteristic of Morris Robinson's silverwork.

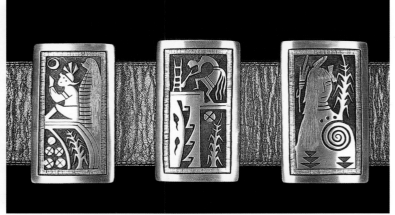

RAY SEQUAPTEWA, SR., HOPI. *Concho belt*, 1986, 40.25 x 2.5. This is a detail of a pictorial belt done in traditional overlay technique. It features scenes from Hopi history and ceremonies. Gift of Mr. James T. Bialac.

"When people ask me where I was born, I always say, 'In my father's land.'" RENA MARTIN, NAVAJO

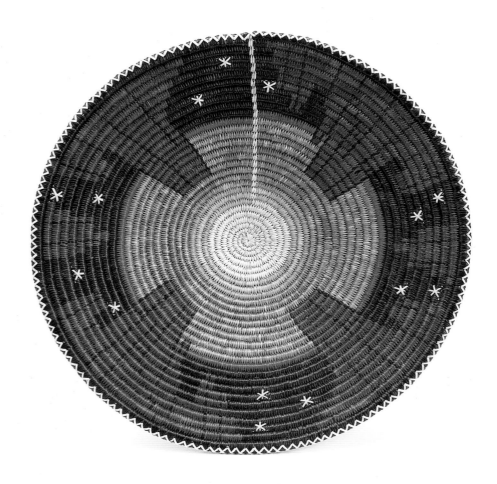

JOANN JOHNSON (B. 1964), NAVAJO. *High Moon Over Monument Valley,* 2002, 3.75 x 18. Joann Johnson has depicted the distinctive Shiprock Butte.

Country

THE COLORADO PLATEAU is the name applied to an entire geologic province that includes the northern third of Arizona to the Grand Wash Cliffs, southern Utah, southwest Colorado and northwest New Mexico. Within that region are many smaller plateaus that vary in height. They include the Coconino Plateau at 6,000 feet, the Kanab Plateau at 5,000 feet and the Kaibab Plateau at 8,000 feet. The plateaus are composed of colorful layers of sedimentary rocks that have eroded into tablelands separated by canyons and cliffs with steep slopes. The creeks that cut down through the rocks are fed by seven to 13 inches of precipitation in a year.

PRECEDING PAGES: Monument Valley, Arizona, c. 1985. Jerry Jacka, photographer. Jacka Photography, Payson, Arizona.

Navajo HOME IN THE NAVAJO NATION

"The mountains remind me of home. It just feels like you're in a big bowl, and you're protected from all the outside forces." MICHAEL ORNELAS, NAVAJO

THE NAVAJO BELIEVE they were born of the Earth, and they call the dry and oftentimes harsh environment of the Four Corners region of the Colorado Plateau home. They refer to themselves as Dineh or the People. Located in Arizona, New Mexico and Utah, the Navajo Nation is the largest population of tribal people in Arizona. Their reservation, approximately the size of West Virginia, is the largest federally recognized reservation in the United States.

Navajo oral tradition explains the placement of the Four Sacred Mountains that border their homeland. They are Blanca Peak near Alamosa, Colorado; Mount Taylor near Grants, New Mexico; Humphrey's Peak near Flagstaff, Arizona; and Hesperus Peak near Durango, Colorado.

FACING: BESSIE TAYLOR (B. ABOUT 1950), NAVAJO. *Rug*, 1982, 64.5 x 63.5. In this style of pictorial textile, the weaver presents scenes of home. This scene includes a range of housing from hogans to mobile homes. A Yeibichai Ceremony is in progress. A man on horseback watches cattle and sheep around a stock pond, and a wide range of vehicles speeds by on the road across the bottom of the pictorial. Gift of Mr. and Mrs. Ed Foutz.

Sheep Is Life Festival in Tsaile, Arizona, 2002. Sam Minkler, photographer.

"If you have ceremonies and know your language, that ties you to the land."

TIMOTHY BEGAY, NAVAJO

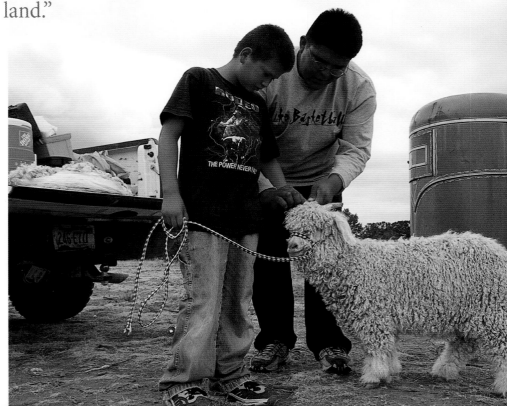

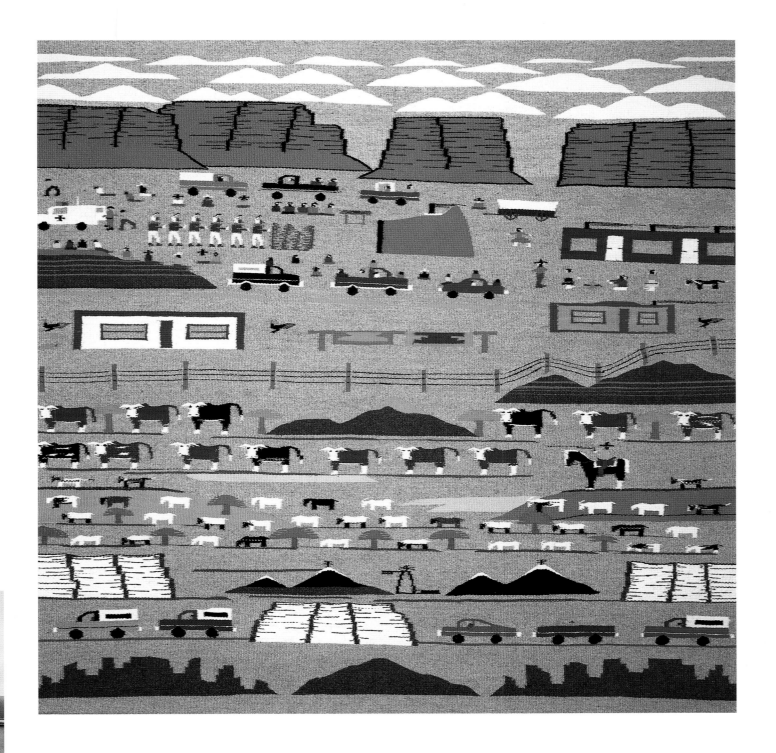

"The smell of wool in the summertime, that reminds me of home."

LYNDA TELLER PETE, NAVAJO

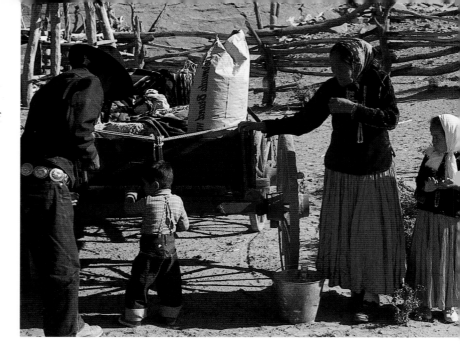

"What really tells me that I'm home is the smell of blue cornbread. It's a little tortilla the size of a regular taco shell. It's a quarter of an inch thick, and they cook them on a grill.... I don't know if you've ever smelled a freshly woven Navajo basket. They're made out of sumac, which has its own aroma. The berries of that plant can be made into a gravy that you can't find anywhere else. That's also a favorite food of mine. I made sure that my sisters know how to make it, so that when I'm an old man, somebody will make and feed it to me." STEVEN BEGAY, NAVAJO

"We didn't have cookbooks. I remember in the morning when I woke up, my grandma would be out separating the sheep. I'd still be in bed, and they would wait for me. Breakfast consisted of handmade biscuits and eggs that were fried really, really slowly and kind of crusty on the bottom, and then sometimes we had jerky. That was the best breakfast! It was all cooked on a woodstove. There'd be a little fire going and the pan would be off to the side where Grandma left it for me. Then I would have to go saddle up my horse and help her tend the sheep."
RENA MARTIN, NAVAJO

LANGUAGE Navajo people feel great kinship to their homeland; every canyon and hill has a descriptive name. The language is still spoken widely in the Navajo Nation, and many school curricula require students to read, write and speak Navajo. In urban centers such as Phoenix, Navajo language and culture are taught to eager classes as Navajos strive to maintain their language.

"When you least expect it, you'll be in a crowd of people and you will hear a child yell out, speaking in our language. It's a rare occasion, but it makes you feel good. It lightens your heart, lifts your spirits and reminds you that there's a younger generation that will keep our language. It makes me feel good that there are still people teaching our language, teaching our culture. They have made a conscious decision to learn the language, and that makes me happy. It gives me peace of mind." STEVEN BEGAY, NAVAJO

FAMILY AND COMMUNITY Family is the foundation of Navajo society. Children are celebrated and included in everyday activities. When introducing themselves, Navajos consider it proper to identify first the clan they are born into (their mother), then the clan they are born for (their father). Next, they list the clan of their maternal grandfather followed by their paternal grandfather's clan. After they've given their clans, they state their home community and then, finally, their name.

Navajo communities are small and spread out, with larger towns sprinkled throughout the reservation. There are 110 chapters or local governing bodies. Each has at least one council delegate who represents the chapter on the Navajo Nation Council. The capital of the Navajo Nation is in Window Rock, Arizona, with a branch office in Washington, D.C.

Grandparents with grandchildren at sheep camp, Navajo Nation, 1965. R. Brownell McGrew, photographer.

FACING: ROSIE YELLOWHAIR (B. 1950), NAVAJO. *Emergence Story,* 60.5 x 42.25. Rosie Yellowhair's sandpainting depicts the Navajo Creation or Emergence Story. In this version of the story there are Five Worlds. The first world had a great deal of water. When there was dissention, the Insect People moved up to the Second World of the Swallow People. Dissention occurred again, causing the Insect People to move up to the Third World, where the Grasshopper People lived. Again, dissention caused the Insect and Grasshopper People to move to the Fourth World, where they found the Four Sacred Mountains that border the Navajo homeland, Dinetah. They met the Animal People as well as the Yéii, who gave instructions for how to live. When Coyote stole Water Creature's Child, Water Creature flooded the world. People escaped by climbing through a reed that extends into the Fifth World. Gift of Jean and Jim Meenaghan.

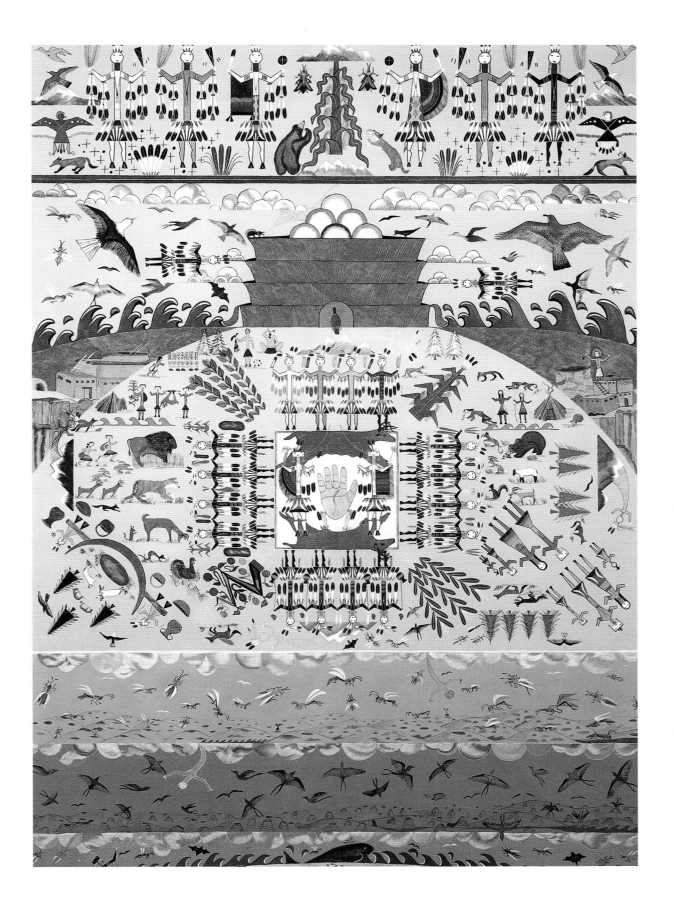

IN PLATEAU COUNTRY **87**

"I never lived in a house with just my biological brothers and sisters. We always had a cousin living with us or I lived at an aunt or uncle's house. Today, we live very different; the children aren't raised together anymore, and when we get together we all have different daily activities." STEVEN BEGAY, NAVAJO

"Knowing your clans and knowing where you come from is important, and you have allegiance to your family above all." SIERRA NIZHONII TELLER ORNELAS, NAVAJO

NAVAJO HOGANS

The traditional Navajo dwelling was a female hogan because it simulates the roundness of the female body of Mother Earth. While most Navajo families do not reside permanently in hogans today, their modern homes almost always include a hogan near the main house. Hogans are used for ceremonies that are still practiced by Navajo people including the Kinaalda, a coming-of-age ceremony for young Navajo women.

Often, family members spend quiet time in the hogan as a way to reconnect themselves with Navajo teachings and to remind themselves from where they have come.

NAVAJO CLOTHING

Early historical clothing styles included woven mantas for the women and wearing blankets for the men. Wearing blankets became popular on the trade market in the 1800s and were exchanged with tribal leaders from other regions like the Great Plains, thus earning the name Chief Blanket.

CLARENCE LEE (B. 1952), NAVAJO. *Bracelet*, 1989, 2 x 2.75. Clarence Lee uses silver as a medium to create scenic and often whimsical views of traditional and contemporary Navajo life. Gift of Jeanie and Joseph Harlan.

FACING: NAVAJO. *Poncho*, 1840-1860, 73 x 47.25. Classic period ponchos were sought-after garments in the Southwest due to the weaver's ability to create an extremely tight weave that was nearly waterproof as well as warm. Fred Harvey Fine Arts Collection.

NAVAJO. *Second Phase Chief Blanket*, c. 1860-1865, 56 x 64.5. Chief Blankets are Navajo textiles woven in the 1800s that were used as blankets for warmth. They became known as Chief Blankets because they were finely woven, highly prized and often owned by individuals of importance. This blanket has blocks of color in a design called a Second Phase Chief Blanket. Fred Harvey Fine Arts Collection.

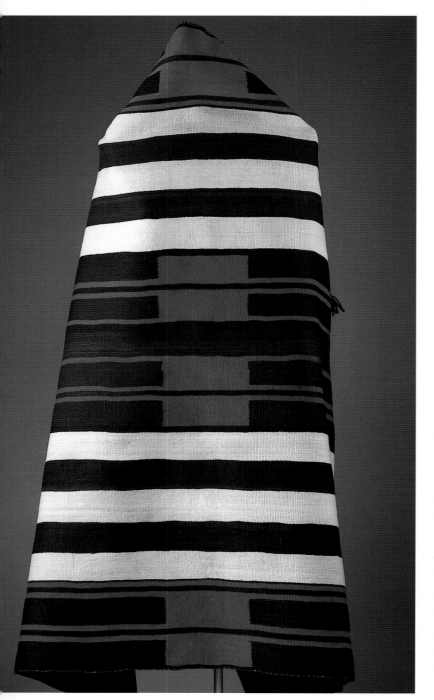

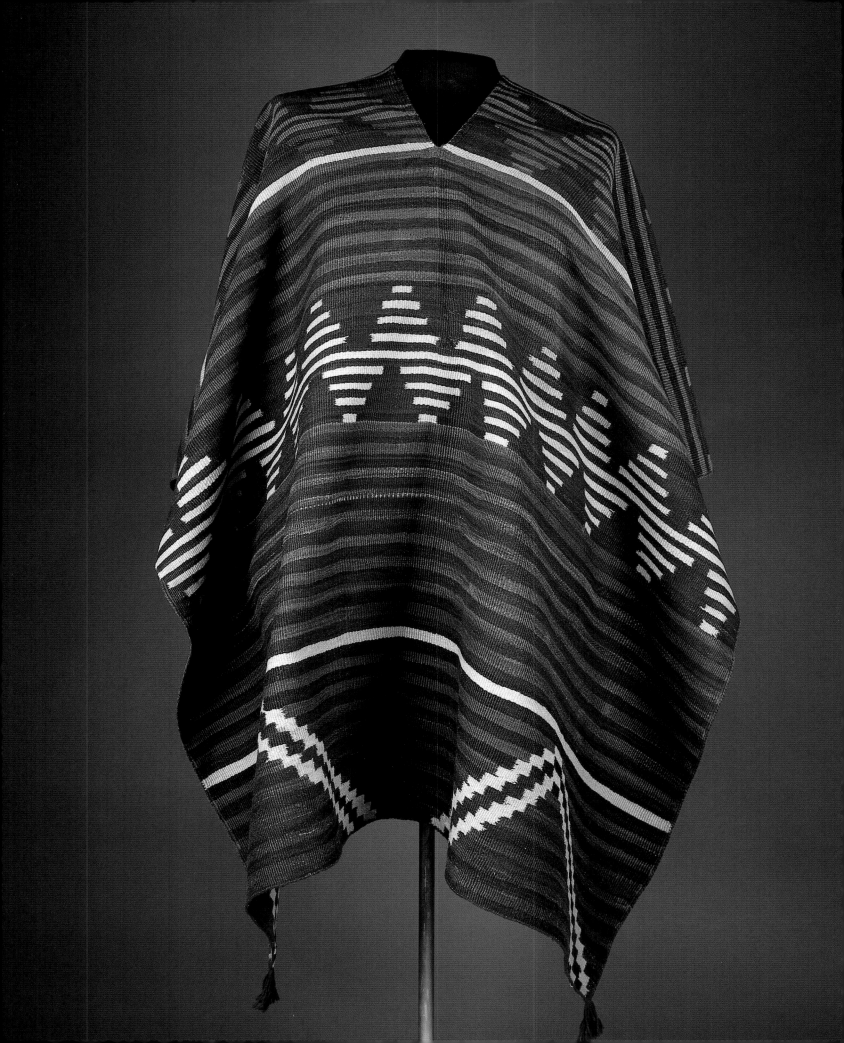

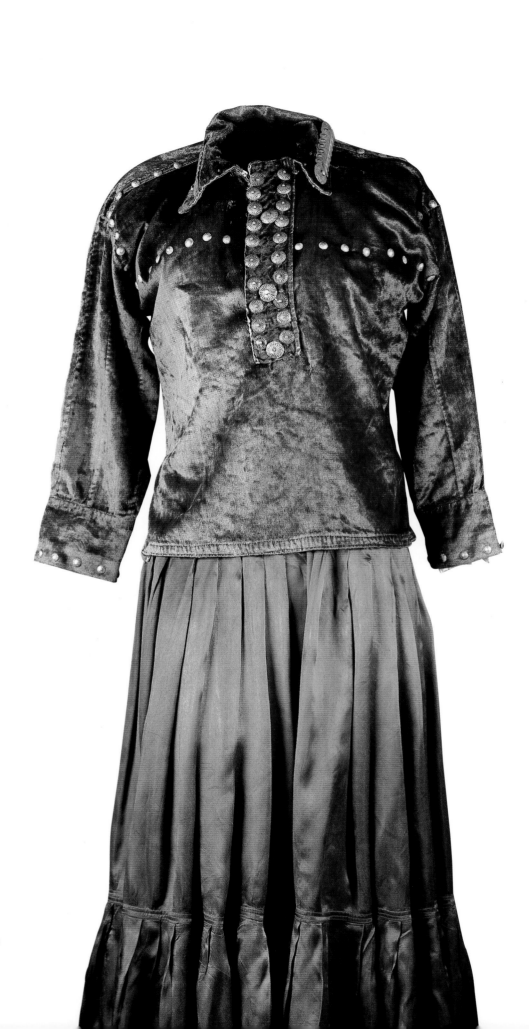

Rena Martin, Navajo, 2004. Walter
BigBee, photographer.

NAVAJO. *Blouse,* c. 1950, 23.5 x 29.
Gift of Mr. and Mrs. Byron Harvey
III; and *Skirt,* c. 1950, 36.5 x 38.5.
This satin skirt and velvet blouse
would have been worn on a special
occasion and complemented with
silver and turquoise jewelry.

After the Bosque Redondo era in the late 1800s, Navajo women started wearing long, full skirts and velvet blouses. The men began wearing cotton shirts and trousers, reflecting the influences of European-American attire.

Today, clothing styles include the woven blanket dress as well as the velvet blouse and long, full skirts of calico or satin. Women's moccasins are crafted from cowhide and buckskin; the buckskin wraps around the legs to the knee. Men's moccasins are made from red cowhide.

Turquoise and silver jewelry is always worn. Many young Navajo women wear their woven dresses for special occasions such as graduations, weddings and traditional ceremonies.

"My grandma always wore skirts, pretty velvet blouses and all her jewelry. She'd be herding sheep and you could see her pins flashing and hear her necklace jingling against her conchos or silver buttons. As a traditional person, you're always supposed to look presentable for the sun to greet you." RENA MARTIN, NAVAJO

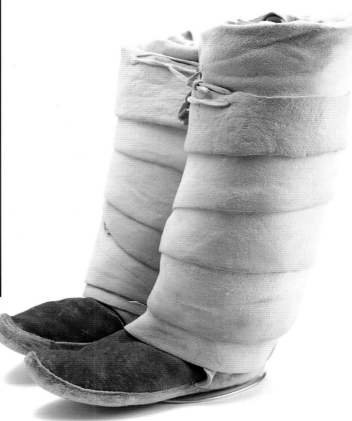

NAVAJO. *Moccasins,* 1960s, 18 x 3 x 10.5. Gift of Mr. and Mrs. Henry S. Galbraith.

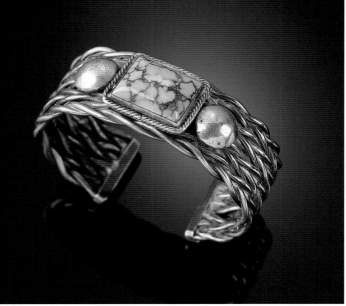

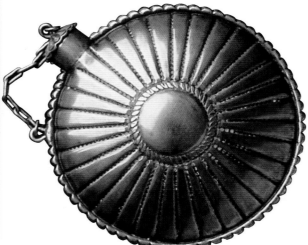

NAVAJO. *Canteen,* c. 1900, 4.25 x 3.63 x 1.25. This small canteen was probably used to hold tobacco. Fred Harvey Fine Arts Collection.

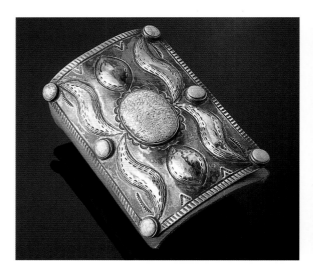

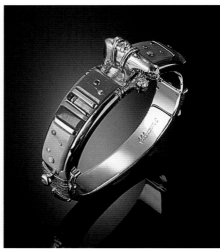

ESKIESOSE, NAVAJO. *Bow guard,* early 1900s, 3.25 x 2.5 x 4.75. This phonetic spelling of the silversmith's name probably was a first and last name that, translated, could mean "skinny man." Gift of Mr. C.G. Wallace.

JESSE MONONGYA (B. 1952), NAVAJO. *Bracelet,* 2002, 3 x 1 x 2.57. This bracelet illustrates the mastery of Jesse Monongya's inlay and jewelry fabrication techniques. Monongya learned basic jewelry skills by watching his father, Preston Monongya, but Jesse excells in intricate inlay. Gift of Jeanie and Joseph Harlan.

UPPER LEFT: NAVAJO. *Bracelet,* 1940s-1950s, 2.5 x 2.87 x 1. "This bracelet has to be done by a person who was in the rodeo business, who has made bull ropes. That's how he can weave probably about eight to 10 wires together and interlock them. You have to have three or four feet of silver to start off with to get the weave all the way through. This was a very complicated thing to do, and it's very well done." Jesse Monongya, Navajo.

NAVAJO JEWELRY Oral tradition explains the significance of jewelry to the Navajo people. White shell, turquoise, abalone and jet are sacred stones used to create the first objects of adornment worn by the Navajo. Turquoise has aesthetic, economic and ceremonial significance and is used as an indicator of status as well as a medium for exchange.

In the mid-1800s, the Navajo were introduced to silverworking by Spanish smiths. They mastered the techniques and, today, are considered among the best jewelers. There are several methods that Navajo artists employ to work silver. One method is wroughtwork, where silver is cut and then hammered, filed or stamped. A second method is repoussé, where the area on one side of a flat metal piece is hammered, causing a raised design to appear on the opposite side. Wirework is another method and is achieved by twisting strands of wire or by shaping and flattening them with a hammer. In the casting technique, a mold is carved from soft volcanic stone called tufa. Molten silver is poured into the mold, creating beautiful works of art.

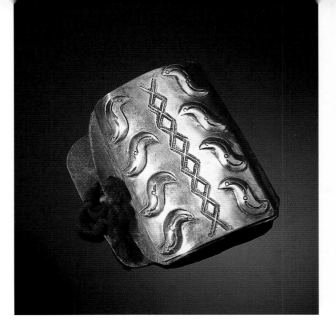

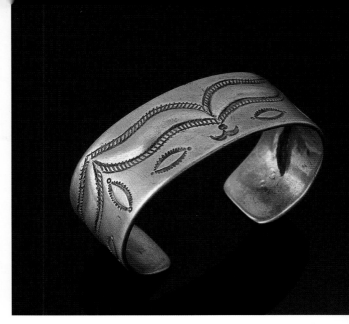

NAVAJO. *Bowguard*, c. 1900, 3.75 x 2.5.

NAVAJO. *Bracelet*, c. 1900, 1.88 x 2.38. This early bracelet has a simple but elegant design. Fred Harvey Fine Arts Collection.

"I started wearing turquoise when I was a toddler, and I can't see myself without it. It makes me feel close to whoever gives it to me. I feel like I'm with my mother when I wear the things she gives me." RENA MARTIN, NAVAJO

NAVAJO. *Stamps*, early 1900s, Left to right, 5 x 2 x 1.6; 3.5 x 1.25 x .8; 3 x 1 x .5; 3.25 x .75 x .25. "These tools are made from scraps. The big one is made out of an axle to make a concho stamp. They temper this, and they throw it in cold water to strengthen it. It's all done by hand using different files to get the shapes. The next one is a railroad tie stake, which is made into a stamp for a smaller concho. One of the two smaller stamps was made out of a file, just cutting a little U into it to get a little curve to make a complete circle. The other one originally was a file for horse hooves and made into a nice stamp. These are some of the tools that are made by the Navajos to punch out their concho belts." Jesse Monongya, Navajo. Fred Harvey Fine Arts Collection.

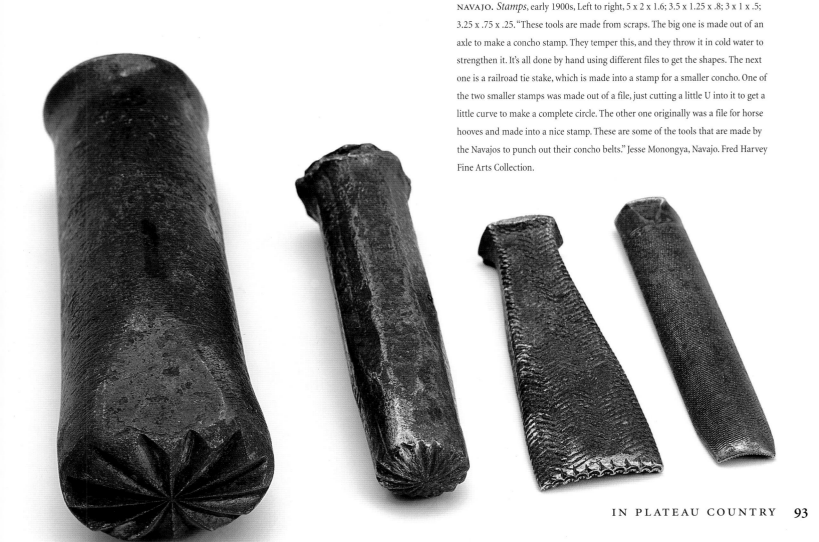

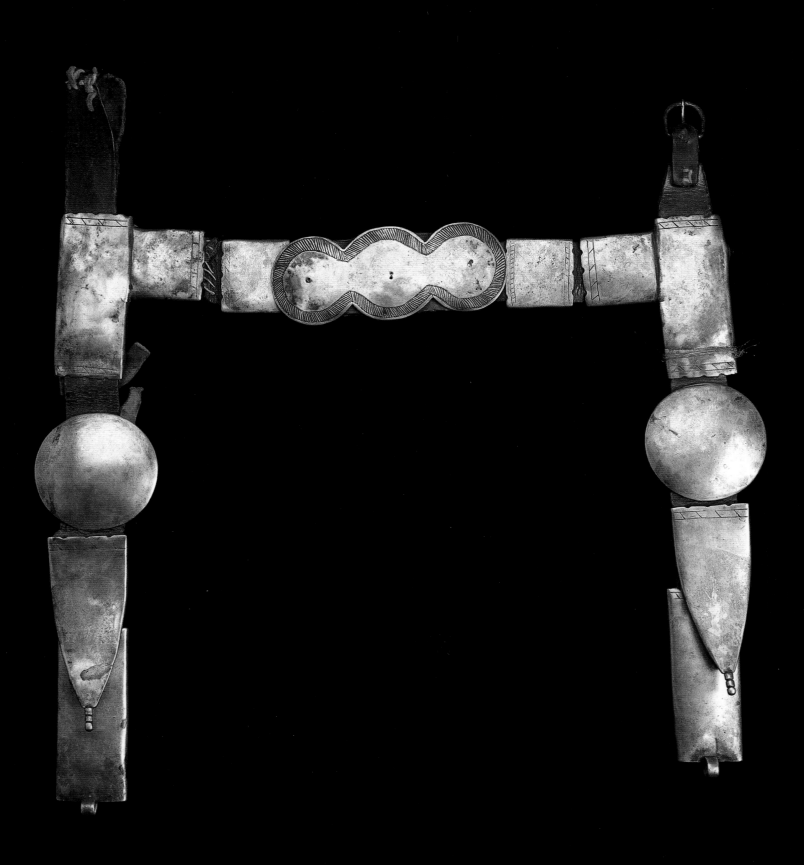

FACING: ATTRIBUTED TO ATSIDI CHON, NAVAJO.
Headstall, c. 1875, 28 x 17. Atsidi Chon is one of the earliest Navajo silversmiths to be distinguished by name. He is credited with being the person who taught Zuni smith La:niyahdi metal working. Gift of The Graham Foundation for Advanced Studies in the Fine Arts.

CLOCKWISE FROM UPPER LEFT: HARVEY BEGAY
(B. 1938), NAVAJO. *Bracelet,* 1997, 2.12 x 2.5 x .75. Harvey Begay often incorporates designs inspired by his Navajo culture, but he may juxtapose contemporary materials and traditional ones such as the coral with gold in this bracelet. The tufa cast technique used for this bracelet is a traditional one, but often Begay will use the non-traditional technique of lost wax cast.

NAVAJO. *Bracelet,* 1900-1910, 2.25 x 2.75. Fred Harvey Fine Arts Collection.

NORBERT PESHLAKAI (B. 1953), NAVAJO. *Bracelet,* 1992, 2 x 2.75 x 1.5. Norbert Peshlakai's jewelry is known for its intricate and complex stamped designs. Peshlakai often makes his own small stamps, combining them to create more complicated patterns. Gift of Jeanie and Joseph Harlan.

PERRY SHORTY (B. 1964), NAVAJO. *Bracelet,* 2001, 2.12 x 2.67 x 1.25. Perry Shorty's jewelry is inspired by classic, early works. He uses traditional techniques and materials.

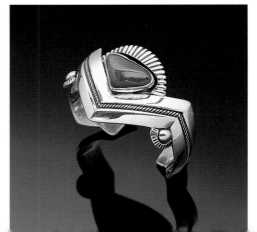

KENNETH BEGAY (1913-1977), NAVAJO. *Bracelet,* 1975, 2 x 2.5 x 1.5. Kenneth Begay's jewelry is known for its clean lines and contemporary look.

NAVAJO BASKETS Navajo baskets have their origins in Navajo oral traditions. Navajo people believe the first baskets were made from the sacred stones that belong to each of the Four Sacred Mountains: white shell, turquoise, abalone and jet.

In historical times, the Navajo created baskets for use in cooking and food storage. They were tempered using piñon pitch, making them suitable for storing water. More importantly, Navajo baskets were and still are used in every ceremony today. In the early 1900s, the Navajo population grew rapidly as did the demand for baskets being used ceremonially. The Navajo looked to their neighbors, the Paiutes, to create baskets to fill the demand. This practice continues today.

FACING: NAVAJO. *Textile*, c. 1900, 78.15 x 53.75. The Navajo woman depicted on this textile is surrounded by design elements drawn from commercial products that were sold at trading posts. Banner Lard is one of the products that caught the weaver's eye. Weavers also incorporated isolated letters or numbers into their textiles as interesting graphic elements. Fred Harvey Fine Arts Collection.

NAVAJO. *Basket*, c. 1900, 4.5 x 19.5. This basket was purchased by the Fred Harvey Company in 1910 from the widow of Richard Wetherill, a trader and explorer. It was probably collected between 1897 and 1910, the period during which Wetherill operated a trading post near the site of Pueblo Bonito. Fred Harvey Fine Arts Collection.

ELSIE HOLIDAY (B. 1965), NAVAJO. *Old #9 Train*, 1998, 13 x 12.5. This is one of a series of baskets that Elsie Holiday wove to depict the changing types of trains that crossed the Navajo Nation over the years. Gift of Dr. and Mrs. E. Daniel Albrecht.

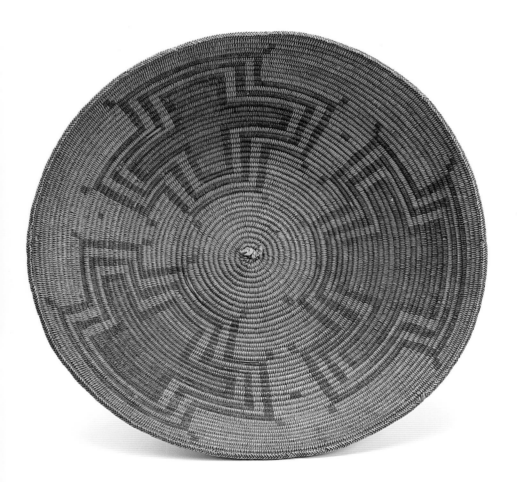

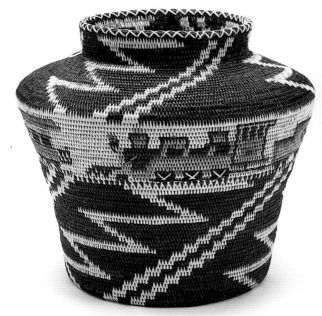

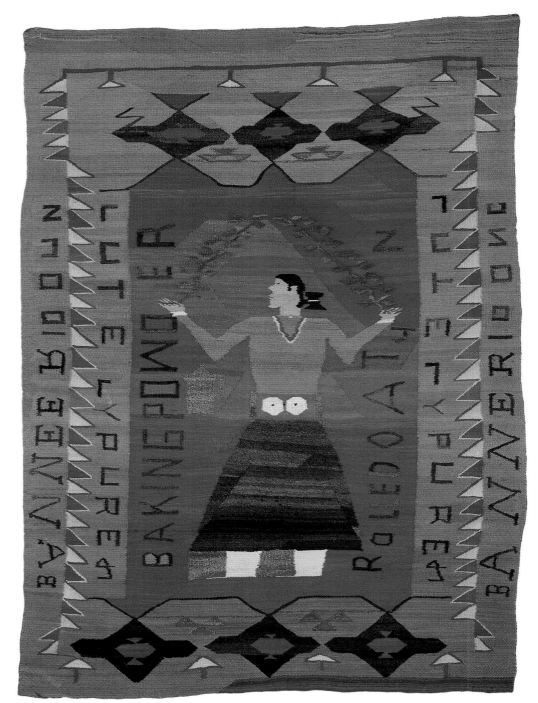

NAVAJO WEAVING Navajo weaving has always reflected the weaver's individuality as well as the changes in use, available materials and market influence. By the late 1800s, with ready-made clothing and cloth available through traders, weavers changed from weaving garments to weaving floor coverings to sell to Anglo-Americans. Around the 1930s, regional rug styles began developing. The styles had names drawn from place names and names of trading posts on the reservation such as Two Grey Hills and Wide Ruins. For several decades, the style of rug a weaver wove reflected her home area. By the late 20th century, weavers were weaving the styles they enjoyed regardless of where they lived. A weaver might have two looms with textiles of very different styles in progress at the same time. Other weavers enjoy working with revivals of old styles. Many finely woven textiles today are meant to hang on the wall and be enjoyed as art.

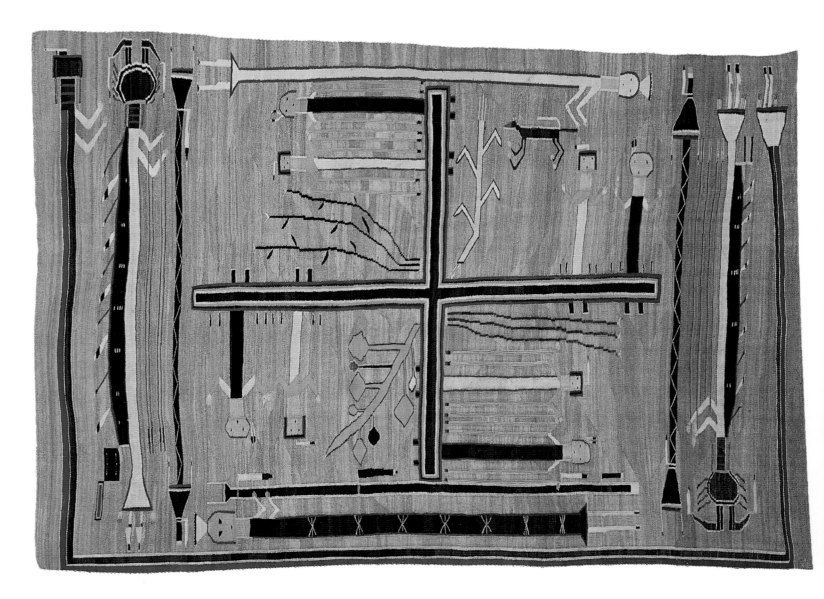

HOSTEEN KLAH (1867-1938), NAVAJO. *Textile,* c. 1921, 79.5 x 110. This piece is thought to be the first sandpainting rug that Hosteen Klah ever wove. It was made about 1921 and depicts the sandpainting called "Whirling Logs" from the Night Chant. Klah was a respected medicine man who was the first to weave images from ceremonies into textiles. Gift of Mr. Read Mullan.

FACING: ROSE MALONEY, NAVAJO. *Storm Pattern textile,* 1961, 69 x 49. Storm Pattern textiles show motifs at each corner that represent the Four Sacred Mountains connected to the center by zigzag lightning. The motif in the center is sometimes described as a hogan at the center of the world. The design originated in the early 1900s, and opinions differ about the extent to which it is trader-inspired. The general layout has been done in endlessly creative abstractions by weavers, and their creativity continues into the present. Gift of Mr. Read Mullan.

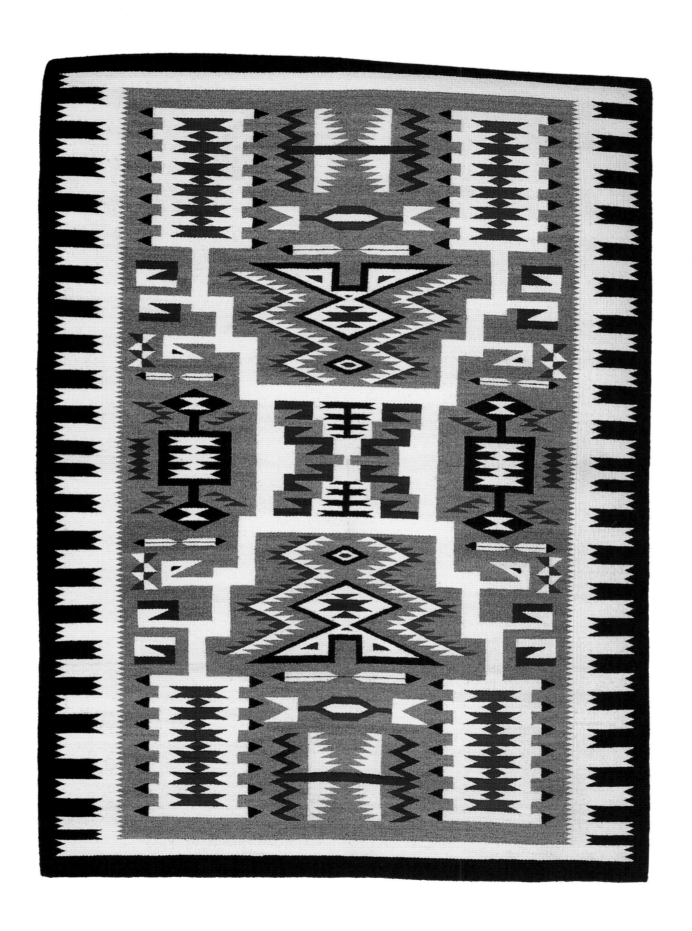

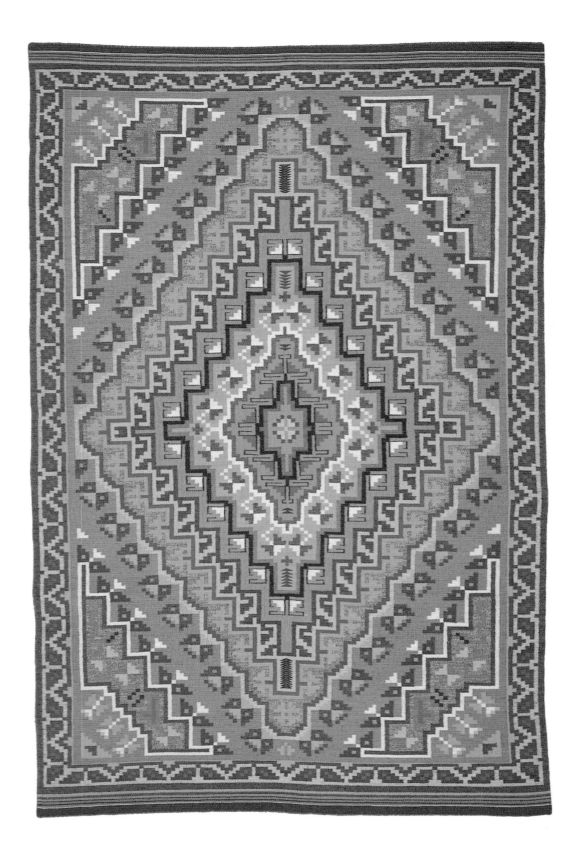

VICTORIA KEONI, NAVAJO.
Burntwater textile, 1992, 87.75 x
53.75. Burntwater textiles are Two
Grey Hills design motifs woven in
pastel colors. Purchased with funds
provided by Mrs. Mary Coughlin.

FACING: DAISY TAUGELCHEE
(1909-1990), NAVAJO. *Two
Grey Hills textile,* 1954, 72 x 50.
Daisy Taugelchee was not only a
weaver of the finest of textiles, she
also was a superb spinner and
skilled at matching the wool colors
into a beautifully balanced design.
Since the 1940s, her standards of
excellence defined the Two Grey
Hills style as the best-known and
best-regarded of Navajo weaving.
This piece won both a First Award
and the Grand Award at the Gallup
Inter-tribal Indian Ceremonial in
1954. Gift of Mr. Read Mullan.

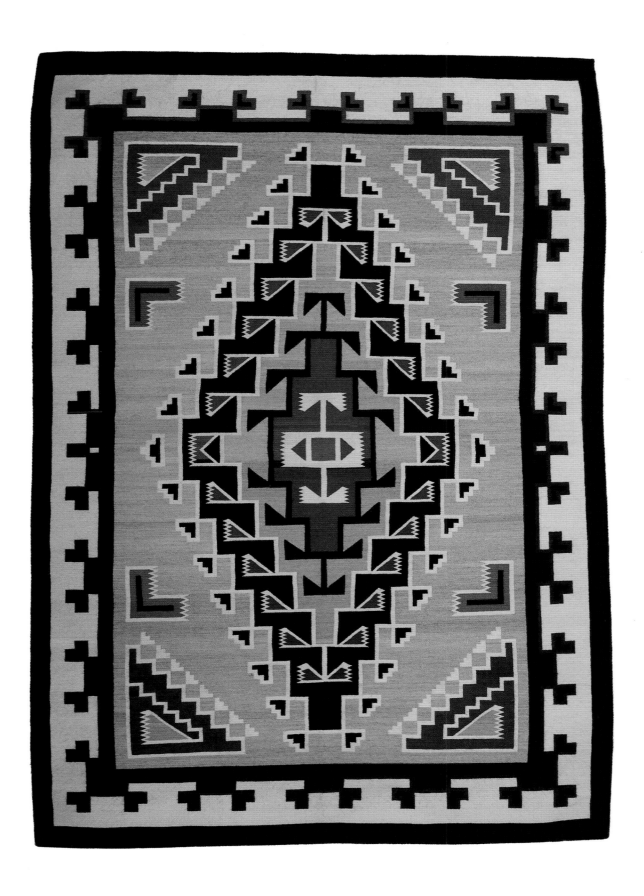

San Juan and Kaibab Paiute

HOME ON THE PLATEAUS

PAIUTE PEOPLE once moved through low deserts and the higher plateaus of their homeland in a pattern based on their detailed knowledge of widely scattered plants, animals and water. The southern boundary of their homeland was the northern half of the Grand Canyon, halfway across the Colorado River. In the dry region of northwest Arizona and southern Utah and Nevada, a good life requires knowledge. Year-round abundance does not exist, so sharing of resources and land is an important value. Competition for Paiute homelands began in the mid-1800s, as more and more people traveled the Spanish Trail, a major wagon route between New Mexico and California. When settlers arrived in Paiute lands, they assumed ownership of the land and fenced off property and enclosed water sources. The delicate balance of Paiute life could no longer continue, and many died of starvation. Today, the Kaibab Paiute have a reservation in Arizona on the Utah border. The San Juan Southern Paiute are the only Paiute living east of the Colorado River. They live on traditional lands within the Navajo Nation and are working to have lands designated for their own reservation.

"Before the drought, we used to have lilacs all over. It would be the first thing that we would smell in spring. They were introduced by the settlers." VIVIENNE CARON JAKE, KAIBAB PAIUTE

Vivienne Caron Jake and niece, 2004. Gloria Lomahaftewa, photographer.

FACING: PAIUTE. *Cradleboard*, c. 1920, 29 x 12.5 x 10.5. This is a Paiute cradleboard for a newborn female. The diamond designs are for a girl; a boy's cradleboard would have crosses on it, according to Brenda Drye, Kaibab Paiute. Gift of A.E. Taylor.

LANGUAGE, FAMILY AND COMMUNITY Extended families were the basis of traditional Paiute life. The land did not support any great concentration of people in a fixed community, so each of the 15 bands of Paiute people lived and moved in their own areas, coming together on communal lands for piñon harvests. During the early to mid-1800s, the Paiute were the victims of an active slave trade. In the 1860s, when Mormon communities were established in the Kaibab area, Paiute people settled near those communities where jobs were available. In 1909, with support from local residents, the Kaibab Paiute Reservation was established. Year-round San Juan communities are in the north around Navajo Mountain in Utah and in the south at Willow Springs.

"Language plays a major role in our ceremonies; we are orators, and a lot of the orators speak in the Paiute language. In order to understand the whole person, the soul and the spirituality of individuals and of yourself, you need to know that language because, otherwise, you're just a body that's walking around out there in the world, not having full knowledge of who you are as an individual, as a member of a group, and how you intermingle with that group."
VIVIENNE CARON JAKE, KAIBAB PAIUTE

"Relationships were very close, because people would do the chores or tasks that needed to be done for the day together. Family is still very important. But in our community, nobody really visits like the old people used to. They would visit in the evening or late afternoon, or in the morning before chores got started, like working in the garden. It seems today, everybody's either working, or they are watching television. That's a big change."
VIVIENNE CARON JAKE, KAIBAB PAIUTE

"Thunder Mountain is a sacred mountain. Back in my grandmother's day, that mountain used to thunder, so it's called after the thunder. And the Kaibab Mountains to the south, the blue mountains, they're called Kai-babage, that means mountain lying down. Those are the two significant landmarks for me. We live north of the Grand Canyon and the Colorado River, and those, too, are significant."

VIVIENNE CARON JAKE, KAIBAB PAIUTE

"The summer house of cedar and sage smelled like fresh air."
BRENDA DRYE, KAIBAB PAIUTE

"They used to make this meal out of cornmeal, and I really liked it. They would put chili and onions and other things in it and fry it. They used to bake bread and meat in the coals covered over with earth. It's really delicious." VIVIENNE CARON JAKE, KAIBAB PAIUTE

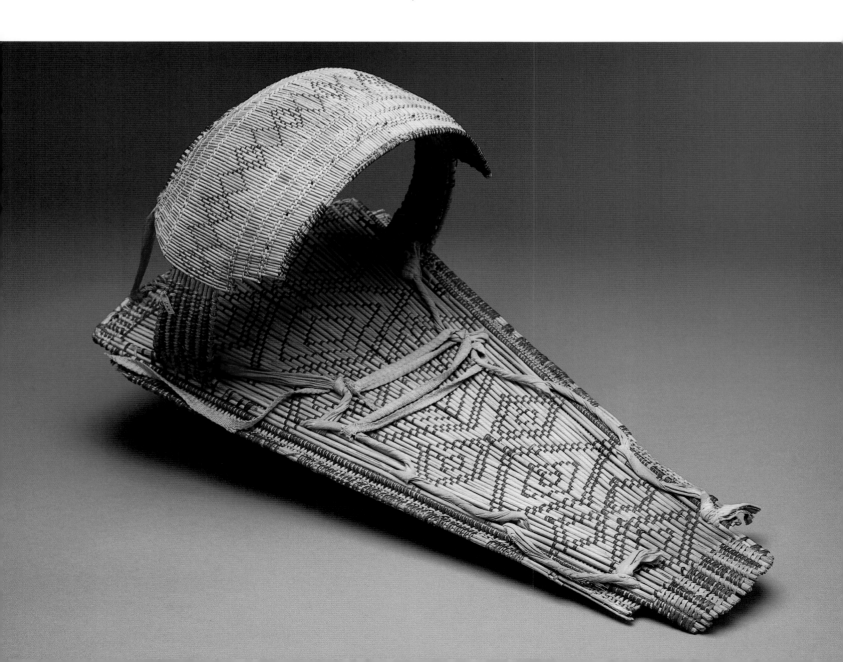

SOUTHERN PAIUTE BASKETS When the Paiute lived in their traditional ways, baskets were important tools for harvesting, sorting, drying and storing food. Paiute people needed winnowing baskets, seed beaters and burden baskets to collect wild foods, including seeds from more than 40 species of grass. Pitch-covered baskets held water and were used to parch corn. Basketry hats protected women's foreheads from the tumplines of filled burden baskets. Basketry cradleboards protected babies. Baskets were even used to cook food, using hot stones moved quickly around to prevent burning the basket.

As traditional lifeways changed, baskets changed. The Paiutes were not on the main tourist routes so, for much of the 20th century, few women wove baskets for sale. San Juan Paiute weavers located within Navajo land wove Navajo-style wedding baskets, which they sold to traders and Navajo customers for ceremonies. The baskets provided a modest source of income. In recent years, a whole artistic tradition of coiled baskets has developed using brilliant dyes and innovative designs.

PAIUTE. *Wedding basket,* c. 1900, 8.5 x 22. Fred Harvey Fine Arts Collection.

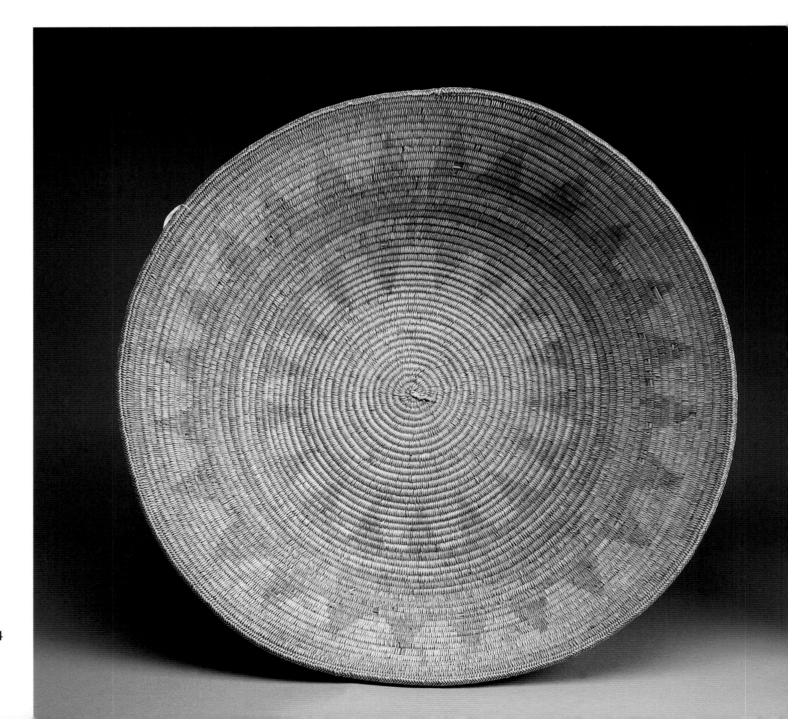

PAIUTE. *Basket,* c. 1900, 11.5 x 16.
Fred Harvey Fine Arts Collection.

PAIUTE. *Water bottle,* c. 1900, 11.5
x 11 x 9.5. According to Brenda Drye,
Kaibab Paiute, this basket would be
used to hold water, and smaller jars
held wild seeds. Fred Harvey Fine Arts
Collection.

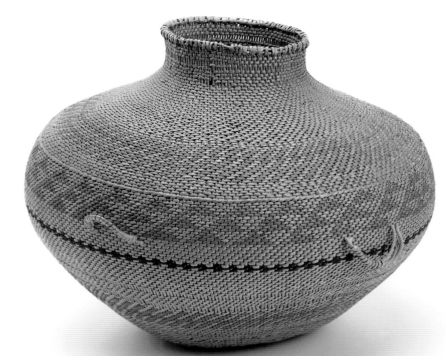

"The way of doing things was to do it together.

If women had basketry to be made, they did it

together. If they had to go out and harvest the

willows for baskets, they would do it together."

VIVIENNE CARON JAKE, KAIBAB PAIUTE

"Home is the mountains, the beautiful, sacred, forested mountains.
We are mountain people, and we have to have
mountains."

RONNIE LUPE, WHITE MOUNTAIN APACHE

SALTON REEDE (1924-1999), SAN CARLOS APACHE.
Fiddle and Bow, 1981, 26 x 8 x 6.5. "You have to hollow the agave out
and then put it back together before painting it. In Apache, the words
are tsee bedodahe, meaning a singing century plant, a singing agave."
Herb Stevens, San Carlos Apache.

Mogollon Rim, 1999. Owen Seumptewa, photographer.

Mountains

SOME OF THE MOST DRAMATICALLY VARIED land in the Southwest crosses from the red rocks of northwestern Arizona toward southwestern New Mexico. The 200-mile-long Mogollon Rim defines much of the distance, as the land drops suddenly from mountain to desert. At the upper elevations are snowcapped mountains more than 12,500 feet high with fir and pine forests. Piñon and juniper grow lower down, and sycamore, oak, walnut and cottonwood grow along rivers and creeks. Below 4,000 feet are desert trees, grasses, agave and cactus. Most of the area is semi-arid, receiving less than 10 inches of rain annually. In the high country, 75 percent of the moisture can come as snow. Sudden, strong summer rains can rage through narrow canyons, as they once raged through the Grand Canyon of the Colorado River before the river was dammed. The Grand Canyon is a wonder that draws people from many countries. The Colorado River itself is 1,400 miles long and continues, as it always has, to be the lifeblood of the region.

Apache HOME IN THE MOUNTAINS

"There's a chief who lived here at Fort Apache; the name he went by was Chief Diablo. He knew this land had a lot of resources—the water, the timber, the mountains. When the U.S. military first came to our reservation and began to burn the corn crops and storage areas, he told his warriors not to retaliate because they would be sent to San Carlos to the concentration camp. Today, because of him, we still live on our homeland. Most of the tribes, their land was taken away. Chief Diablo's the one who chose to let the U.S. military build a fort here at Fort Apache. He foresaw all the resources on our reservation and saved them for the next generations." RAMON RILEY, WHITE MOUNTAIN APACHE

Apache homelands—the territory inhabited by related groups calling themselves Ndee—range from northern New Mexico and southeastern Colorado to the panhandle of Oklahoma and across the western half of Texas, south into Chihuahua and Sonora, Mexico, and through the southeast and central sections of Arizona. It is a vast and rugged territory.

FACING: APACHE. *Saddlebag,* c. 1900, 62 x 19.5. "This is an authentic, full-size saddlebag that was draped on the back of a horse. There is a slit in the middle where, on one side, it was packed with food, like dry meat or bread. The opposite side was packed with extra clothes or maybe a blanket or moccasins, or whatever extras they had. They would pack this on the back of a horse along with their bedrolls. And this is an old example of a saddlebag. It was made with hand-tanned buckskin. Apaches were the only ones who used cutout designs with the red material underneath." Larry Brown, San Carlos Apache.

Larry Brown, San Carlos Apache, 2004. Craig Smith, photographer.

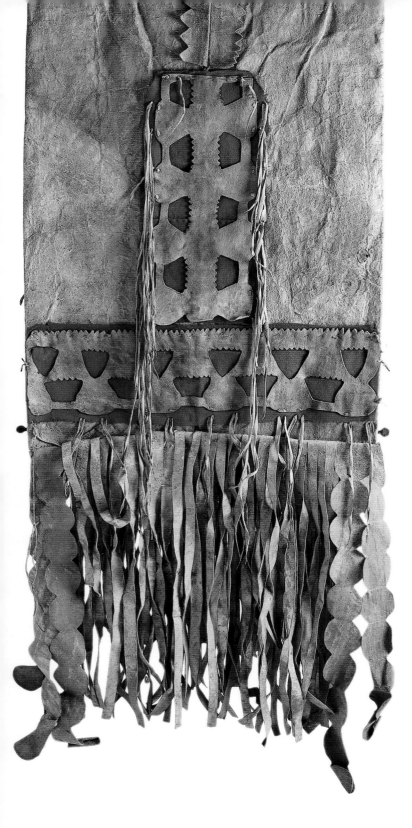

LARRY BROWN, SAN CARLOS APACHE

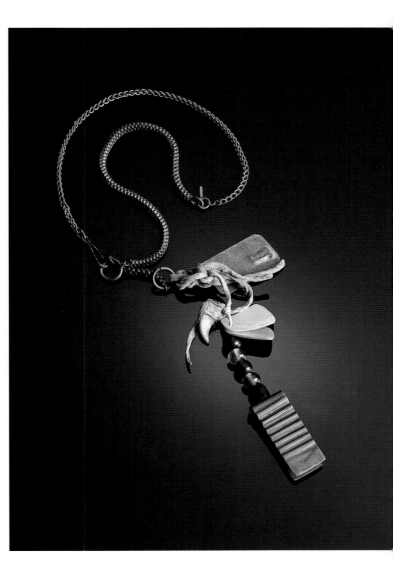

APACHE. Tweezers on a brass chain, late 1800s, 24 x 2. In the 1880s, men wore tweezers around their necks and used them to remove facial hair. They were frequently made out of rifle cartridges. Fred Harvey Fine Arts Collection.

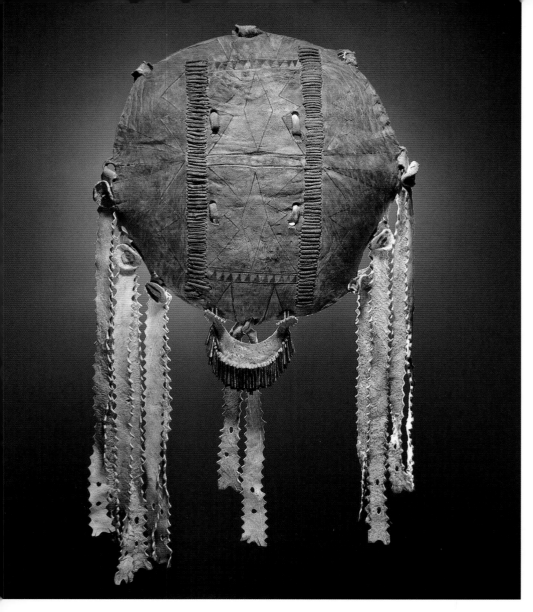

The varied geography of the Apache homelands provided a seasonal round of hunting and gathering opportunities. Harvests of cultivated agricultural plots associated with summer villages supplied the people with other goods. When the ancestral territories came under pressure from Spanish, Mexican and then Anglo settlers, the Apaches needed to raid to get a large portion of their food. The resulting conflicts brought about the establishment of reservations, a system instituted by the Spanish in the late 18th century and again by the U.S. military a century later. The reservations did not provide enough territory to sustain the Apache people, and government rations were inadequate. Shortages once again led to raiding. Breakouts from the restrictions enforced on the reservation were frequent. In 1874, Apaches west of the Rio Grande as well as the Yavapai were relocated to San Carlos. This created a volatile situation with openly hostile groups forced to settle in a small area.

Despite military defeats, enforced relocations and assimilationist policies, the Apaches have not lost their physical and spiritual connections to their homeland. Today, stories connected to specific landmarks are passed from one generation to the next through oral tradition. They teach how to keep on the right path or live a correct Apache life.

ALLAN HOUSER (1914-1994), CHIRICAHUA APACHE. *The Wild Horses,* 1953, 23 x 39. This painting is rendered in the Studio style while displaying a monumental feel for the depiction of a wild horse roundup. The utilization of the entire picture plane is similar to Southwest mural tradition, which Houser studied. Gift of Read Mullan.

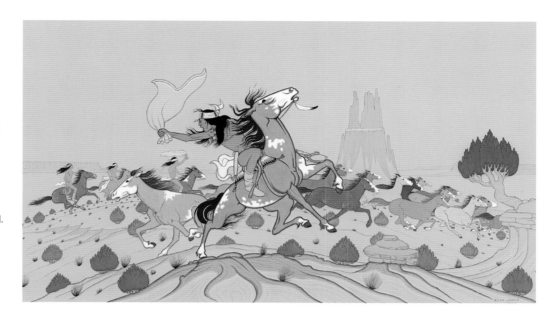

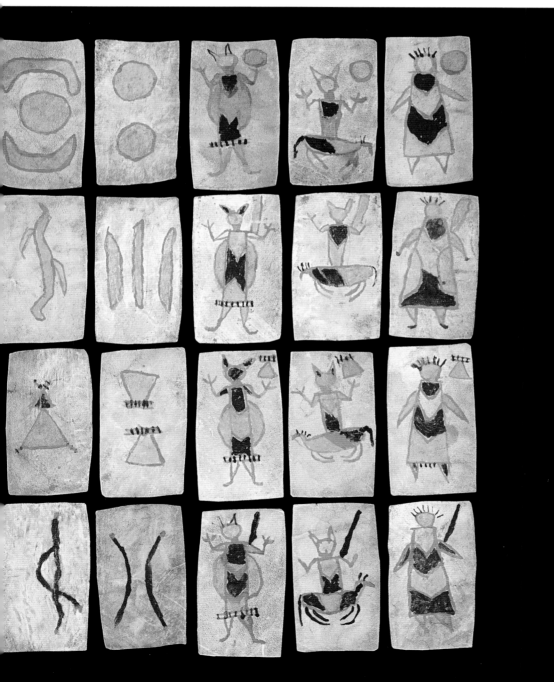

ALLAN HOUSER (1914-1994), CHIRICAHUA APACHE. *Night Guard,* 1985, 23.5 x 11 x 7. Bequest of Mr. Weston H. Hausman, Sr.

"When you come home, you smell the cedar trees. When you're by the river, there is a clean smell of the plants, especially the sage. You don't smell it anywhere but here, where our land is. Also, the smell of smoke reminds me of home. My mom used to cook outside all the time making coffee and tortillas."

RAMON RILEY, WHITE MOUNTAIN APACHE

"As an Indian, you know it's not raining right there in your little town, but in the breeze is the smell of rain somewhere. There is the smell of the wild flowers and the rose bushes that you have at home."

GLADYS LAVENDER, WHITE MOUNTAIN APACHE

"It's no secret that the sacred Sunrise Ceremony for a young girl brings a wealth of blessing for all. The beginning part of the Sunrise Ceremony sequence allows for a food exchange between the sponsor and the co-sponsor. Always included in the menu is the Apache delicacy acorn stew, also fresh corn—ground and made into dough and fried in beef grease. A variety of other traditional foods are specially prepared in the Apache way, including squash, venison and elk. Blacktail and whitetail deer and elk make food available to us in the wintertime. It's very important to us that the food is still here."

RONNIE LUPE, WHITE MOUNTAIN APACHE

"My mom would make this Apache dish called acorn dumplings. It was a treat to have because we lived in California, but my relatives would send acorns to us. One Thanksgiving, we ate only Apache food. We took everything out of the front room and put sheets down and ate on the floor. My mom said, 'We're not White people, we're Apaches, we're going to eat Apache food.' My mom would make acorn soup. She would boil a big pot of meat and make the acorn dumplings and put them into the boiling water with the meat. She'd thicken the soup with a paste of ground acorn and water." LARRY BROWN, SAN CARLOS APACHE

"You've got a big responsibility to teach your child the right kind of language [Apache] in the home as soon as they start walking."

GLADYS LAVENDER, WHITE MOUNTAIN APACHE

Herb Stevens, San Carlos Apache, 2004. Craig Smith, photographer.

ALMA GUSTA THOMPSON (1904-1986), SAN CARLOS APACHE. *Cradleboard,* c. 1956, 35 x 14 x 13. "The frame of this cradleboard is made from mesquite root. You have to go down to the wash after a real heavy rainstorm, and the root sticks out. That's when we go and cut it. I remember going with my grandmother. We used to go up to Dry Wash with just jerky and maybe ash bread and a canteen of water. It would get to be 100-degree weather, scorching hot. But we would leave the first thing in the morning. And we would see the roots coming out of the mesquite. She would chop it off and leave it there, continue on, keep on going until she thinks she has enough. And then we would go back and collect each one and return home." Herb Stevens, San Carlos Apache.

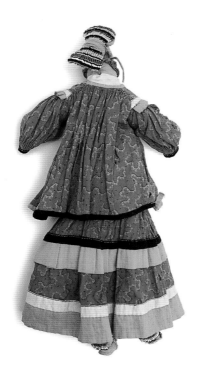

LANGUAGE Language is key to the teaching of cultural values for the Apache. There has been a resurgence of interest in language and culture since the 1980s. Tribal cultural centers are repositories for Apache heritage through preservation of cultural and historical objects, archives and oral traditions. The centers work toward revitalization through such programs as documentation of place-based oral traditions.

Studies of Apache dialects show the historical relationships of Apachean-speaking people, demonstrating ties to the Navajo (Dineh) and other peoples in the Pacific Northwest and Western Canada.

FAMILY AND COMMUNITY Apache families of 150 years ago had a complex system of clan networks. Extended families related through the mother's side lived together and worked cooperatively for the basic needs of food, water and shelter. There were numerous divisions and clan groups speaking the same language and having similar lifestyles, but following their individual clan leaders and living in territories they themselves defined. Larger communities came together for ceremonies, for social gatherings or to form a war party.

Today, Apache communities utilize resources on their reservations—lumber, cattle and the tourist attractions of skiing, camping and hunting. When young people leave the reservation for post-high school education or work, family and community bring them home to visit often.

SAN CARLOS APACHE. *Doll,* 1880-1920, 16 x 7.75. When the reservations were established and cotton materials became readily available, women wore these loose-fitting blouses and long, full skirts. Dolls were made in great detail including the petticoats. The hair ornament on the back of this doll's head appears very large but is proportionately accurate. The hair ornaments was traditionally worn by a girl between her first mensis and the birth of her first child.

"The first thought that comes to my mind regarding home is a sense of belonging because of the family closeness that I come from. I come from a unique group of people. I belong to a clan of my mother, the maternal side, and born for a clan of my dad. Home is vital to my breathing, my living, my thinking, my play, my existence, my relationship to God. Also, it reflects a strong sense of spirituality. That's what my description of home is."
KAREN KETCHIYAN JONES, SAN CARLOS APACHE

"Family means knowing clan relatives and the importance of a close-knit family. Kinship is forever. That's how it was a long time ago. We, as Apache people, come from different clans that live in different areas of our land. My clan is Roadrunner clan. All those people supported each other, as far as food, clothing and protection. Today, it's not like that anymore. Today, it's just your immediate family. Ever since we were put in boarding schools and HUD homes, the family ties and values were destroyed." RAMON RILEY, WHITE MOUNTAIN APACHE

"Looking back from where I'm at right now, being a mother and grandmother, what really gives me hope for the future of my community is that we're more vocal, we're open to sharing our experiences so that we don't lose the practices of the people regarding worship. Also, in the areas of the government, being more vocal about the needs of the people and even within the churches on the reservation, we're more vocal of where we're really at with ourselves as individuals. Being truthful about things that are very meaningful, that gives me great hope about the strength of our community, the stability, the honesty of admitting that yes, we do have an alcohol problem or a drug problem or domestic violence, issues that really play a big impact of crippling family, crippling individuals, acknowledging that and then allowing healing to take place and then move forward. Those are our strengths."

KAREN KETCHIYAN JONES, SAN CARLOS APACHE

COMING OF AGE CEREMONY The Apache people celebrate their creation story and their reverence for women in a ceremony also called the Sunrise Ceremony. When a young woman reaches puberty, a community of family and well-wishers celebrates her transition to adulthood. In a four-day ceremony, she is united spiritually and personally with White Painted Woman, a supernatural being central to all Apache beliefs. The ceremony brings the young woman strength and blessings for a healthy life. With her power at this time, the young woman can cure or bless those who want it.

Ceremony preparations can take more than a year. The young woman is trained and guided by a selected medicine man and elder female sponsor, known as her godmother. There are several other key players including attendants and singers. Family and friends assist in the building of a ceremonial wikieup, arbor and storeroom. Women prepare food for all the participants and guests. The attendees also receive gifts of food, baskets and other items. The Coming of Age Ceremony is an important event in a young Apache woman's life and is undertaken by many young women today, despite the major investment of time and money by the young woman and her family.

WESTERN APACHE. *Beaded T-necklace*, 1900-1920, 13.5 x 11.5. "This type of necklace was worn during puberty ceremonies for girls. In the early part of the century, they were made small and narrow like this as opposed to now, where they are wide, with more design. This was made after the 1900s. Before that time, Apache women would wear strands of blue and white beads." Larry Brown, San Carlos Apache. Gift of Ms. Leona Koch.

"When a girl comes of age, she chooses a godmother. They take the feather of their family and go early, early, in the wee hours of the morning, knock on the door with their gifts, and they present the woman, the godmother, with a feather. She'll be the godmother for the girl during a Sunrise Dance and throughout life. When you receive a feather, it's definitely an honor, but it does come with a lot of responsibility. It's not just a responsibility for that year of preparation or those days of the Sunrise Dance. It's a lifelong thing."

KEALOHA ALO, WHITE MOUNTAIN APACHE/POLYNESIAN

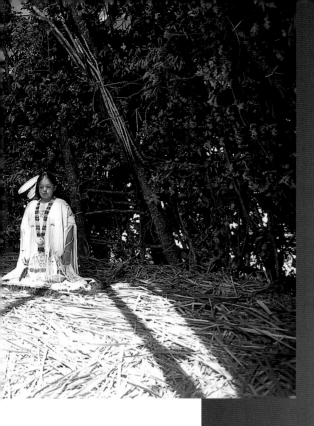

Wyndi Caje during her
Coming of Age Ceremony,
Mescalero Apache, 2003.
Sam Minkler
photographer.

MESCALERO APACHE.
*Coming of Age
Ceremony skirt and
poncho,* early 1900s, 34 x
38, 30 x 33. When a young
woman reaches puberty,
a community of family and
well-wishers celebrates her
transition to adulthood in
a four-day ceremony.
Fred Harvey Fine Arts
Collection.

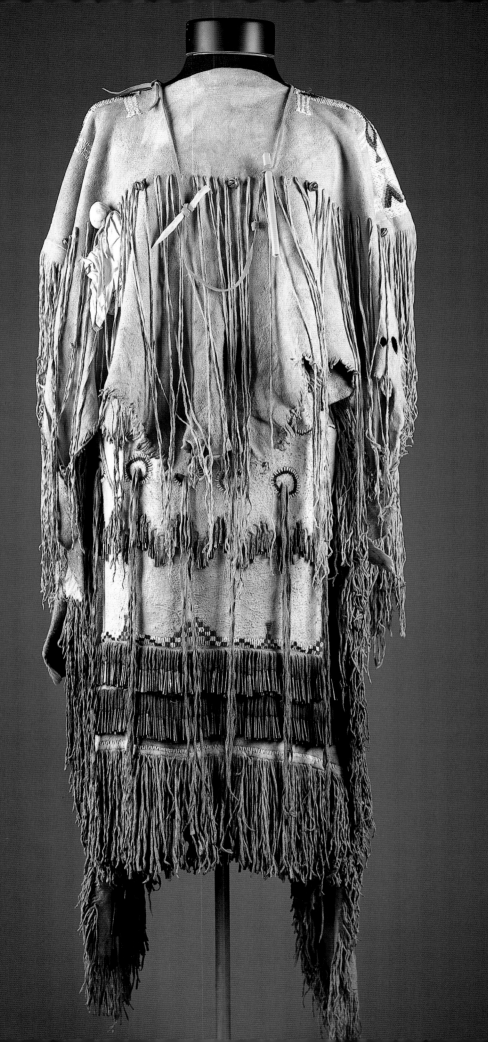

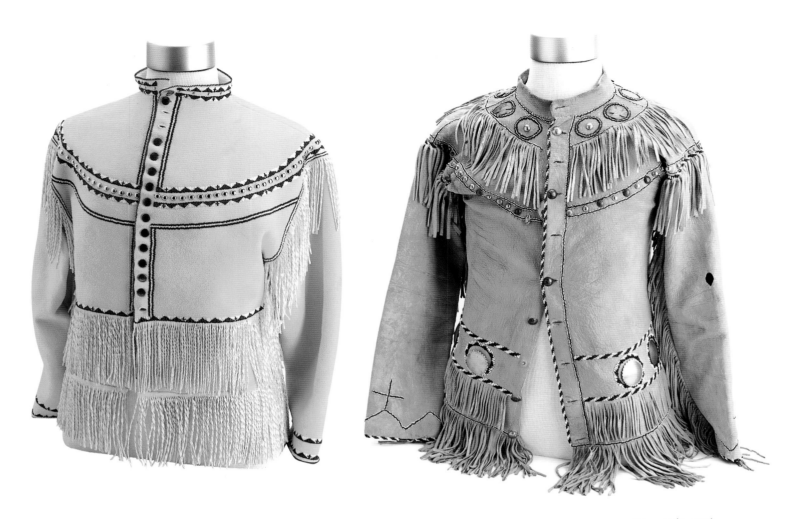

"Clothing tells a story." JEANETTE CASSA, SAN CARLOS APACHE

LEFT: DALE GILBERT (B. 1965),
SAN CARLOS APACHE. *Shirt,* 2001,
28 x 25. This is a contemporary shirt
inspired by 1880s Apache scout shirts.

RIGHT: WESTERN APACHE. *Shirt,*
late 1800s, 31 x 23.5. This leather shirt
is based on the full-dress coats worn by
U.S. Army officers during the Indian
Wars. The Apache scouts who served in
the U.S. military from 1871 to 1923
were never issued a military uniform.
They created leather shirts full of
meaning to the Apache—yellow ochre,
a sacred pigment, and rows of buttons,
beadwork and fringe typical of Apache
clothing and accessories. Serving as a
scout was a source of income and
pride, a status worthy of special attire.
Fred Harvey Fine Arts Collection.

APACHE CLOTHING The Apache people historically made clothing and accessories out of animal hides. Frequently, the buckskin clothing, bags and moccasins were decorated with vegetal paints and beadwork.

When reservations were established and cotton materials became readily available, women wore camp dresses—loose-fitting blouses and long, full skirts. Men wore white cotton trousers, shirts, Western-style vests and breechcloths. Leather moccasins continued to be worn as well as other accessories made out of buckskin—bags, sheaths and hourglass-shaped hair ornaments, usually decorated with beads and buttons.

Women's accessories provided information about social status. In the late 1800s, strands of beads around the neck and wrists indicated financial well-being. Today, young girls wear more trim on their camp dresses than a mature woman. A widowed woman will not wear ornamentation on her dress. The hourglass-shaped hair ornament was traditionally worn by a girl after she had her first mensis but before she had her first child. Today, women of all ages wear the hair-ties.

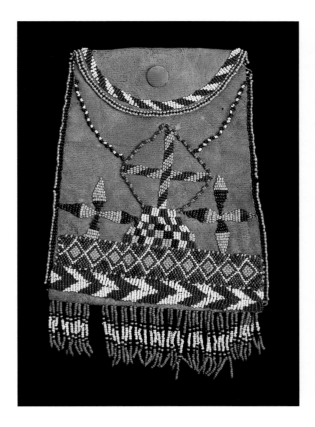

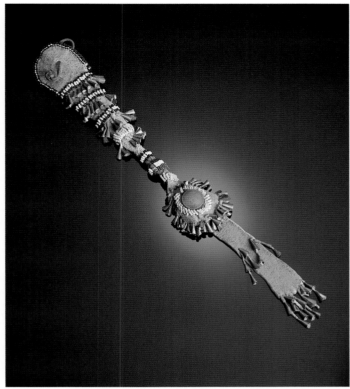

WESTERN APACHE. *Beaded bag,* 1910-1920, 9.5 x 6.75. Gift of Mrs. Louis Ott.

WESTERN APACHE. *Awl case,* late 1800s, 14 x 2.25. Awls were made of sharpened wood or animal bone, and they were used to separate basketry foundation fibers to insert the weaving fibers or to puncture holes in leather for sewing. They were useful tools that could be carried in cases that were sometimes decorated with beadwork. Fred Harvey Fine Arts Collection.

MESCALERO APACHE. *Young woman's beaded moccasins,* 1900-1920, 19 x 9. "Beadwork and stitching on the inside of the uppers is typical of Mescalero moccasins." Larry Brown, San Carlos Apache.

WESTERN APACHE BASKETS Before reservations, Western Apache home life meant moving from camp to camp on horseback, and possessions had to be few and practical. Baskets were easy to transport, less breakable and lighter in weight than pottery. Apache women made coiled and twined baskets for seed parching and winnowing, for the preparation and storage of grain, for gathering, mixing, cooking, serving and washing food, and for holding the sacred pollen used in ceremonies. Water jars were used to transport and store water. These jars were waterproofed by covering or brushing the interior and exterior with heated pitch from the piñon tree. Burden baskets were used to gather wild seeds and berries and to transport foods and other goods. Foods collected in baskets included acorns, corn, sumac berries, wild black walnuts, mesquite beans and piñon nuts. Burden baskets continue to be used today to hold food for guests attending Apache ceremonies.

By the 1880s, Western Apache basketweavers were creating large, dramatic jar baskets and flat trays for the tourist market. Thin rods formed the foundation for coils that are less than a quarter-inch wide. After 1920, fewer weavers made large basketry jars because the demand wasn't supporting the investment of time and effort. As coiled basketry declined in the 20th century, weavers continued to make twined baskets. These baskets were used in ceremony and could be produced more quickly for sale. Revitalization efforts continue in Apache communities.

WESTERN APACHE. *Burden basket,* early 1900s, 24 x 15. Weavers made burden baskets for both food collection and all-purpose transport. Gift of Mr. and Mrs. Byron Harvey III.

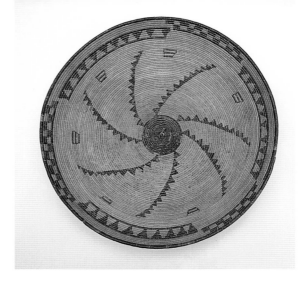

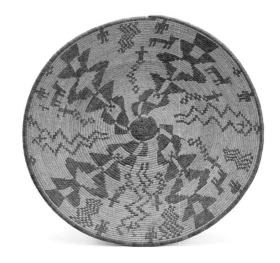

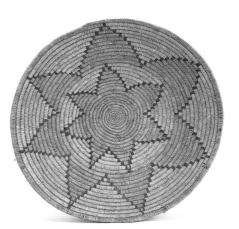

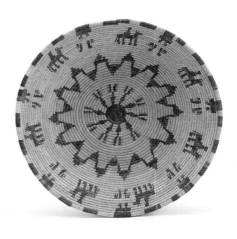

CLOCKWISE FROM UPPER LEFT:
WESTERN APACHE. *Basket,* late 1800s,
4.5 x 15. This basket is so finely woven that it
could hold water. Early baskets such as this
could have been used for food service. A basket
very similar to this one is seen in a historic
photograph from the 1880s and identified by
the photographer as Chiricahua Apache. Fred
Harvey Fine Arts Collection.

WESTERN APACHE. *Basket,* early 1900s,
4.5 x 19. Referred to as story-teller baskets,
these were commonly sold at trading posts at
the turn of the century. Gift of Miss Marion R.
Plummer and Mr. and Mrs. Stanley W.
Plummer.

WESTERN APACHE. *Basket,* c. 1910,
3.5 x 12.75. The motif of a horse with a rider is
an unusual design. Gift of Mr. and Mrs. Henry
S. Galbraith.

MESCALERO APACHE. *Basket,* 1950s,
5 x 20.5. Gift of Ms. Anne Burmister in
memory of Robert Bashford Burmister and
Martha Gage Burmister.

"You can tell about the spirit or

character of the basketmaker by

looking at the basket. It was

common to borrow and loan

baskets in times past."

CORNELIA HOFFMAN,
WHITE MOUNTAIN APACHE

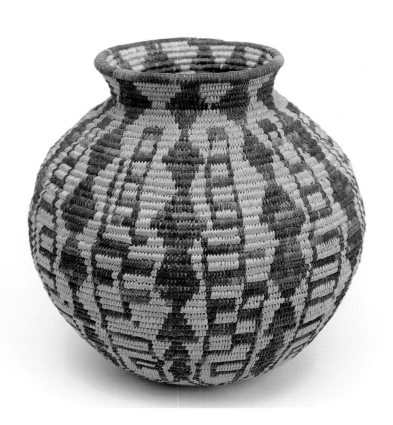

WESTERN APACHE. *Basket,* c. 1900,
10.25 x 11.

CLOCKWISE FROM RIGHT: WESTERN APACHE. *Basket,* early
1900s, 12.5 x 6.5. This double-lobe basket was another form covered
with piñon pitch and used to hold water. When it was used as a canteen,
a carrying rope was tied around the middle.

WESTERN APACHE. *Basket,* 1900-1925, 28 x 28.5. Big baskets were
frequently made for the tourist market. Gift of Valley Bank.

WESTERN APACHE. *Basket,* 1920-1930, 16.5 x 18. This bowl and olla
basket are woven in one piece. Woven in the diamond designs are names
and numbers that read BESSIE and GISELA, the latter of which is a
community southeast of Payson, Arizona. Gift of C.A. Upton.

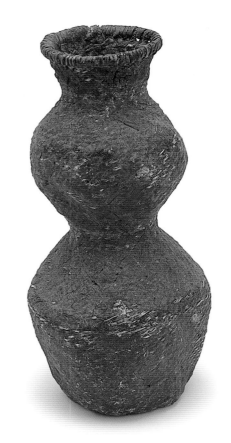

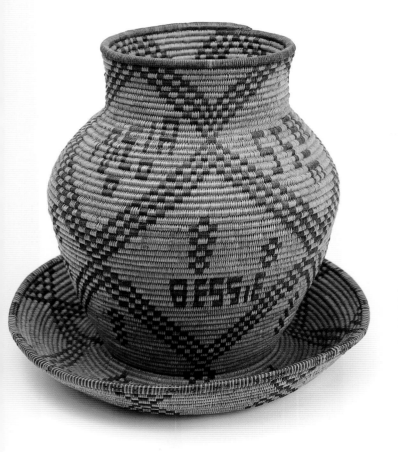

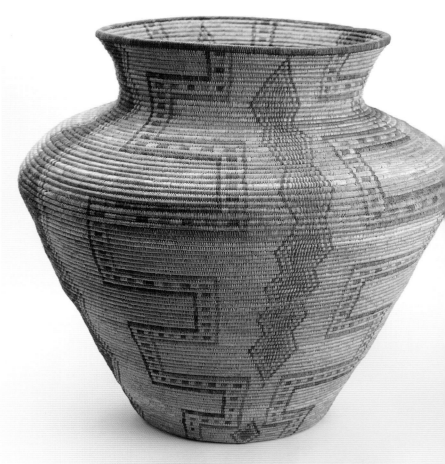

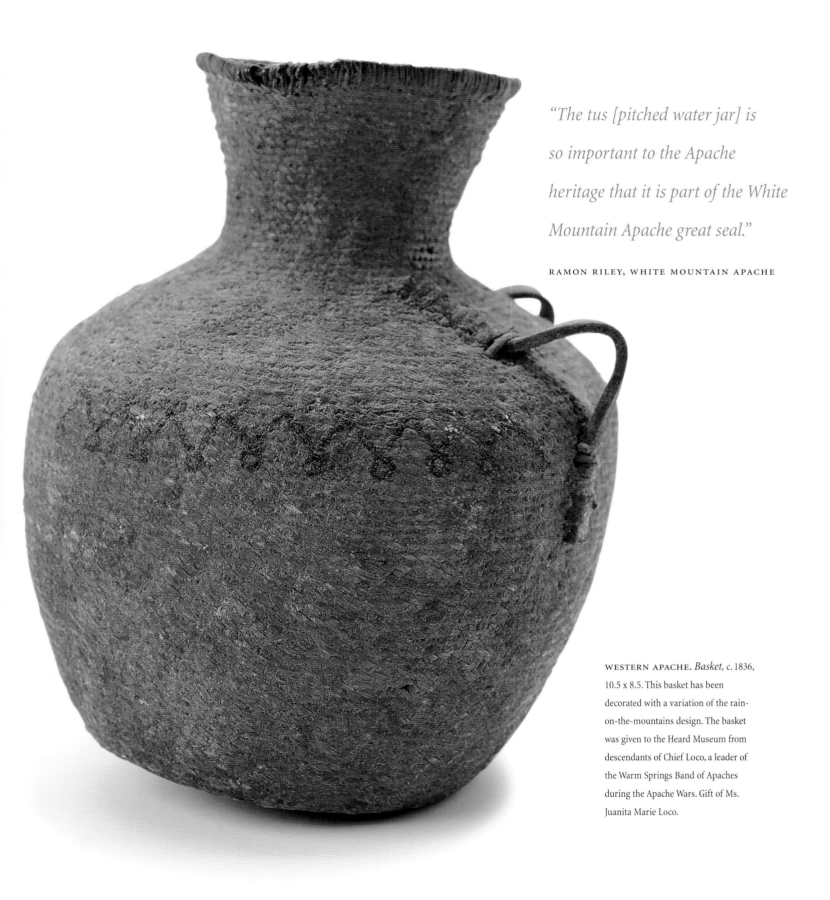

"The tus [pitched water jar] is so important to the Apache heritage that it is part of the White Mountain Apache great seal."

RAMON RILEY, WHITE MOUNTAIN APACHE

WESTERN APACHE. *Basket,* c. 1836, 10.5 x 8.5. This basket has been decorated with a variation of the rain-on-the-mountains design. The basket was given to the Heard Museum from descendants of Chief Loco, a leader of the Warm Springs Band of Apaches during the Apache Wars. Gift of Ms. Juanita Marie Loco.

Yavapai HOME IN WIDE AND CONTESTED LANDS

"We had millions of acres years and years ago. Then when the White man
started moving west, why, it got smaller and smaller. Now the land that we
have, it's very small." BERT BONNAHA, YAVAPAI

AT ONE TIME, 10,000 YAVAPAI in four subtribes moved over nearly 10 million acres of central Arizona from deserts at 500 feet to mountains at 7,000 feet. They hunted game, gathered plants and grew crops, relying on specific knowledge of water sources and seasonal ripening of foods. Each subtribe's territory covered about 2,000 square miles. In the 1860s, prospectors discovered rich minerals on Yavapai land. The military arrived to protect mining interests, and with it came farmers and ranchers to provision the forts. Deprived of food sources, the Yavapai fought to keep their way of life but, by 1873, most Yavapai were living on reservations. When corrupt officials saw profit in placing the Yavapai on the San Carlos Apache Reservation, the Yavapai were marched 180 miles through the mountains in winter. Each February, the Yavapai commemorate that event on Exodus Day. After 25 years, the Yavapai were released and returned to small parcels of their old homelands, where they farmed or worked for wages for the railroad or the mines in nearby towns.

"The Yavapai land in the Verde Valley is very beautiful. You see the red mountains and you feel the comfort and the spirit of the valley; that's where creation started for us."

KATHERINE MARQUEZ, YAVAPAI-APACHE

"Home—we're tied to the land. As children, we were quite familiar with our homeland—the river, the mountains, and the open space that we had. We enjoyed that type of life, and when we were away at school, we wanted to go back to it."

CLINTON PATTEA, YAVAPAI

Katherine Marquez and niece, Mandy Marquez, 1999. Craig Smith, photographer.

YAVAPAI. *Basket*, early 1900s, 20.25 x 18. Advisor Katherine Marquez indicated that this basket was Yavapai, not Western Apache. The extensive use of devil's claw and the wide mouth are two design features of Yavapai jar baskets. "The saguaro are Yavapai people," she noted. Gift of Barbara Lenone.

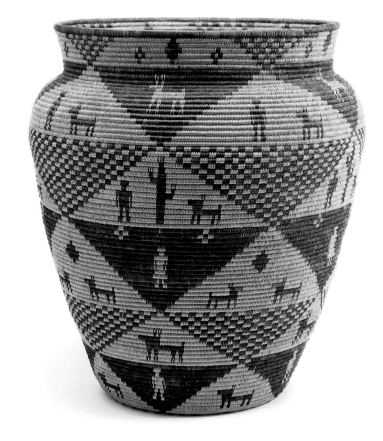

"My mother used to make acorn soup. My father worked for Phelps Dodge in the smelter in Clarkdale. We were transferred down to Ajo [in Southern Arizona], but even though we lived down there, my mother still got acorns to make the traditional acorn soup."
KATHERINE MARQUEZ, YAVAPAI-APACHE

"Good old beans and fry bread. And that's about it. I love fry bread and beans. I can eat them three times a day." BERT BONNAHA, YAVAPAI

YAVAPAI LIFE Yavapai language speakers can understand the other Upland Yuman-speaking tribes, the Hualapai and the Havasupai. In 2004, an estimated 10 people spoke the Yavapai language. Language preservation efforts include classes in school and informal conversation groups with elders and young people.

Today, despite tremendous changes in the Yavapai lifeway, some residents of each reservation are from clans that once lived in the area. During much of the 20th century, the economies of the Yavapai communities were limited. The proximity of Yavapai communities to the growing urban areas of Phoenix and Prescott have increased economic development options, especially in tourism and gaming. Funds have been used for social services, education and cultural preservation activities. Twentieth century leaders among the Yavapai have included Dr. Carlos Montezuma of Fort McDowell, a Native rights advocate who fought to secure Yavapai homelands; Viola Jimulla of Yavapai-Prescott, the first woman to be elected leader of a North American Indian Nation; and Frank Harrison and Harry Austin of Fort McDowell, whose 1948 lawsuit gained voting rights for Arizona Indians.

YAVAPAI. *Basket*, early 1900s, 2.25 x 11. "The star represents Skatakaamcha, Star-in-the-night, or one that wanders. Lightning flashed when the night star went up. Yavapai oral histories tell how Skatakaamcha went to the top of Bell Rock, in the Sedona area, and pushed the mountain down into the earth. Bat woman, Kampanyika, knocked him down. His bones lay all around the base of Bell Rock, spreading medicine all around." Katherine Marquez, Yavapai-Apache. Gift of Mr. and Mrs. John M. Clements.

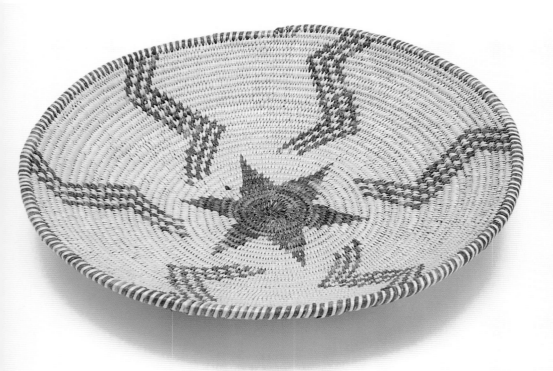

"When it rains, you can smell the greasewood for miles and miles; it has the most beautiful smell. If you ever throw water into a burden basket, you will smell the aroma of the plants. And the Verde River, it smells so good."

KATHERINE MARQUEZ, YAVAPAI-APACHE

YAVAPAI OR APACHE. *Basket,* early 1900s, 12 x 14.5. This basket has been variously identified as Yavapai and Apache. The history of Yavapai and Apache people, with both confined to the reservation at San Carlos, probably led to the sharing of many basketry designs and techniques. This basket is very finely woven and features an eagle and motifs that some think represent military medals. From the Bert Robinson collection. Gift of Miss Marion R. Plummer and Mr. and Mrs. Stanley W. Plummer.

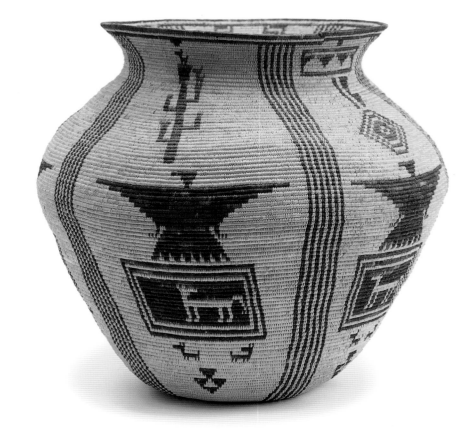

"The language has kept us together. Growing up, we all spoke the language. That was our basic way of communicating within our families."

CLINTON PATTEA, YAVAPAI

YAVAPAI. *Basket,* early 1900s, 2.5 x 16.5. This is a winnowing basket. Acorns were cracked in a flour sack, and the meat was separated from the husk in a winnowing basket such as this one. The acorn meat would be ground up on a trough-style grinding stone with a two-handed mano. The flour would be used for acorn stew. Katherine Marquez's mother made jerky gravy, which she sprinkled with acorn flour. Deer meat also was sprinkled with acorn flour. Fred Harvey Fine Arts Collection.

"The Tolkapaya, the Kewevkapaya and the Wipukpaya are the clans of the Yavapai Tribe. We, who are living up in the Prescott area, are considered the Tolkapaya."
BERT BONNAHA, YAVAPAI

"During my growing-up days, uncles, aunts, cousins, grandparents, all lived within the community. We depended on each other. We had farming and cattle raising in our community, and every family was expected to contribute towards the work, taking care of our cattle, our farms. We, as individuals, volunteered our time. We weren't paid to take care of our needs, so we all worked together to bring about a better economy within our community. Today, we have electricity and running water, and the conveniences that you see in an urban area. We didn't have that when I was growing up, so there's quite a difference now."
CLINTON PATTEA, YAVAPAI

Havasupai HOME IN THE CANYON

FOR CENTURIES, THE HAVASUPAI HOME has centered on the Grand Canyon. In the past, the Canyon had been a summer home where the Havasupai grew food for the winter. In winter, when the Canyon floor was cold and damp with only five hours of sunshine, the Havasupai moved to the Canyon's south rim. There, they hunted game and gathered wild plants. As competition for land around the Canyon increased, the Havasupai were denied their winter homes. By 1882, the Havasupai homeland had been decreased to a land base six miles wide and 12 miles long totaling 518 acres and located entirely within the Canyon. For 66 years, as crowding in the Canyon became worse, the Havasupai petitioned Congress for the return of their land. Finally, in 1975, the tribe received 185,000 acres of their winter homeland on the Coconino Plateau. It was the largest amount of land ever restored to a single tribe. In 2000, there were approximately 100 homes in the Canyon. About 450 of the tribe's 650 members live in the Canyon. The potential for building houses on the plateau lands outside the Canyon is a sensitive issue because of environmental concerns. Any building project in the bottom of the Canyon is a difficult and expensive undertaking, since large military helicopters must be used to bring in prefabricated housing parts. This makes the damage done to homes by periodic floods especially serious.

Eating peaches at Havasupai, 1950. Bill Belknap, photographer. Cline Library, Northern Arizona University, Flagstaff, Arizona.

LEFT: HAVASUPAI. *Burden basket,* early 1900s, 28 x 23. The base of the basket is covered with hide that has some fur remaining.

In the Havasupai language, the people are Havasuw 'Baaja, People of the Blue Green Waters. Isolation has helped to preserve the Havasupai language. As mainstream music and satellite television bring the outside world to the Canyon, families and teachers have worked to develop special curriculum materials and programs to continue the language.

With space very limited in the Canyon, several generations may live together. This continues a tradition of grandparents being especially important in children's lives. However, overcrowding is a serious problem because land used for residences cannot be used to grow food. Children can go to school in the Canyon for the first eight grades. After the eighth grade, children leave home for boarding school or stay with families outside the Canyon and attend public school. Most of the community members are employed in the tourism industry, guiding mule trains in and out of the Canyon.

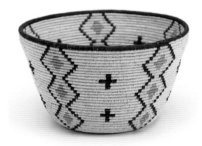

HAVASUPAI. *Basket,* c. 1934, 6 x 10.25.

FACING. Havasu Falls, 2003. Sam Minkler, photographer.

"Here, the families are closely knit. If we left forever, we would feel like we were neglecting our mothers, our grandparents. That's the most important cultural tradition we have. We come back for the elders." ROSE MARIE MANAKAJA, HAVASUPAI

"My grandma used to mix figs with apricots and piñon nuts. She'd boil it to make jam. She would mix piñon nuts with the deer meat and cornmeal. Some of that food was just outstanding....One of my dreams is to get a tribal farm started, so that we could sell that food, either to the markets or sell it to the tourists who come here. In the 1800s, Supai had peaches, apricots from wall to wall, and were selling those or shipping those to the Indian schools. I'd like to see that come back." ROLAND MANAKAJA, HAVASUPAI

"When people talk about the Grand Canyon, they're speaking about our home."

ROLAND MANAKAJA, HAVASUPAI

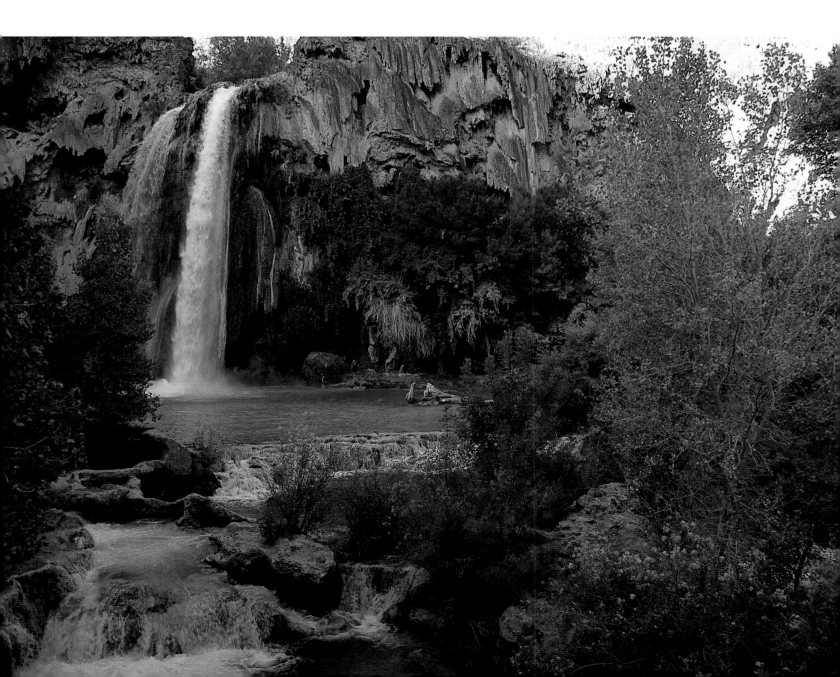

Hualapai HOME ON THE PLATEAUS

HUALAPAI AND HAVASUPAI PEOPLE were once part of the same group, living in adjoining territories. The land had streams and springs that people used to irrigate crops in spring and summer. Following a fall harvest, crops were processed and dried for the winter. People traveled in their territories, hunting game and harvesting piñon nuts. Agave or mescal also was harvested, and the hearts were roasted in a pit. The roasted agave was dried, ground and used throughout the winter.

In the 1860s, miners and settlers came to Hualapai lands and appropriated the Hualapai springs and other water sources. In 1881, the railroad established a depot at Peach Springs, and the pace of change increased. Some Hualapai people found jobs on ranches or farms, or they worked for the railroad. Their reservation was established in 1883 and includes land at the rim of the Grand Canyon.

In their language, the Hualapai call themselves People of the Tall Pine. Hualapai language speakers also can understand other Pai languages. According to Native language teacher Lucille Watahomigie, an innovator in developing classroom curricula, many adults age 30 and older speak the language and know the cultural traditions.

Loretta Jackson, Hualapai, 2004.
Craig Smith, photographer.

"In historic times, we raised pumpkins, corn, watermelon and squash. We traded with the people to the east—the Hopis and the Zunis—and the Mohaves to the west. You would come back to the same area year after year to harvest agave. You roasted agave plants underneath the ground and let them dry out for a couple of days. Then you processed the agave on metates with grinding stones. You'd turn it into meal or dry it into a cake so that you could use it for the winter." LORETTA JACKSON, HUALAPAI

"There are big differences between how we live today and how things were several centuries ago when you existed as bands. You had specific roles, and you were taught from a baby on what your role was going to be. You had a place in that little society, and it was important that you knew your place. Imagining the way that we existed on the land several centuries ago is astounding. We had a systematic way of cooperating and surviving off the land. You couldn't afford to make any mistakes. If you made a mistake, it cost the lives of the whole band."
LORETTA JACKSON, HUALAPAI

"I was raised in Milkweed Canyon where there was a spring, and that's where my grandmother and grandfather lived. It was the traditional territory of my mother's father, and that's the band that we were from, the Milkweed people. That's what home is to me, wherever my family is—my mother, my father, my grandparents, my children. . . . The smell of the pine trees, the sage, and the wind blowing, those remind me of home." LUCILLE WATAHOMIGIE, HUALAPAI

"My favorite smells include the water willows that are along the Big Sandy River, and there along the banks of the river are the smells of our old native plants. My mother made utilitarian baskets that people used to gather their seeds and grains and clean them. They used baskets a lot back then."

MALINDA POWSKEY, HUALAPAI

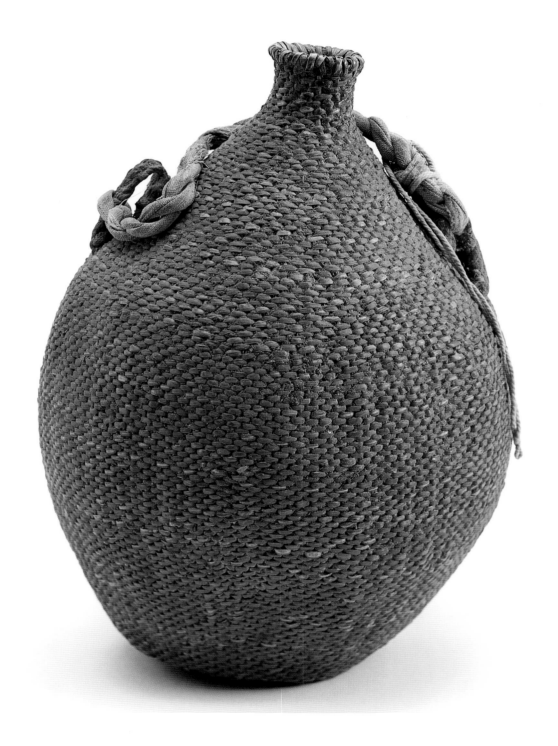

HUALAPAI. *Water bottle*, c. 1900, 9.5 x 7. According to Loretta Jackson, Hualapai, "This twined water bottle made from squawberry was covered with hematite to make it the red color."

"My dad grew a lot of produce, had an orchard and planted alfalfa. He planted a lot of alfalfa that was feed for the animals. We'd take the alfalfa to a horse-drawn horse bailer, a John Deere horse-drawn manual bailer—one of the first ones. My job was to sit on Old Texas and make sure that he kept going around in a circle. He was the power behind the machine."

MALINDA POWSKEY, HUALAPAI

"Home is northwest Arizona, over seven million acres. We cover large landscapes—over 100 miles a day, and several hundred miles to get groceries in Kingman. We're pretty unique."

LORETTA JACKSON, HUALAPAI

COMMUNITY Today, Peach Springs is the largest Hualapai community with 500 residents. Because Hualapai lands include the western rim of the Grand Canyon, the tribe has developed tourism businesses including a hotel, restaurant, river rafting tours running down the Colorado and big game hunting. Community activities honor the past and educate young people. The yearlong Hualapai imprisonment at LaPaz, Arizona, in 1874 is commemorated with an annual relay run between Parker and Peach Springs. For more than 50 years on Memorial Day, a ceremony has been held for those who have passed on to teach young people about Hualapai heritage.

"In the late 1800s, Anglo ranchers employed Hualapais to do ranch work and cowboying. That adopted tradition is one of the first things we were allowed to learn in order to keep our land. They said that we would have to run cattle on our land. I'm proud that my father taught us those ways. . . . Once, it was easy to take over your family's livelihood. As things continued down the generations, that began to break up. My grandfather was a tribal herd manager, and it was easy for my dad to take over that role because that was how he grew up. My mother followed in the footsteps of her mother. Everything was set in a certain way in the early 1900s when we were just starting to become part of the melting pot in this Anglo society. . . . Now, I think self-sufficiency is something that we really need to work on. We have a rich cultural heritage. Eco-tourism or culture-tourism can be identified as one of our leading economic development plans. Community members could feel free to use that as their selling points or their base of income." LORETTA JACKSON, HUALAPAI

LANGUAGE

"Language is a very important lifeline of a tribe. Traditional landscapes—places—have certain meanings and activities that happened that can only be explained in Hualapai."

LORETTA JACKSON, HUALAPAI

"When you say things in Hualapai, it goes all the way to the heart. And that's what keeps us together as a family or as a tribe—one group of people that has a common bond."

MALINDA POWSKEY, HUALAPAI

PAI BASKETS Baskets are woven into Pai history. When the Yavapai were force-marched in the dead of winter through the mountains to confinement on the San Carlos Reservation, there is a story, still told today, of an old man who carried his ailing wife in a burden basket. The baskets reflect the

history of Pai homes. For the Hualapai who traveled over wide areas harvesting wild grasses and foods, baskets were the essential tools that had to be perfectly suited to gathering and keeping the many small seeds. Stewed peach pulp, mescal pulp and pitch were just some of the coatings applied to strengthen baskets and suit them to carrying small seeds or liquids. These baskets were all twined. Havasupai twined utilitarian baskets were very similar to those made by the Hualapai. Havasupai weavers began making more coiled baskets in the 1880s. They traded them to the Hopi and other Puebloan people and sold them to tourists. The Hualapai made coiled baskets for a time and then returned to weaving distinctive twined baskets for sale.

The long association of the Yavapai with the Western Apache, first as allies and then on the reservation at San Carlos, has led to many cross-influences in basketweaving that make designs of the two difficult to distinguish. Both groups wove superb coiled baskets, mainly of willow with devil's claw designs. Students of basketry have been trying for years to discover traits that distinguish Yavapai from Apache, but often unless the weaver is known, which is very rare in older pieces, distinctions may be subjective. What is true is that for both groups, for the first part of the 20th century, basketry was a highly prized art form for collectors that contributed to the household income of weavers.

"We do have a lot of art in the baskets that our people weave. Animals, or stars and the sun, they're all woven into the baskets. We have a word in our language which means to write in your basket."

CLINTON PATTEA, YAVAPAI

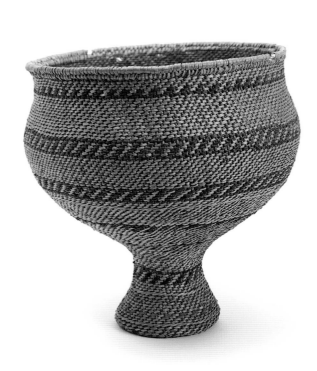

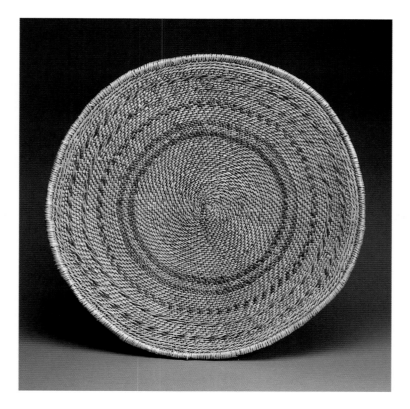

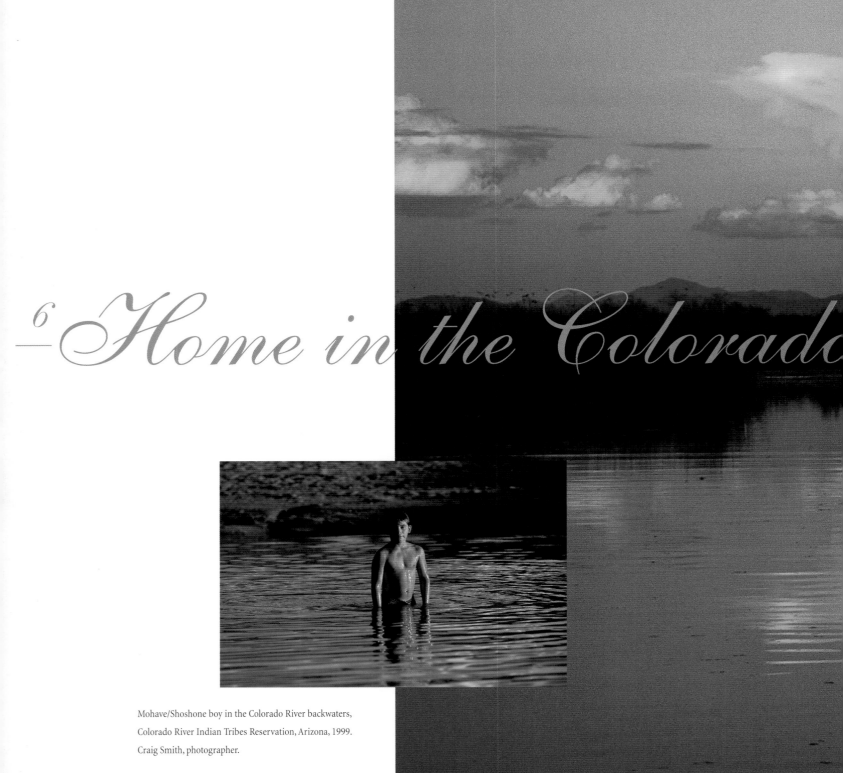

Home in the Colorado

Mohave/Shoshone boy in the Colorado River backwaters,
Colorado River Indian Tribes Reservation, Arizona, 1999.
Craig Smith, photographer.

Catfish Bay, A'hakhav Preserve, 1999. Craig Smith, photographer.

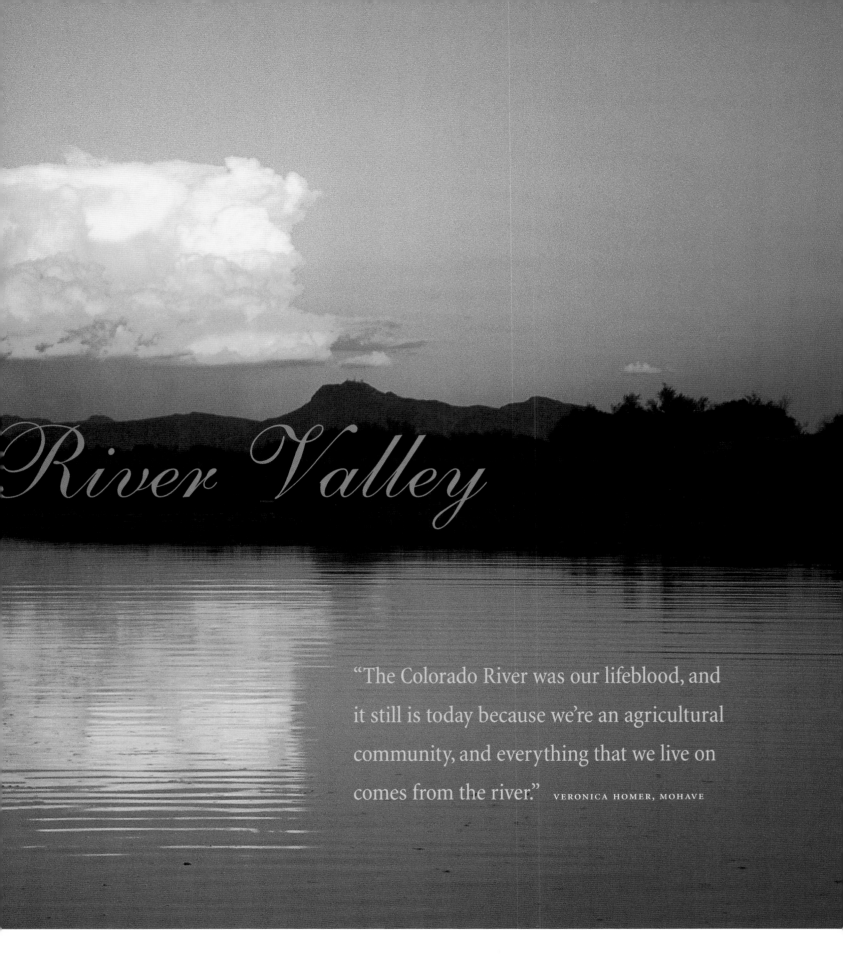

River Valley

"The Colorado River was our lifeblood, and it still is today because we're an agricultural community, and everything that we live on comes from the river." VERONICA HOMER, MOHAVE

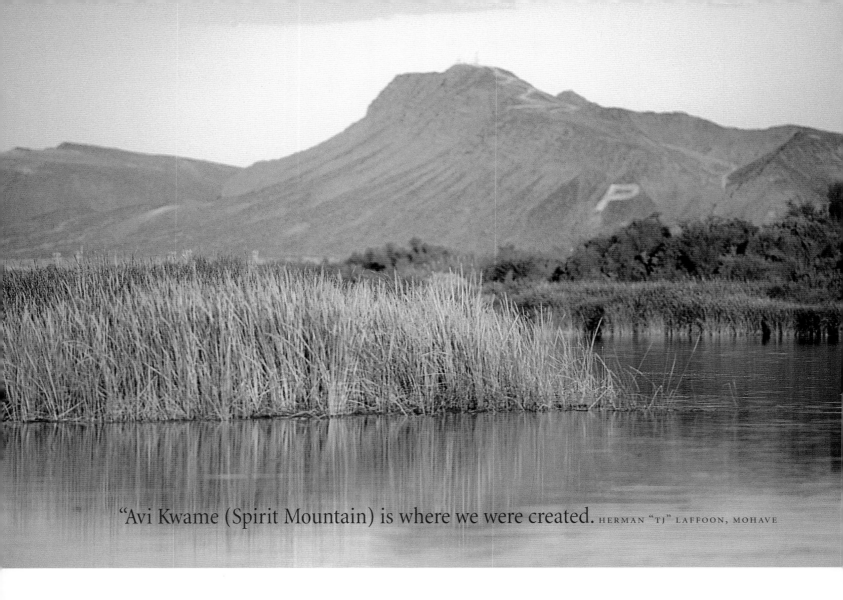

"Avi Kwame (Spirit Mountain) is where we were created. HERMAN "TJ" LAFFOON, MOHAVE

"The Colorado River goes through our reservation, and we're protected by the mountains. Avi Kwarotat (Monument Peak), Avi Vatai (Riverside Mountain), Avi Iver (Big Maria Mountains), Kapet Nyha (LaPaz Mountain), Avi Hilya (Moon Mountain), Avi A Ise (Screwbean/Mesquite Mountain), Avi Suquilya (Black Mountain or Red Hawk Mountain), protect our reservation. They're all sacred to us." HERMAN "TJ" LAFFOON, MOHAVE

A'hakhav Preserve, 1999. Craig Smith, photographer.

WHEN THE COLRADO RIVER LEAVES THE GRAND CANYON and turns south, it passes between the Sonoran Desert on the east in Arizona and the Mojave Desert on the west in California. With mild winter temperatures and summer temperatures at a maximum 125 degrees Fahrenheit, this is one of the driest parts of the Southwest. Annual rainfall is about 4.5 inches. Mountains named in origin stories flank the lower Colorado River Valley. Avi Kwame or Spirit Mountain in Nevada is known to people who speak the Yuman language as the place of emergence for all people. Before dams, snowmelt upstream would cause the river to flood in May and June, depositing rich soil for farming. Above the bottomlands, thick stands of mesquite were an important food source. Today with dams, access to irrigation water is essential. Further south at an elevation of 100 feet above sea level, the Colorado's mouth was a rich, moist, grass-filled marsh that fed fish and water birds. Today, the Colorado River is used up before it can form a delta.

Homelands for some Yuman-speaking people lie along the Colorado River. The Mojave to the north are the largest group, occupying more than 100 miles along the Colorado. The Quechan are south of the Mojave, and the Cocopah in the river delta have traditional lands in the United States and Mexico. Once, people combined farming in fertile floodplains with fishing, hunting and gathering desert plants. Every year in May and June, the Colorado River would flood, bringing more rich soil for the fields. But the river that supported the Yuman people became a major artery of western expansion for explorers, trappers, military expeditions, miners and, finally, settlers. Since the 1800s, the Yuman people have worked to stay connected to a portion of their homeland. Hoover Dam, built in the 1930s, ended their floodplain farming and made access to irrigated lands essential for survival.

"We were always in this territory here from the beginning, before anybody else was here."
ELDA BUTLER, MOJAVE

MOHAVE. *Skirt,* mid-1800s, 25 x 12. Before the 1860s, Mohave women wore knee-length skirts made of soft shredded fibers from the inner bark of willow trees. Gift of Ms. Ruth Thomas.

"Picacho Peak, legend has it that when we were living in this area, all the way down to Mexico, the Creator said, 'You will be here. I'll be watching over you. I'll protect you and make sure that your lands will not be taken away from you.' So the Spirit turned himself into that mountain. It's like a sentinel watching over the whole area, the land and the people."
VERNON SMITH, QUECHAN

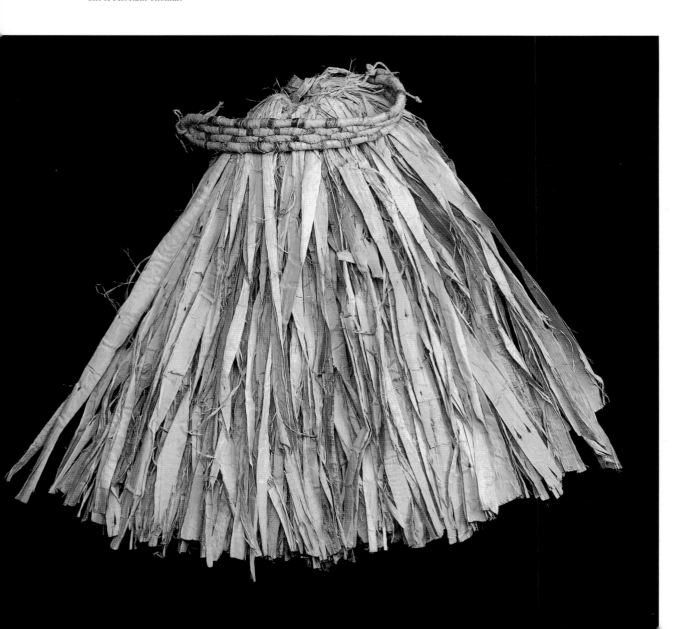

"Working at the Salt River Pima-Maricopa Indian Community, I had some of the land operation staff come over and take me out on the reservation. We were driving around, and even though it was July, I opened the windows and stuck my head out, enjoying it. I said, 'Oh, that just smells so good—that reminds me of home.' And the gal who was driving turned around and said, 'Veronica, that's rotten cantaloupes.' And I said, 'I know, doesn't that smell good.' It just really reminded me of home." VERONICA HOMER, MOHAVE

"We grew our own beans [teparies] and preserved them. We called them Indian beans, and that's what we ate all through the winter and summer. The squash we grew ourselves. The Indian beans, corn and watermelon were all favorite foods. The smell of home would be the scent of fresh cut alfalfa, mesquite wood burning, the water, the clean air. It smells like freedom." HERMAN "TJ" LAFFOON, MOHAVE

"We'd cook outdoors in the summer evenings. We ate squash, pumpkin, fish. I remember going across the river one time when they were having big doings. They had a great big pot, and they were cooking fish with a sauce-like gravy in there. It was so good, I can almost taste it. They did a lot of outdoors cooking; they had to." ELDA BUTLER, MOJAVE

"My father used to have about five acres of corn, all kinds of watermelons and tepary beans. Every evening after our supper, we'd go out there and weed them. I used to have a lot of fun. I miss all that—especially the corn and the tepary beans. We used to eat rabbits and fish. Once in a while, they'd kill a cow and everybody shared. We didn't eat much meat, but it was a delicacy once in a while.... The smell of beans and mesquite reminds you of times past. Everybody used to cook outside, and you could smell the cooking for miles. Mesquite has a real strong aroma when it burns. It gives good heat." PAULINE JOSE, QUECHAN

Pauline Jose, Quechan, 2004. Gloria Lomahaftewa, photographer.

LANGUAGE Yuman peoples' language is rich and deep in oratory and song. Today, bird songs are a primary part of language preservation and are sung at social gatherings and at funerals. The songs can consist of more than 30 cycles of 200 to 350 songs. The songs are stories that may have their origins in dreams, and the dreams are an important source of inspiration for life and creativity.

Herman "TJ" Laffoon, Mohave, 2004. Gloria Lomahaftewa, photographer.

Veronica Homer, Mohave, 2004. Gloria Lomahaftewa, photographer.

"You learn English to be able to progress in the White world, and your own language in order to survive forever." VERONICA HOMER, MOHAVE

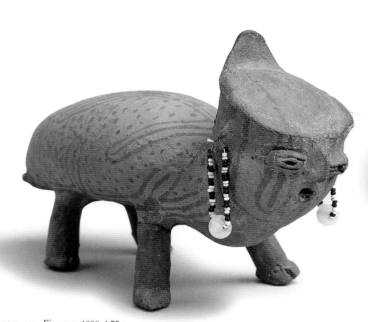

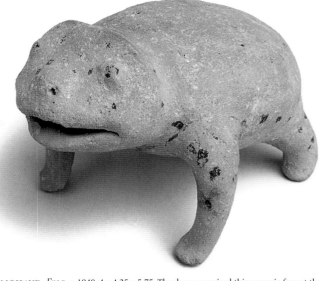

MOHAVE. *Figure,* c. 1900, 4.75 x 3 x 10.25. Advisor Herman "TJ" Laffoon remarked that this creature resembles a black-and-white beetle that lives in willow trees. He called it an Ava Kato. The fanciful figure is wearing earrings.

MOHAVE. *Frog,* c. 1940, 4 x 4.25 x 5.75. The donor acquired this ceramic frog at the railroad station in Needles, California. Its spots were originally greasewood leaves that have since worn off. Commenting about the people selling crafts at the railroad station, Mohave elder Louise Patch said, "They couldn't speak a word of English, but they were in business." Gift of Mrs. Nora Kreps Loerpabel.

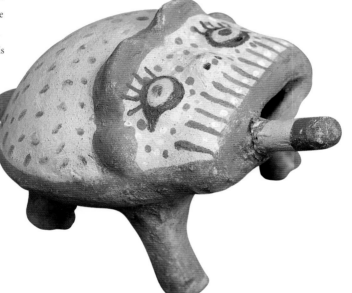

ANNIE FIELDS (1884-1971), MOHAVE. *Frog,* 1960-1970, 4 x 5 x 6.25. This frog carries a fire stick in its mouth. In Mohave origin stories, when the son of Earth, Mutavilya, was about to die, he instructed people that he was to be cremated. The Mohave did not have fire in those days, so a frog hopped to the west across the desert to a volcano, where he placed a stick in his mouth and lit it. Then he hopped back across the desert with the burning stick. When the frog returned, Mutavilya had died. The frog lit the funeral pyre, establishing the Mohave tradition of cremating the dead with their belongings. Gift of Mrs. Nora Kreps Loerpabel.

"Our own language doesn't have any cuss words in it; it's clear, concise, to the point. It tells you of your roots—everything that's happened since we were created. It's all there. You learn about the Quechan through the songs, the legends, the stories, the way we dress, the way we eat. Everything is there."

VERNON SMITH, QUECHAN

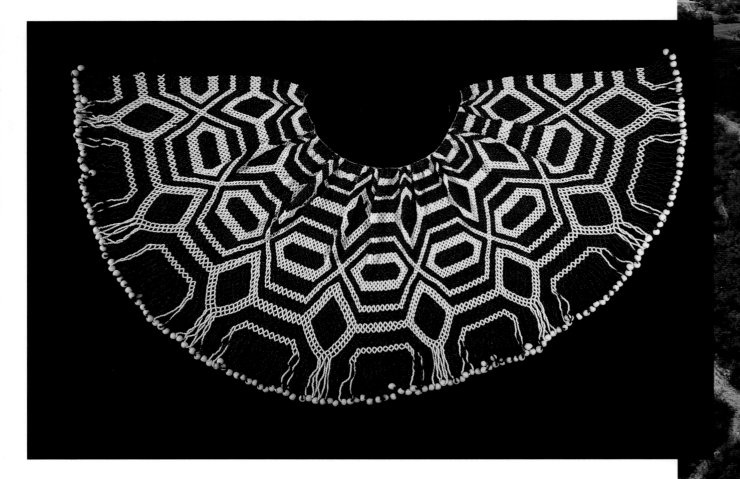

FAMILY AND COMMUNITY Traditionally, Yuman people built homes in groups spread over a mile or two, with four or five miles between groups, leaving room for fields and gardens. Neighbors were extended family and clan members. In the mid-1800s, military forts became the nucleus around which reservations were formed. Today, the Mohave people live on two reservations. In 1865, the government tried to move all of the Colorado River people onto one reservation, establishing the Colorado River Indian Tribes Reservation (CRIT). The Paiute-speaking Chemehuevi joined the Mohave. The Fort Mojave Reservation near Needles, California, was established for the Mojave who remained behind. People from Fort Mojave spell their cultural affiliation with a "j" instead of an "h". In 1945, the government opened CRIT to Hopi and Navajo families who had suffered from the Depression and livestock reduction programs. In recent years, economic development activity has greatly improved the economy at CRIT. Successful programs have included irrigated agriculture programs, long-term land leases and the prosecution of land claims.

The Quechan homes were located near the heavily trafficked river crossing at Yuma. Until the railroad reached Yuma in 1877, some Quechan made a living ferrying and piloting ships on the Colorado. In 1884, the Quechan were settled on the Fort Yuma Reservation. Land swindles left them with land too far from water to be of use. In recent years, the successful prosecution of land claims has brought land and money to the Quechan, with which they have developed a sand and gravel business and irrigation projects. Winter visitors to Yuma also make tourism a profitable activity through a casino and RV parks.

MOHAVE. *Necklace,* late 1800s, 17 x 29. The Mohave began to make beaded collars in the early 1880s. Blue and white were the most popular colors for collars. The glass trade beads became available through contact with explorers, settlers and soldiers. Mohave elder Louise Patch referred to the design on this cape necklace as a turtle shell design. She said the diamond shapes represent the bank of the Colorado River, and the elements near the neckline are the tributaries of the Colorado such as the Bill Williams River. Fred Harvey Fine Arts Collection.

Colorado backwaters, A'hakhav Preserve, 1999. Craig Smith, photographer.

The Cocopah have been split between the United States and Mexico since the Gadsden Purchase of 1853. In 1917, Cocopah leader Frank Tehanna persuaded the federal government to establish the Cocopah Reservation near Somerton, Arizona. In 1985, a land claims settlement against the United States added 4,000 acres of leaseable land to the reservation. Other businesses include a casino and the Cocopah Bend RV and Golf Resort.

"Our tribe is growing. We have to make use of our land and think about more homes. I think we have a real good future." PAULINE JOSE, QUECHAN

"CRIT is unique because of our tribal make-up. We're in two states and three counties, and we have a non-Indian town [Parker] within the reservation. . . . I see the tribes administering a lot of government programs and moving to acquire lands near their reservations. I see the casino dollars and economic development really helping. I see more of our young people being educated, and I think they will be returning to the reservation. I see the tribes taking on major projects like hydroelectric plants, and I think that's all good."

VERONICA HOMER, MOHAVE

FACING: AMELIA ESCALANTI CASTER, QUECHAN. *Dress,* 1974, 47.5 x 42. When Elissa Percharo (Th-a-nov), Pee Posh and Yolanda Hart Stevens, Pee Posh/Quechan, saw this dress, they said, "This dress has many songs behind it," referencing bird songs sung by the Yuman-speaking people. This dress could be worn for either a ceremonial or a social occasion; ANONA HILLS QUALUPE, QUECHAN. *Belt,* 1974, 46 x 1.67; and JUDITH PIRETTA, QUECHAN. *Necklace,* 1974, 16 x 4.5. According to Elissa Percharo and Yolanda Stevens, this necklace could be worn by either a man or a woman.

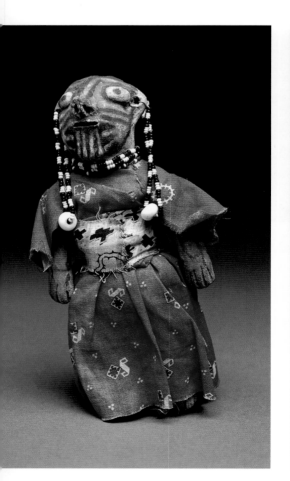
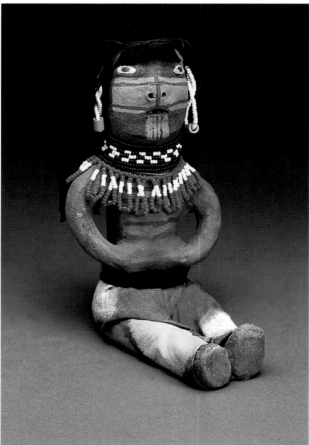

MOHAVE. *Doll,* c. 1900, 6.8 x 2.5. Mohave potters painted the faces and bodies of figurines with designs that represented styles of tattooing and body painting. Fred Harvey Fine Arts Collection.

ANNIE FIELDS (1884-1971), MOHAVE. *Doll,* c. 1963, 7 x 5 x 3.75. Annie Fields lived in Needles, California. Her work is distinctive for her attention to details of clothing and jewelry, especially the beaded collars and earrings. Gift of Mrs. Nora Kreps Loerpabel.

"*We are now able to do a lot of things on our own. We have our own police department, which we didn't have before. We have a program for our seniors. Our seniors are important to us, so we try to take care of them.* We need to look at the community as a family. We need to protect that."

VERNON SMITH, QUECHAN

ELMER GATES (1929-1990), MOJAVE. *Jar,* 1974, 6.75 x 8. Elmer Gates revived vessel shapes and design styles of the Hohokam with this contemporary jar. Gift of the Gila River Arts and Crafts Center.

FEEDING

My mother taught us

Whoever comes across

The threshold of your house

Is not a stranger.

Feed them.

Even if you only have a piece of

Dried tortilla, share it.

WATTO

'Am watto weco, 'am watto hugidan.

Beneath the ramada, next to the ramada.

Things happen there.

Meals are cooked,

meals are shared.

Good news is delivered there,

bad news is delivered there.

People laugh there,

people cry there.

People mourn their dead there,

people celebrate their births there.

SMOKE IN OUR HAIR

The scent of burning wood holds

The strongest memory.

Whether it is mesquite, cedar, piñon or juniper.

It is distinct.

The sweet smell holds the strongest memory.

We stand around the fire

Smoke like memories permeates our hair,

Our clothing, our layers of skin.

We walk away from the fire

No matter how far we walk

We carry this scent with us.

Paris, France or Germany

We catch the scent of burning wood

We are brought home.

THE TWO VILLAGE SYSTEM

The man from Jiawul Dak (Fresnal Village, on the O'odham Reservation)

I knew when it was time to move again.

My mother was starting to pack our things,

our bedding, some cooking pots, our food.

I didn't like it when we moved.

It was hard work. We all had to help, even the children.

We carried our things over the mountain to the other place we lived.

Going over the mountain was hard.

I remember how happy I would be when we climbed to the top of the mountain.

I was happy because I could see our other village down below on the other side.

With my little pack tied to my back, full of belongings,

I would run down the side of the mountain.

I was lucky I never fell, it was a steep mountain,

I was tired but somehow had the energy to run,

you know the way children are. I was eager to get to where we needed to go.

I was happy to be home, to be at our other home.

We would not move again for a long time.

That, I was most happy about.

SQUASH UNDER THE BED

There were always crooked neck squash under our beds.

The space under the bed met the criteria of a cool, dark, dry place.

These large, hard skinned squash with speckled and

serrated green and yellow designs shared space under our beds

with new cowboy boots, lost socks and long forgotten toys

not to mention dust and little spiders.

The squash rested under there with our memory of summer,

awaiting winter.

With the cold weather, we split the hard skin and expose the

rich yellow meat inside, the bounty of large seeds entangled in the

wetness of its origin.

We save the seeds for next summer.

We eat the soft, sweet meat of the winter squash.

FRY BREAD

My mom makes lots of it.

Stuffs grocery bags full.

Try and make it last as long as possible.

The greasewood, when it rains you can smell it miles

and miles away, it has the most beautiful smell.

IT HAS NOT ALWAYS BEEN LIKE THIS

The young people

They think it has always been like this.

No. The roads have not always been paved,

They were dirt.

The water didn't run in the house,

If you were thirsty you went to the river.

If you were hungry you cooked outside.

They think it has always been like this,

Run down to the Circle K or McDonald's

To get anything you want.

The river has its own smell, smell the river and it

smells so good. The Verde River smells so good.

WHEN THE GROUND WAS STILL WET

When we talk about our stories,

When the ground was still wet,

I thought we borrowed that from

The White people, Noah's Ark

You know,

But now I know,

Science tells us,

We did have floods here on our land.

I learned this from the Science Channel.

Sprinkle water in the burden basket

and you will smell the place of its origin.

THREE TIMES A DAY

Good ol' beans cooking,

And fry bread.

That's about it.

I love fry bread and beans

Always been my favorite food,

I could eat it three times a day.

That's it.

WINTER SQUASH

A soft clunk, another clunk and another.

My mother takes her small machete-style knife

and rhythmically chips away the hard skin.

She rotates the body of the squash, holding it by

the neck.

They look like a dancing couple.

Facing each other, twirl and chop.

The chop resonates through the thick skin.

The meat of the squash will be steamed until soft.

From there a variety of other possible preparations.

Refried like a vegetable.

Sweetened with brown sugar or panoche from Mexico for dessert.

Mixed with milk is the best!

Desert

"When I come home and see the mountains on both sides of us—the Santan Mountains and the Sacaton Mountains—that says home. When I see the cactus, that says home. Home is also heat, because we come from the desert and I like the heat. It feels good on my skin."

TIM TERRY, JR., AKIMEL O'OTHAM, GILA RIVER INDIAN COMMUNITY

PRECEDING PAGES: Papago Butte, 1999. Craig Smith, photographer.

THE SONORAN DESERT receives approximately eight inches of rainfall a year. Its winter temperatures are mild in the daytime but drop to freezing at night. In the summer, temperatures well over 100 degrees Fahrenheit are the rule. Desert elevations vary between 1,500 and 3,500 feet. As with most deserts, the words hot and dry apply, but the Sonoran is far from barren. The desert supports a rich variety of plants and animals that have adapted to their two seasons of rainfall. One of the most distinctive and important plants is the saguaro cactus that feeds people and animals. For the O'odham people, picking the saguaro fruit in June has been the traditional preparation for the summer rains— violent storms fed from the south in July and August. Winter rains that come from the Pacific to the west and pass the mountain barriers are gentle and may last more than a day. In between these two seasons are dry months, when desert plants, animals and people must call on all of their adaptive skills and knowledge to wait for the next rain.

Desert Ancestors

"My grandfather told me about the ancestral shell-workers. He said this is what we do, the work that we do. We work with shells; this is how they did it." TIM TERRY, JR., AKIMEL O'OTHAM, GILA RIVER INDIAN COMMUNITY

HOHOKAM. *Pendant,* A.D. 650-1100, 1 x 1. Hohokam people carved frogs—animals associated with water—on marine shells. The shells were transported from the Gulf of California and the Pacific Ocean along established trade routes and carved by specialists into pendants, bracelets and rings.

THE HOHOKAM made their home in the Sonoran Desert, an arid land with seven to eight inches of rainfall annually. They made their homes along rivers of central and southern Arizona—the Salt, Gila, Verde, San Pedro and Santa Cruz—as well as in northern Mexico. In ancestral times, the rivers flowed year-round with fish and other aquatic animals and plants.

The ancestors of the Hohokam were hunters and gatherers who moved across the landscape with the seasons. Around A.D. 1, the Hohokam settled into agricultural villages along the rivers and, within two generations, they were building irrigation canals. Over several centuries, the Hohokam learned to build increasingly complex canal systems. At their peak, there were hundreds of miles of waterways; some canals were seven to 10 miles in length, 30 feet wide and 10 feet deep. Hohokam people knew how to keep an even flow of water by calculating elevations and gradients over the course of the waterway—a master engineering feat with the most rudimentary tools.

SALADO. *Belt,* detail, c. A.D. 1300, 2.5 x 20. This belt is made by finger-weaving finely spun cotton. Entire shirts were made with these intricate openwork techniques.

HOHOKAM. *Gila red jar,* A.D. 1100-1250, 11.75 x 13.5. Found in the area of Globe, Arizona, this jar exhibits marks of polishing stones and fire clouds that occur when fuel touches the jar during firing. Some potters today use fire clouds and polishing marks as decorative features on plainware ceramics.

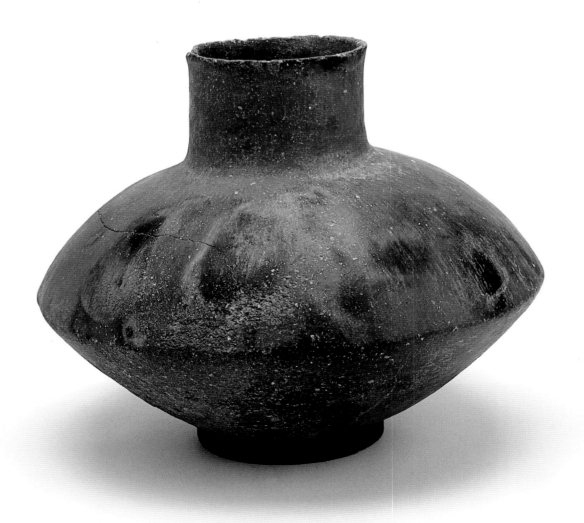

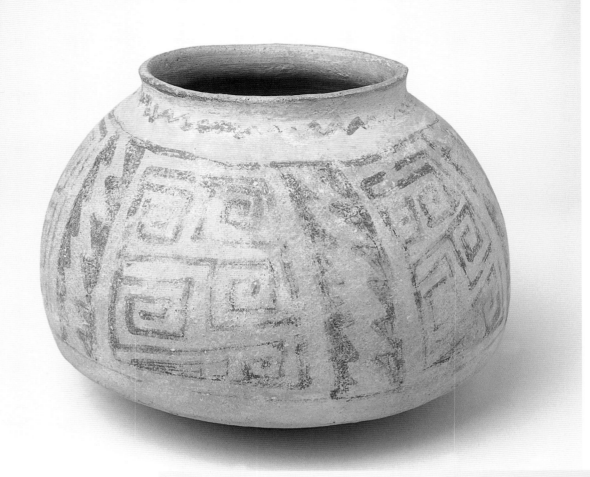

HOHOKAM. *Jar,* A.D. 900-
1100, 7.25 x 9.75. This red-on-
buff jar has designs distinctive
of the Sedentary Period, when
the Hohokam lived in
communities with large
dwellings and plazas.

SALADO. *Jar,* A.D. 1250-
1450, 7.5 x 5.

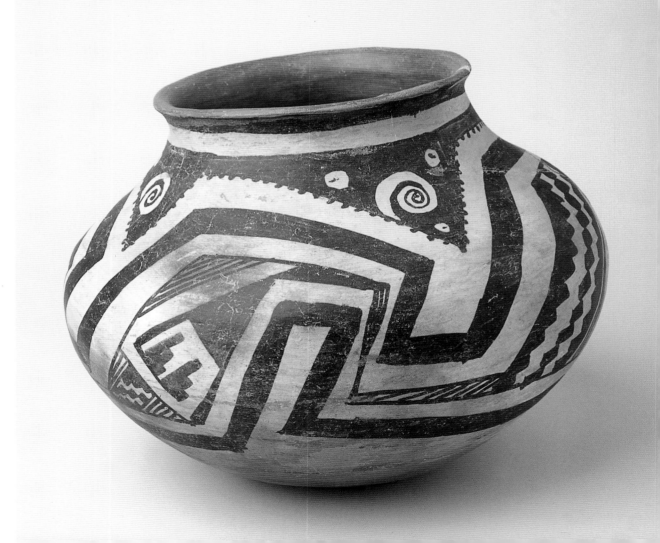

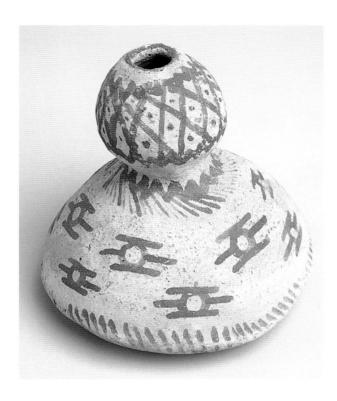

HOHOKAM. *Jar,* A.D. 900-1100, 8 x 5. This unusually shaped vessel resembles a gourd and has some free floating design elements more characteristic of an earlier style of pottery.

These desert farmers planted corn, beans, cushaw and butternut squash, pumpkins, amaranth, gourds and cotton. They encouraged the growth of agave (century plant) and cholla cactus for food sources.

HOMES AND COMMUNITIES From A.D. 1 to 1450, the Hohokam built pithouses. These were single-room, oval-shaped structures with shallow pits and wooden superstructures that were covered with mud and adobe. They clustered the pithouses around a central courtyard. The clusters most likely housed related families. They shared ovens that were pits lined with rocks to bake agave hearts or cholla buds.

While the old-style pithouse home continued, from A.D. 1150 to 1450, people built a second type of home. These homes were above-ground and rectangular. They were made of adobe and also were clustered and walled-in, creating the look of an ancient apartment complex.

Part-time artists and craftspeople worked from their homes making tools and ornaments of shell, stone, bone and clay. These items were traded widely from Mexico to Utah and the Pacific Coast to New Mexico. The Hohokam traded cotton, crops and shell jewelry for raw materials such as turquoise and obsidian or for exotic goods from Mexico such as macaws and copper bells.

The Hohokam villagers were successful farmers, with time to build structures beyond basic homes for everyday living. They built monumental structures called platform mounds and a few multistory adobe towers with multiple rooms. These non-residential structures required combined labor of many people for many hours.

Social or religious class distinctions are suggested by the walling in of structures, the existence of two types of residences including pithouses and above-ground complexes, and the use of exotic materials—colorful feathers, turquoise mosaic and worked marine shell—to indicate social status.

COLLAPSE OF LARGE VILLAGES Some estimates of population for the Hohokam reach 50,000 or more. Around A.D. 1450, the Hohokam moved away from their villages along the Salt and Gila rivers and the Tucson basin. Most likely, a combination of factors contributed to the collapse including internal conflict triggered by environmental pressures. Floods in the late 1300s may have damaged canal systems that supported large numbers of people. Akimel O'otham oral traditions tell of how their ancestors overthrew the rulers of the platform mound villages, suggesting social unrest. Warfare and migrations help explain the dramatic drop in population and change in settlement between A.D. 1400 and 1700. Some Hopi clan migrations describe people coming from the south.

THE HOHOKAM CANAL SYSTEM Today, as in the past, canals play an important role in desert life. The ancestral desert people, the Hohokam, were building canals by A.D. 50. By A.D. 600, there were large irrigation systems on both sides of the Salt River. In what became a highly developed canal system, main canals fed into smaller lateral channels, which fed into the fields. By A.D. 1150 to

1450, known as the Classic Period, there were more than 300 miles of main canals in the Salt River Valley alone. Individual canals could extend to more than 20 miles in length and serve many separate communities. Large canals were more than 30 feet wide and 10 feet deep. The Hohokam dug canals using wooden and stone tools.

Even though the Salt River flowed freely, the amount of water available for canal diversion may not have accommodated all of the Classic Period canals at once. By A.D. 900 to 1150, the Hohokam had built a number of major towns along their canals, located at roughly three-mile intervals. These towns were political and religious centers. If a canal had only one major site on it, that site tended to be located at the midpoint, three miles from the source of water and three miles from the end of the canal. There is evidence that during later periods, an elite group living in major villages and towns controlled the canals. It is possible that the entire Hohokam area was under the control of centralized leadership residing in the major towns.

Maricopa FOLLOWING THE GILA RIVER TO HOME

THE ORIGINAL HOMELAND OF THE MARICOPA was along the Colorado River with other Yuman-speaking people. Beginning in the 1600s, warfare among Colorado River groups pushed the Maricopa and others to move east up the Gila River. By the 18th century, they had formed a defensive alliance with the Akimel O'otham (Pima) to defend their new homeland. By the mid-1800s, the alliance was an important defense for settlers and an aid to the military fighting the Apache. The Maricopa farming heritage fit well with the Akimel O'otham as long as the Gila and Salt rivers ran. When the water was taken away, wage work in nearby urban areas became a source of revenue. Today, the Maricopa have informally clustered in specific areas of two predominately Akimel O'otham communities. At the Gila River Indian Community, Maricopa people live on the west side around the town of Laveen. At the Salt River Pima-Maricopa Indian Community, Maricopa people live on the south side of the Salt River around the town of Lehi.

In the past, many Southwestern Native people needed some knowledge of three or more languages—their Native language, Spanish and English. The people generally known as Maricopa are Piipaash or Pee Posh in their language. The latter is the preferred spelling at the Gila River Indian Community.

Maricopa families remain a community within the larger Akimel O'otham communities. They continue their family ties to relatives along the Colorado River. They also have continued the tradition of bird singing, rooted in traditions of the Colorado River people. Their traditional clothing, worn for special social and ceremonial occasions, echoes that of other Yuman peoples.

"All our uncles and their families lived at our grandparents' place in small houses. In the daytime, everybody would go to work, and all the women would fix a big meal. We had tables under a big cottonwood tree by the house. Every evening, family dinner was like having a big community feed, but it was just a family dinner. After dinner, we'd all sit and talk, and the kids would play. People from the community would come by and talk about the news going on, who did what and who got seen doing this and that, all kinds of stuff."

RON CARLOS, PIIPAASH, SALT RIVER PIMA-MARICOPA INDIAN COMMUNITY

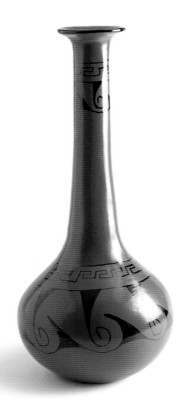

BARBARA JOHNSON (1923-1997), PEE POSH. *Vase*, 1985, 19.5 x 9. "Long-neck vases are really hard to make. From the neck on up, you have to stop between different coils because it takes a little bit longer for it to harden. Smoothing it is a little bit more delicate, too, because you have to be careful of getting hairline cracks along the neck. The designs on the pots are for water. The scroll design is also known as a water design." Dorothea Sunn-Avery, Pee Posh.

"When I think of home, we had our own orchards with pomegranates, oranges, plums and apricots, a whole orchard of trees. We'd grow our own plants, squash and beans. Everything was just green around us, and we had lots of water. Nowadays, you can see dry fields, the roads are dry, and there's nothing around. It's just barren looking, and it wasn't like that when we were growing up."

RON CARLOS, PIIPAASH,
SALT RIVER PIMA-MARICOPA
INDIAN COMMUNITY

MARICOPA. *Jar,* 1880-1915,
14.75 x 10. Gift of Jeanie and
Joseph Harlan.

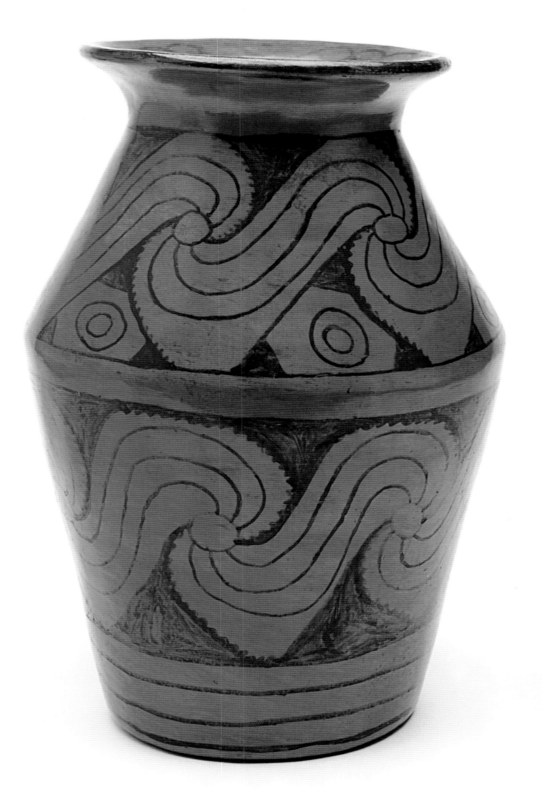

"The special foods my grandmother made were beans and popovers. She used to boil little quail eggs for me. When I was young, there was no candy or gum, so sometimes grandmother and I would look for a little hole in the ground where bees had left little pockets of honey. She would dig and maybe find four or five pockets. She would clean around a pocket and open the top for me to drink. That was my candy. My grandma did a lot for me. When she passed away she was 105." ELISSA PERCHARO (TH-A-NOV), PEE POSH

"My great-grandfather had his ranch area near Lehi, which he ultimately gave to the Mormons. He was here when the Mormons came. He translated Spanish for them and the O'odham and Piipaash. The Piipaash worked for him. He was Tohono O'odham, and he came up from Caborca via Ajo because the Federales were killing all the O'odham down in Mexico. His family was left behind and they were killed." GARY OWENS, PIIPAASH/TOHONO O'ODHAM, SALT RIVER PIMA-MARICOPA INDIAN COMMUNITY

MARICOPA POTTERY The history of Maricopa pottery is one of successive revivals, as pottery transformed to serve the home differently. Traditionally, Maricopa pottery was used in the home for cooking and for the storage of water and grains. When metal utensils replaced pottery in the late 1800s, potters decorated their work and sold it primarily to tourists visiting the Phoenix area. During the early 20th century, potters found that falling prices did not repay the hours of work they invested. A potter might sell a small piece to a trader for 5 cents, and the piece would be resold for 20 cents. In the late 1930s, potters formed the Maricopa Pottery Cooperative with the goal of raising the quality of work and commanding higher prices. Today, there are approximately eight Maricopa potters. The Pee-Posh Project is working to generate interest among young Maricopas in the pottery tradition.

MARICOPA. *Effigy jar (detail)*, early 1900s, 13.5 x 9 x 8.

HOPE FOR THE FUTURE

"Back when I was going to school, it was the 'in thing' not to be Indian. A lot of the light-skinned Indians would say, 'Oh, I'm Mexican, I'm Italian.' Those of us who were dark skinned like myself, they would criticize us and make fun of us because we talked 'too chiefy,' as they would say. But it's not like that now. Nowadays, the young people grow up with culture; it's not considered something that's bad. I'm hoping that these ones who go to school and become doctors and lawyers, or whatever, that they have that cultural aspect in their minds. Only time will tell. It depends on the older folks to try to teach them. But, ultimately, it's going to be their choice. I have more hope with the youngest ones, because they're more exposed to culture than the teenagers. In Head Start, they start teaching them culture. Before, they weren't doing that. So by the time they get into high school, they should have received a lot more culture and language than anyone. I'm hoping they will have that in their minds and be able to keep the traditions and our culture in the community going." RON CARLOS, PIIPAASH, SALT RIVER PIMA-MARICOPA INDIAN COMMUNITY

Red Mountain, 1999. Craig Smith, photographer.

"There in Maricopa Colony [at Gila River Indian Community], everybody always identifies me as coming from Fort Yuma. Fort Yuma people identify me as coming from Maricopa Colony. Wherever I go—different places, meeting relatives—it feels good. It feels like they're part of my home."

YOLANDA HART STEVENS, PEE POSH/QUECHAN, GILA RIVER INDIAN COMMUNITY

"We had relatives who used to make pottery. We'd go up to Red Mountain and make a big picnic and dig in little areas where there was red clay. We'd go up there and spend the day at the river and swim around or go hunting."

RON CARLOS, PIIPAASH, SALT RIVER PIMA-MARICOPA

INDIAN COMMUNITY

MARY JUAN (1920-1972), MARICOPA. *Pitcher*, c. 1950, 13 x 7. "Mary Juan did pottery that was thin and really delicate. Making this style of pottery is really hard to do with this handle on it. The handle has to be made and then allowed to dry, to harden a little bit, and then has to be remoistened to put on each end. Everything else is polished with the rock. The two saps of the mesquite tree make the black design. Right along the lip is an arrow, and right along the bottom there is an arrow. A long time ago, a lot of Maricopas used the arrowhead design. Later, Mary Juan and Ida Redbird and my grandmother, Mable Sunn, all used it." Dorothea Sunn-Avery, Pee Posh.

MARICOPA. *Bowl*, c. 1900, 5.25 x 11.25. Gift of Mrs. Vincent Sweet.

Tammi and Frances Kisto, Akimel O'otham, 2004. Gloria Lomahaftewa, photographer.

"My grandmother would bake bread in the ashes of the fire and make chili, that's what I enjoy. We would eat from pottery bowls that we would buy from the Maricopas."

FRANCES KISTO, AKIMEL O'OTHAM, SALT RIVER PIMA-MARICOPA INDIAN COMMUNITY

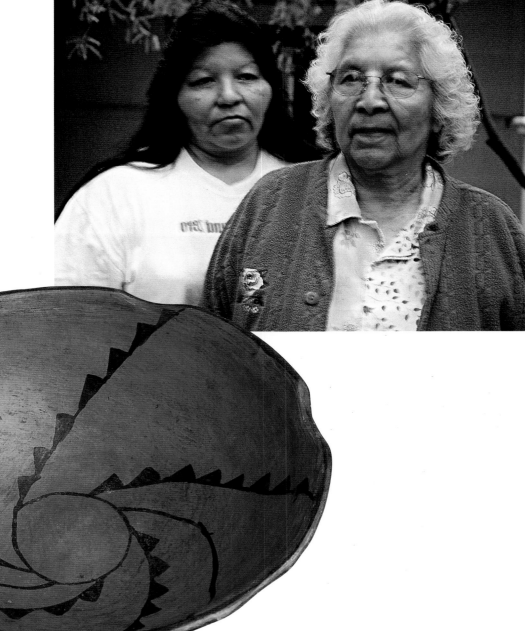

AKIMEL O'OTHAM TRADITIONAL LANDS are along the Gila River. The river was strong and wide, and the Akimel O'otham farmed in the river's floodplains. In addition to irrigated crops, the Akimel O'otham also hunted and gathered desert foods such as mesquite pods, saguaro fruit and cholla buds. Their farms produced enough food for families to live in year-round villages. Although Spanish influence in Akimel O'otham lands was limited, by the late 1600s Spanish-introduced wheat became an important crop. When the westward expansion began, the Akimel O'otham farms were major suppliers of food for the military and wagon trains. During the 1700s and 1800s, the Akimel O'otham were the subject of raiding parties from Colorado River groups to the west and Apache to the east. The Akimel O'otham were successful in repelling raids and were allied in these battles with the Maricopa, a Colorado River people who had settled in O'otham lands after being driven from their original land by warfare.

AKIMEL O'OTHAM. *Miniature baskets*, early 1900s, largest is 6.75. These miniatures have geometric designs that are identical to those on full-size baskets. Akimel O'otham miniature baskets were especially popular with collectors during the 1920s and 1930s. Maie Heard collected more than 200 miniature Akimel O'otham baskets. Fred Harvey Fine Arts Collection.

"Well, we always tell the children, when you see Red Mountain, you're home. Once you see that Red Mountain, then you're home. This is your land. This is your home, it's just not this reservation. It's not this little boundary, no. The birds have told you this is your land. They sing about these songs. You have songs for all these mountains here. But when you do see Red Mountain, that's the important one." GARY OWENS, PIIPAASH/TOHONO O'ODHAM, SALT RIVER PIMA-MARICOPA INDIAN COMMUNITY

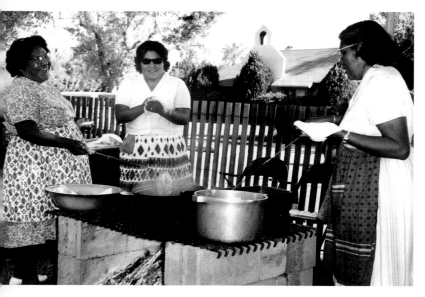

"If you look at the village in Ak-Chin, there's only one way coming in either from the east or west. If you know about Ak-Chin, you know that many of the families in that area live in clusters of families that are related in one way or another throughout the community in the old village area."
ELAINE PETERS, TOHONO O'ODHAM/AKIMEL O'OTHAM, AK-CHIN INDIAN COMMUNITY

Pima (Akimel O'otham) popovers being cooked at the fairgrounds, Salt River Pima–Maricopa Indian Community, 1950s.

SCENTS AND FLAVORS OF HOME

"My grandmother made biscuits that they called cowboy bread. It's just cooked in a pan. She also made lemonade from scratch. It was so good eating outside under our ramada, or what we call the vato. I really enjoyed just having the family sit down to eat and watching the moon or stars come up, smelling the food, my grandmother's lemonade and her cowboy bread."
TIM TERRY, JR., AKIMEL O'OTHAM, GILA RIVER INDIAN COMMUNITY

They Call us Pima, but that's not our real name. Our real name is
Akimel O'otham, which means the River People."

TIM TERRY, JR., AKIMEL O'OTHAM, GILA RIVER INDIAN COMMUNITY

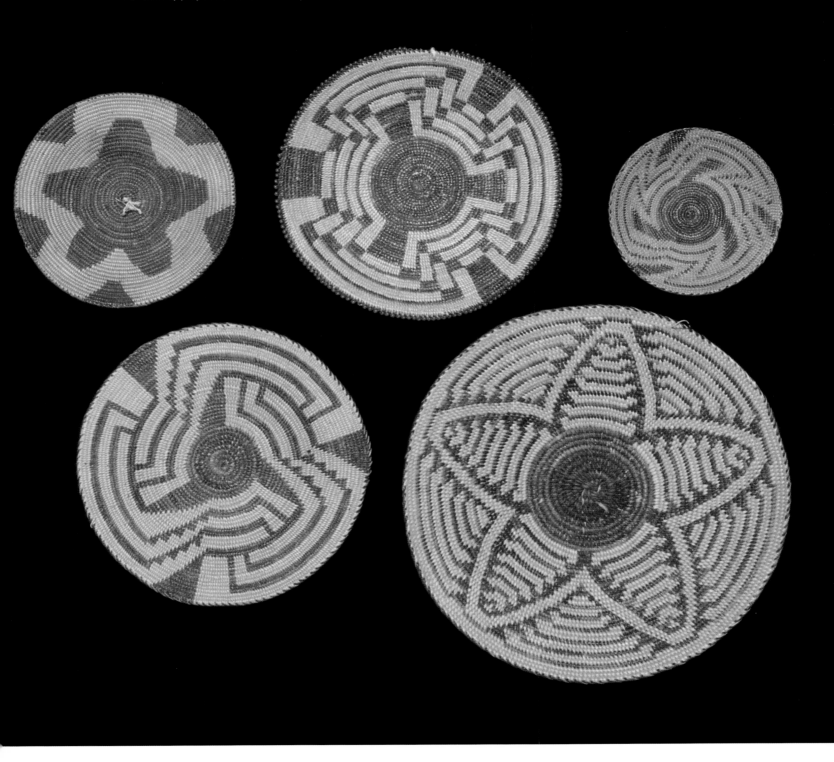

"Morning, afternoon, evening, everyone used to be outside cooking. Everybody really recognizes the 'village smell,' as we call it. When the rains come are the best times—smelling the wet dirt—it smells so clean and fresh. I think that is just so much of where I come from, our land, that it makes me feel healthy in some ways. Then you start all over again— facing the heat. Those are some of the smells that remind me of home."

ELAINE PETERS, TOHONO O'ODHAM/AKIMEL O'OTHAM,
AK-CHIN INDIAN COMMUNITY

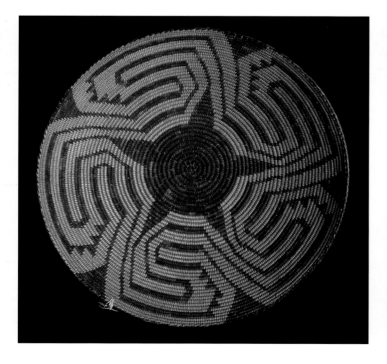

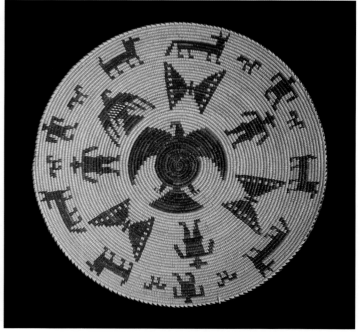

"My grandmother made menudo out of wheat. She would pound it 'til the husks came off, and then she boiled it with soup bones and brown tepary beans. Then she made popovers with wheat flour. She baked her bread in the ashes of the fire when it had just the coals on top. She'd smooth the surface with a pan and put her bread in there and cover it up with the ashes and the coals on top. When it's done, the ashes will crack here and there. She'd take it out, clean it up and put it in a basket. We'd put chili in some water and then dip the bread in."

FRANCES KISTO, AKIMEL O'OTHAM, SALT RIVER PIMA-MARICOPA INDIAN COMMUNITY

FAMILY AND COMMUNITY Unlike their desert relatives, the Akimel O'otham could live in one community year-round. People built their homes near family members, and several extended families formed a community. The Akimel O'otham lived near the growing urban area of Phoenix and near the Southern Pacific Railroad's first station in the town of Maricopa. A branch line was later built to Phoenix. The Gila River Indian Community was the first reservation in Arizona, established by an act of Congress in 1859. By 1870, more Anglo farmers were drawing water from the Gila River, leaving too little for O'otham farmers. When a drought made conditions even more difficult, some O'otham and Maricopa moved to farm along the Salt River, where a reservation was established in 1879. Since that time, water rights were the subject of ongoing litigation that was finally settled in 2004. The Ak-Chin Reservation—composed of Tohono O'odham and Akimel O'otham and some Yaqui residents—was established in 1912. The close proximity to the expanding cities of Phoenix and Scottsdale has presented both problems and opportunities related to choices about development or preserving a rural lifeway. Casinos, resorts and business parks provide income for communities. At Gila River and Ak-Chin, farms are once again proving profitable, and the Ak-Chin Community does not require any federal assistance.

"Family has always been a part of my life, my mom, my dad, my sister, they've always been a part of who I am. Family now has kind of gone into the nuclear idea of family, just mother, father, sister. Life is changing so fast that we forget that we have our relatives, our cousins, our grandparents. In the O'otham way, your first cousins are your brothers and sisters; your grandparents' siblings are your grandpa and your grandma, too. Family is actually your whole community. It's a part of who helped to raise you." TIM TERRY, JR., AKIMEL O'OTHAM, GILA RIVER INDIAN COMMUNITY

"Language is really important in our community. Not very many people speak the language. Not very many people were taught the language. But it's up to us whether we're going to learn the language or not. I speak some; I understand more. One of the reasons why people don't speak it a lot is because they're afraid that they might say something wrong, or say it in the wrong way, because language has changed a lot, too. The old language is totally different than our O'otham language now. If you listen to our music and our songs, it's different, too. So, it's kind of hard to interpret, but we can if we just listen to it." TIM TERRY, JR., AKIMEL O'OTHAM, GILA RIVER INDIAN COMMUNITY

"When we were small, O'otham was the only language we learned. They'd tell us about all the legends. And we would sit there and listen. Sometimes we fell asleep before they got to the end. When we did that, they'd make our faces black, 'cause they believed that when somebody goes to sleep that shows they weren't listening. We talked O'otham until we went to school. I was 6 years old. My grandfather led me down the road to take me to school. That's where we learned how to talk English. These days I look back, and it was good that they taught us English, but I would like to have the people learn more about O'otham. There's a lot of us trying to teach it." FRANCES KISTO, AKIMEL O'OTHAM, SALT RIVER PIMA-MARICOPA INDIAN COMMUNITY

TIM TERRY, JR. (B. 1965), AKIMEL O'OTHAM. *Calendar stick,* 2004, 55.5 x 1. "A calendar stick is like a diary—a way of recording your life in a form that you can share with other people. Each stick is different. Each stick is personal, so each one is decorated and presented in the way the person feels that they want it to be presented. This is a replica I made of older ones. We were very fortunate that we had three elderly gentlemen keep a record of their sticks on a piece of paper, and it was shared with the community. This calendar stick is made out of cactus rib." Tim Terry, Jr. Inset is a detail of the calendar stick that recalls the years 1856 to 1859. The figure on the bottom left segment is a reminder of an 1859 meteor seen by the Akimel O'otham.

AKIMEL O'OTHAM. *Basket,* early 1900s, 6.5 x 9. This basket has qualities that make it prized by collectors. Unlike the older utilitarian baskets, it has a flat base, convenient for placing on a desk or end table. It also has extremely fine stitching, with 18 stitches and nine rows per inch. Fred Harvey Fine Arts Collection.

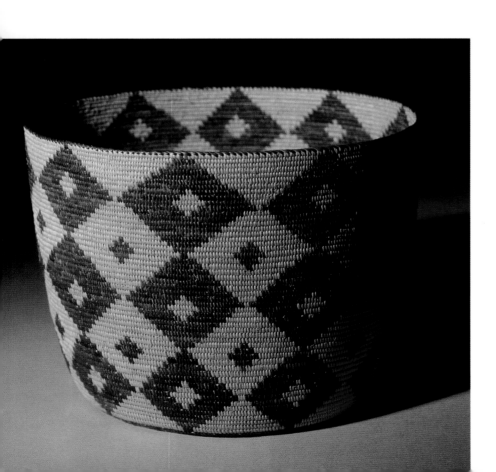

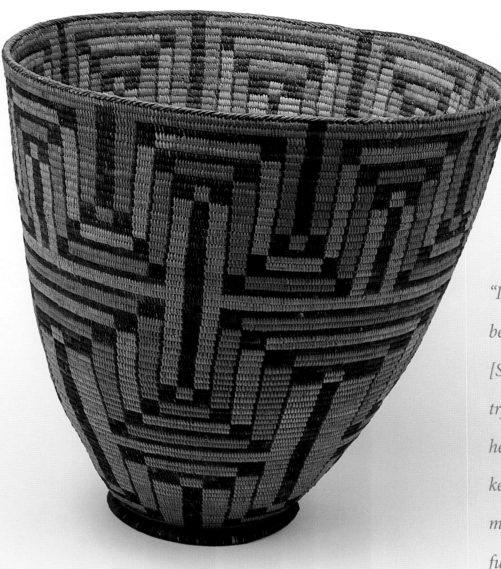

AKIMEL O'OTHAM. *Basket,* 1920s-1940s, 19 x 18.5. The weaver of this basket created a variation of the squash blossom design on a large, vase-like basket. Usually, the design is worked on a fairly flat basket; creating the design on this shape would have been quite difficult.

"I think our tribe is going to change because we're on the city's [Scottsdale's] boundaries. We have to try to do what we can to use that to help us get by. Although we can still keep our cultures, I'd hate to see too much change, but the future is the future, and if we don't change with it, then we're going to be swallowed up."

TAMMI KISTO, AKIMEL O'OTHAM, SALT RIVER

PIMA-MARICOPA INDIAN COMMUNITY

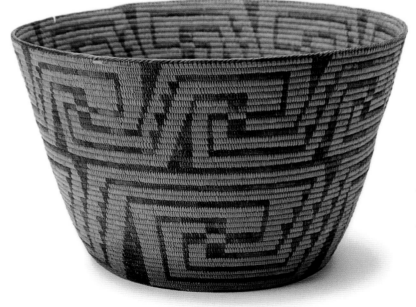

AKIMEL O'OTHAM. *Basket,* early 1900s, 10.625 x 16.75. Fred Harvey Fine Arts Collection.

Tohono O'odham HOME IN THE DESERT

THE TOHONO O'ODHAM traditionally occupied approximately 24,000 square miles of the Sonoran Desert in southern Arizona and northern Mexico. Their desert home is studded with volcanic mountains. Baboquivari Peak, a 7,000-foot-high mountain, is at the heart of the homeland. The O'odham knew how to live in a place that received less than eight inches of rain annually by moving between winter "well" villages in the foothills and summer "field" villages at the mouths of streams created by run-off from the rains. The O'odham traditionally harvested saguaro fruit and conducted ceremonies that brought summer rains and began their new year. In the far west of O'odham lands, the Hia Ced O'odham knew how to live in the driest desert by moving among the small water sources, hunting wild animals and gathering the few plants that could live in the dunes. Today, the Tohono O'odham Nation is the second largest reservation in the United States, approximately the size of the state of Connecticut. Sixty-four miles of the International Border run through traditional O'odham land. Once this was not a major problem, but as the border has become more closely guarded, it is increasingly difficult for O'odham on both sides to stay connected.

Danny Lopez, Tohono O'odham, 2004. Gloria Lomahaftewa, photographer.

"*Being a desert person, I always liked to smell the dampness when wind comes before the storm. And after the storm, you have that damp smell of the earth.* That damp smell of the earth always reminds me of our community and the desert. *After a good rain, you can smell that fresh creosote smell; creosote is a medicine for us. We use it in different ways. I always love those two smells.*" DANNY LOPEZ, TOHONO O'ODHAM

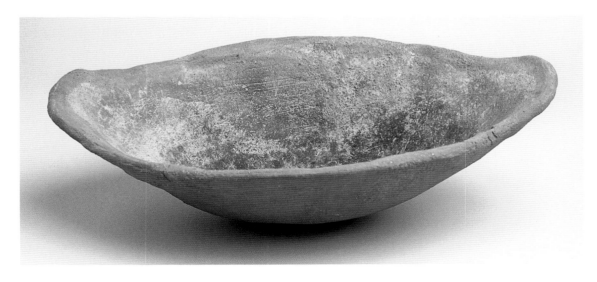

TOHONO O'ODHAM. *Bowl,* 1940, 3.5 x 14. This is a parching bowl used for roasting wheat.

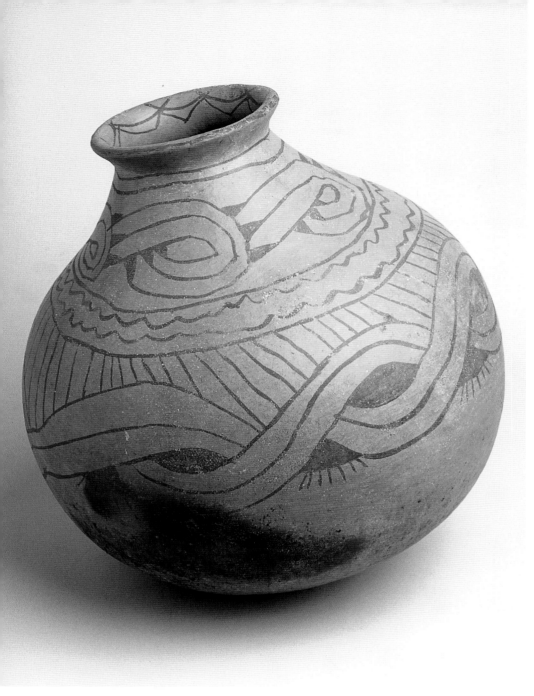

CLOCKWISE FROM TOP: TOHONO O'ODHAM. *Wine jar,* c. 1930, 12 x 13. The design on this jar is sometimes described as a wave motif by Maricopa potters.

TOHONO O'ODHAM. *Wine basket,* c. 1900, 9.75 x 18. During the rain ceremony, this type of basket is used to hold the saguaro wine. Poems of rain are recited over the wine. The men of the village sit in a circle and take turns drinking from the baskets until the baskets are empty. The baskets are so tightly woven that they can hold liquids.

TOHONO O'ODHAM. *Basket,* 1974, 4 x 14.5. This basket is made entirely of devil's claw, a difficult material to work with but one that is very tough. Gift of Mr. and Mrs. Glenn E. Quick, Sr.

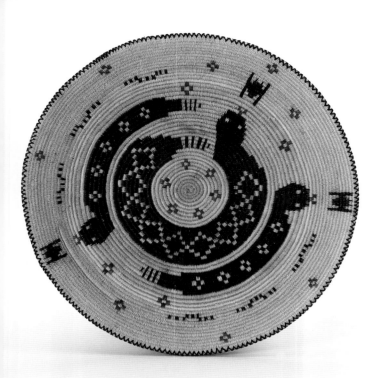

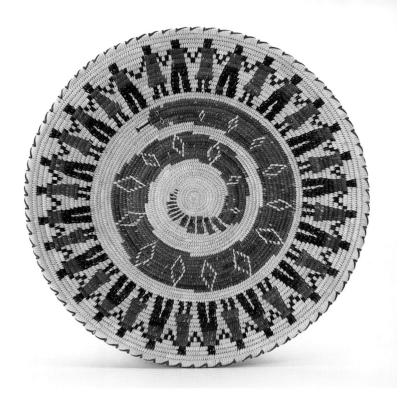

"In my homeland, there are mountains that are sacred to us. Baboquivari Mountain is a significant place for all O'odham, because that's the home of our ancestors and our Creator. Everything in our creation story is geared to this mountain."

JOE JOAQUIN, TOHONO O'ODHAM

"The mountain that is significant to our community of Gu Oidak, Big Fields, is called Giho Do'ag, Burden Basket Mountain. Like most villages, we claim a mountain. It is the place where people used to gather saguaro fruit. Certain families would go to the base of that mountain to camp for several weeks to gather the saguaro fruit. Some of our men used to go up that mountain to hunt the mountain sheep and the deer and the javalina. In some of our ceremony songs, we sing about Giho Do'ag, and we also have social songs about it." DANNY LOPEZ, TOHONO O'ODHAM

"You're still O'odham, no matter what you have, how much education you've got, you're still O'odham, and you have to believe in some of the things that our grandparents, our ancestors, left behind for us to carry on. How many people really know the Tohono O'odham? They say, 'Oh, yeah, you're Papago.' No, I'm not Papago."

JOE JOAQUIN, TOHONO O'ODHAM

LANGUAGE In 1986, O'odham language came to the forefront when the Tribal Council authorized an official name change from Papago to Tohono O'odham, the name the desert people had always called themselves. The word "Papago" is supposed to have derived from the Spanish period as a corruption of a word meaning "bean eaters."

"We have five different dialects in the O'odham country, but we can understand each other." JOE JOAQUIN, TOHONO O'ODHAM

ABOVE, LEFT: ATTRIBUTED TO BETTY ELIZABETH, TOHONO O'ODHAM. *Basket*, 1970s, 1.12 x 8.75. This basket is made of horsehair. Designs worked in horsehair have a sharp, crisp appearance that lends itself to pictorial representations. Gift of Mr. Michael Mulberger.

ABOVE, RIGHT: MARY THOMAS, AKIMEL O'OTHAM/ TOHONO O'ODHAM. *Bowl*, 1981, 2 x 10.5. "Mary Thomas is a well-known leader and is known for doing miniature baskets. She does a lot of special designs. This particular piece has a snake in the middle with a friendship dance depicted. Mary is a very friendly, happy person with a lot of positive energy, and you can see that in her work." Terrol Dew Johnson, Tohono O'odham. Gift of Mrs. Mary Coughlin.

"The elderly were having a gathering, and somebody asked them what they wanted for lunch. They said, 'We can get you some rabbit—traditional food.' Some lady said, 'No, we want steaks. Steaks! Back then all we had to survive on was rabbit. Now we've got all these other choices, so we want steaks.'" JOE JOAQUIN, TOHONO O'ODHAM

"We need language to tell our stories. We need our language in our ceremonies. It's not just the singing; certain parts of speeches have to be made in the language. It's kind of like a person's heart. You need your heart to survive. When your heart stops, you're dead. And it's the same thing with the language, because it is our heart. It's what keeps our culture alive."
DANNY LOPEZ, TOHONO O'ODHAM

Joe Joaquin, Tohono O'odham, 2004. Gloria Lomahaftewa, photographer.

FAMILY AND COMMUNITY Extended families were once at the heart of community for the O'odham. Elders remember a time when the nearest homes belonged to family members. Each village had a community building where people gathered to discuss community affairs and hold ceremonies.

Even today, some elders find the modern arrangement of houses along a paved street, dictated by the installation of water and sewer lines, to be odd. In the 20th century, the Tohono O'odham pursued cattle ranching, and some worked in the growing Tucson area and in mines around Ajo. The first Tohono O'odham Reservation, established in 1874, centered around the mission church of San Xavier del Bac, followed shortly by the main reservation in 1916. Small land parcels are located near the Arizona towns of Florence and Gila Bend. The government began digging wells on the Tohono O'odham Reservation in 1912, establishing a year-round source of water, and communities clustered around these wells.

In 1996, community members formed Tohono O'odham Community Action (TOCA), a grassroots organization dedicated to cultural revitalization, community health and sustainable development. Community health projects focus on reintroducing native foods as a way to combat diabetes, which affects nearly 70 percent of the community.

While ranching continues to be important, in the past several years the O'odham have capitalized on its proximity to Tucson and Mexico to establish an industrial park, foreign trade zone and casino. Tohono O'odham Community College opened in 1996.

"Years ago, families all stuck together. In my own family we always worked together as we chopped or picked cotton. Even in the village on Sundays when we went to church, we walked together as a family—my late parents and my sisters. After church, we'd come back together, and mother would cook something, and we'd sit under the ramada around the table and eat together. I often think of that as being a family."
DANNY LOPEZ, TOHONO O'ODHAM

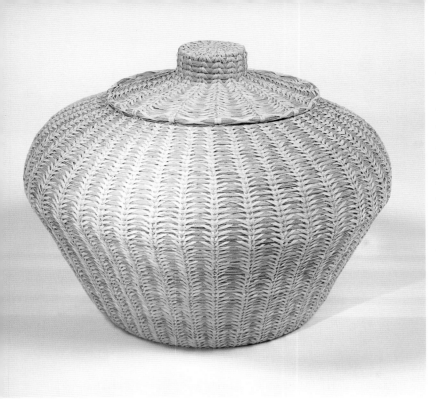

TOHONO O'ODHAM. *Basket with lid,* 1974, 17.5 x 13 x 23. This basket is made with a split-stitch that exposes the underlying foundation material of the coil. "There is more to this basket than first meets the eye. The weaver completed one full coil by weaving in one direction, then returned in the opposite direction to place an additional stitch. This basket is a descendent of the large grain storage baskets. It takes the same techniques and refines them." Terrol Dew Johnson, Tohono O'odham. Gift of Mr. and Mrs. Glenn E. Quick.

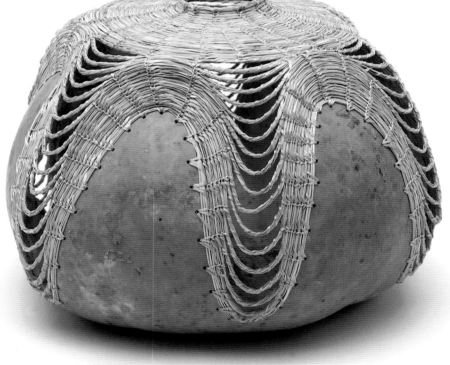

TOHONO O'ODHAM. *Martynia,* c. 1980, 10 x 14.5. Martynia or devil's claw pods are hooked together in a convenient bundle that preserves their tips and can be easily stored.

Jennifer Martin and Terrol Dew Johnson harvesting martynia, 1999. Craig Smith, photographer.

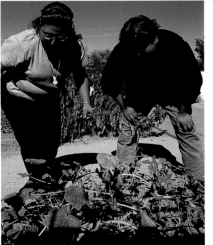

TERROL DEW JOHNSON (B. 1971), TOHONO O'ODHAM. *Basket,* 2001, 13.75 x 15.25. "This basket is one of my contemporary pieces. This was made with a gourd as a base and bear grass for the top. I do traditional and contemporary work. This reminded me of ripples of water. When you drop a stone in the water, the water comes up, but it also ripples." Terrol Dew Johnson.

"In tribal tradition, a person who nurtures the community spirit is a practitioner of O'odham Himdag—the desert people's way. Our elders expect us to take responsibility for creating a healthier, stronger world." TERROL DEW JOHNSON, TOHONO O'ODHAM

DESERT FOODS The Sonoran Desert contains many wild plant foods used by both the Hohokam and O'odham for centuries. The Hohokam ate several varieties of cacti including the saguaro, cholla, prickly pear and hedgehog. Usually, cactus fruit was the most commonly eaten part. Agave and cholla cactus remains have been found in quantities at some Hohokam sites, suggesting that they were transplanted and deliberately grown as food sources.

Over the centuries, the O'odham became masters at gathering desert plant foods, collecting 375 species in a complex pattern year-round. Some plants could only be utilized for a short period of time or were available only in certain locations, or they could be processed and used only in special ways. The key to desert subsistence is to find major food resources at different times of the year.

For the O'odham, one of the most difficult periods in the Sonoran Desert was the early spring before most plants had produced seeds or fruit. At this time, the buds of the cholla cactus were a valuable food rich in protein and calcium. These very prickly buds are picked with a pair of tongs. But it is the saguaro that has great symbolic meaning for the O'odham. Its fruits ripen during one of the driest, hottest and leanest months of the year. In the past, the ripening of the sweet fruit in late June and early July meant an end to hunger and the coming of the summer rainy season.

At one time, another important food source for the O'odham was the mesquite tree. When the Gila River still flowed, woodland groves of mesquite grew in its floodplain. The seed pods developed in midsummer, providing a carbohydrate-rich food. The mesquite also has an edible flower, which was picked as a delicacy in the early spring.

Today, organizations such as Tohono O'odham Community Action are working to decrease the high incidence of diabetes by teaching the benefits of traditional foods.

"We cooked and dried cholla buds, and we stored them away. So, come wintertime, when there was not much, that's what we relied on until about April, when the foods came back." DANNY LOPEZ, TOHONO O'ODHAM

"All year-round, we were watching where the wild things grew so we could pick them. Elder Brother (Creator) planted those things for us. He told us where they are and how to cook them. Those are the good foods." CHONA, TOHONO O'ODHAM

"My favorite foods are cholla buds and all the fruits from the cactus that we used to eat. There's a few that still go out and get the mesquite bean. You pound it until it makes a sweet flour that you can put in water and drink. Those were the things that I grew up with, and I miss those things sometimes." JOE JOAQUIN, TOHONO O'ODHAM

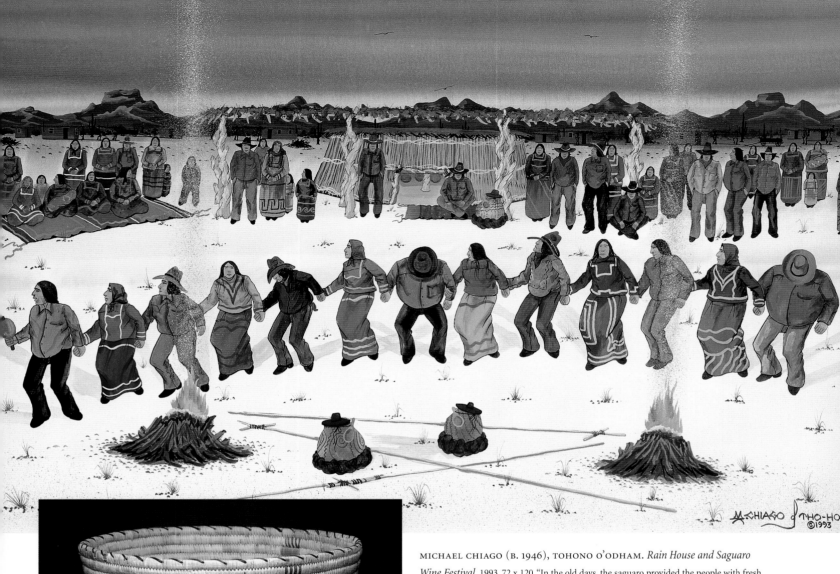

MICHAEL CHIAGO (B. 1946), TOHONO O'ODHAM. *Rain House and Saguaro Wine Festival,* 1993, 72 x 120. "In the old days, the saguaro provided the people with fresh fruit, syrup and a cake made from the seeds. The syrup-making process produces a juice, which ferments for three days in the rain house under the care of the Keeper of the Smoke, the village headman and ceremonial leader. Rain songs are sung, and men and women dance at night. At noon of the third day, the headmen gather to recite poems over the baskets of wine. The men of the village sit in a circle and pass the baskets until they are drained. The planting of crops takes place after the wine festival to make use of the rains that are bound to follow. Today, many families still prepare the saguaro wine for their own use, and the custom to cover the wine with a song continues; anyone who accepts a drink of the wine recites a poem, which invariably relates to clouds or rain." Michael Chiago.

TOHONO O'ODHAM. *Basket,* 1960s, 12.5 x 14.5. A woman is picking fruit from a saguaro cactus on this basket. Basketry depictions of this important cultural activity called pulling down the clouds are fairly common. Gift of Mr. and Mrs. Byron Harvey III.

BAPTISTO LOPEZ, TOHONO O'ODHAM. *Fruit picking stick,* c. 1974, 203 x 9. In the Tohono O'odham language, this is called a kui'pad. It is more than six feet tall and made of saguaro ribs.

Ha:san Bak masad ~ June

Saguaro moon: The new year begins with the harvesting of the saguaro fruit.

Jukiabig masad ~ July

Rainy moon: Summer thunderstorms and the planting of corn, beans and squash begin.

Sopol Esabig masad ~ August

Short planting moon: Final time for planting crops.

Wasai Gak masad ~ September

Dry grass moon: Summer rains end and the grass quickly turns brown. Crops are ripening.

Wi'ihanig masad ~ October

Moon of persisting: The drought-resistant crops have gone into final maturation and ripening in the dry fall seasons.

Ke:g S-Hekpjig masad ~ November

Moon when it is getting good and cold: A time for the hunting of wild game.

Edg Wa'ugad masad ~ December

Inner backbone moon: The backbone of winter, coldest time of the year.

Gi'ihodag masad Uiwalig masad ~ January to early February

Time when animals have lost their fat and time when they mate.

Ko:magi masad ~ February

Gray moon

Ce:dagi masad ~ March

Green moon: Plants and tree buds begin to bloom.

Oam masad ~ April

Yellow-orange moon: A time of beautiful desert wildflowers.

Kai Cukalig masad ~ May

Moon of the black saguaro seeds: The saguaro fruit is ripening.

THE TRADITIONAL CALENDAR The traditional Tohono O'odham calendar reflects the relationship of the O'odham to the Sonoran Desert homeland. The "new year" was marked by the ripening of the saguaro fruit in late June. The lunar months were named for the state of the various plants or the activities of the season. The Akimel O'otham calendar was similar but traditionally did not have 12 "months;" it had a set of named seasons.

O'ODHAM BASKETS The materials, designs and uses of O'odham baskets tell a great deal about their makers and the distinctions between their river and desert homelands. Historically, baskets were utility containers in households. They were used to gather, parch, winnow and store grain, seeds and desert foods. They held liquid for daily use and ceremonies. The burden baskets carried many kinds of loads including firewood and pottery containers. Traditionally, the majority of baskets were made by the time-consuming coiling process. Older O'odham baskets from the 19th and early 20th centuries were made of willow, with geometric designs in devil's claw.

During the early 1900s, the tourist market for baskets became a source of income for O'odham families. Akimel O'otham basketmakers were closer to the larger urban areas than Tohono O'odham in the desert. Tourists and collectors wanted baskets with flat bases that could sit on tables, pictorial baskets with desert creatures, jar-shaped baskets that could be wastebaskets or umbrella stands, and lidded baskets for sewing baskets. They also appreciated fine stitching and miniaturization. Miniature baskets of horsehair became popular in the 1970s. It was, however, the Tohono O'odham who ultimately developed the most thriving basket production, using desert materials of yucca and bear grass that gave a distinctive look to their baskets. The Tohono O'odham continued to innovate basketry, developing the more efficient split-stitch style. Men entered the women's craft with wire baskets made from bailing wire. Today, the Tohono O'odham Basketweavers Association is working to redevelop an interest in weaving—especially among younger people—and to ensure that weavers receive a good return on their baskets.

"Grandmother made pinole. People came around to buy it and her baskets. That's how we lived. She taught her daughters to make baskets, my mother and my Aunt Martha, they all made baskets." FRANCES KISTO, AKIMEL O'OTHAM, SALT RIVER PIMA-MARICOPA INDIAN COMMUNITY

EUGENE LOPEZ, TOHONO O'ODHAM. *Basket,* c. 1970, 12.5 x 11. "Eugene Lopez is the weaver who brought the wire basket to the public. He has done a lot of wire baskets that have amazing shapes and sizes. He has taught classes. He now works with bailing wire baskets. He gets the wire from cowboys, who leave it out when they are finished with the bails of hay. He strings it and works it and weaves baskets. He also taught his niece how to weave wire." Terrol Dew Johnson, Tohono O'odham. Gift of Mr. and Mrs. Byron Harvey III.

"The most interesting thing about our tribe is that we can travel 400 miles to the south, and we can return to our ancestral land near the ocean. Our relatives in Rio Yaqui live in the same type of home that was documented by the scribes of Captain Diego Guzman, the Spanish explorer, in 1533. They still follow the ways of our ancestors." AMALIA A.M. REYES, PASCUA YAQUI

FACING: ALEX MALDONADO (B. 1959), PASCUA YAQUI. *Harp*, 2004, 46 x 15.5 x 32. "Harps have been used for a long time since they were introduced to our tribe by the Spaniards. Catholicism was also introduced into our culture. So there's a combination of old traditions and what we consider new traditions, even though it was introduced probably almost 400 years ago. The harp is usually used in our ceremonies, whether it's funerals or baptismals or celebrations, and also social events. Generally, when the harp is being played, we have a dancer called the pascola, and he dances in front of the harp. The harp is accompanied by the violin. So that's what we consider the newer tradition. The old traditions would consist of a drum and a flute played at the same time by a person called tampaleo." Alex Maldonado.

Alex Maldonado, Pascua Yaqui, 2004. Gloria Lomahaftewa, photographer.

THE YAQUI LIVE IN TWO COUNTRIES. Some live in the homeland along the Yaqui River in Sonora, Mexico. Others live in Arizona communities at Penjamo (Scottsdale), Guadalupe (near Tempe), Yoem Pueblo (Marana), Old Pascua, Pascua Yaqui and Barrio Libre (all three in Tucson).

Oral traditions tell how Itom Achai placed The People, Yaqui, along the fertile river bottoms of the Yaqui River, an oasis in the middle of the desert.

Those who fled to the United States found work in Yuma, Tucson and Phoenix in agriculture or the railroads. Building temporary communities where they found work, these places have now become home. The once rural communities have been surrounded by urban sprawl. None of their settlements had reservation status until 1964, when the U.S. government granted the Yaqui 200 acres of land near Tucson for the community of New Pascua. In 1978, the Yaqui became a federally recognized tribe.

The Yaqui have been called an enduring people. They survived centuries of warfare to retain their land and endured forced removals, enslavement and assimilation. By 1910, they were the most dispersed Indians in North America, with thousands deported to work as slaves on the Yucatan plantations. A thousand or more fled to the United States, scattering across 3,500 miles. In 1937, a Mexican presidential decree established a third of the original territory as the Yaqui Indigenous Zone, an unprecedented recognition of Yaqui land claims in Mexico. The Sonoran Yaqui continue as farmers and ranchers in their homeland along the Yaqui River.

"For the Yaqui people, the fact that we retain 485,000 hectares in the State of Sonora, Mexico, is a historical marker in itself, since many wars took place to remove us from the land."
AMALIA A.M. REYES, PASCUA YAQUI

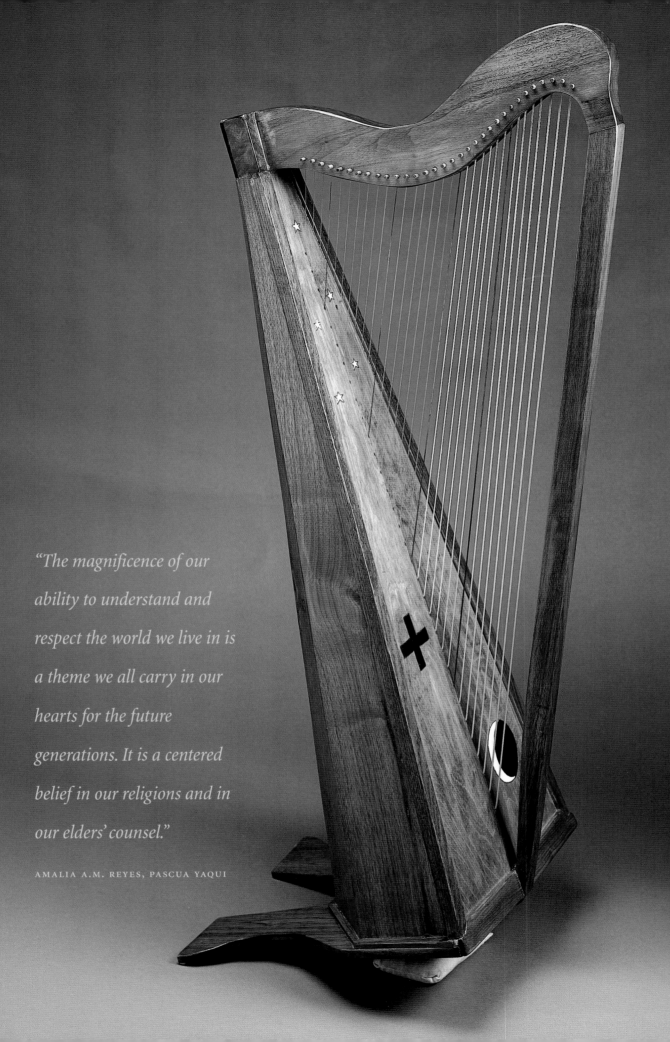

"The magnificence of our ability to understand and respect the world we live in is a theme we all carry in our hearts for the future generations. It is a centered belief in our religions and in our elders' counsel."

AMALIA A.M. REYES, PASCUA YAQUI

FAMILY AND COMMUNITY Before contact with Europeans, the Yaqui lived in communities of 300 to 400 people, in dome-shaped houses with adjacent ramadas or shade structures with no walls, where much of the food preparation and sleeping in hot weather occurred. They grew amaranth, beans, corn, squash and cotton in non-irrigated fields.

Beginning in 1617, the Jesuits consolidated the Yaqui into eight communities of 3,000 to 4,000 people. The towns, based on a Spanish model, centered on a plaza with a walled church and public buildings flanking the town square. The Yaqui adopted a new style of house in these towns, rectangular wattle-and-daub with fenced household compounds. The rural areas maintained the scattered dome-shaped home settlements. Wheat, peaches, figs, sheep, cattle and horses were supplied by the Jesuits and successfully grown.

The Spanish introduced a new social institution, the system of godparents (compadrazco), with obligations for rites of passage such as baptism, confirmation, induction into ceremonial societies, marriage and death. This enabled families to create family-like support when actual families were torn apart by deportations or flight. The Yaqui continue this practice in ceremonies today.

When many of the Yaqui left their homeland at the end of the 19th century, they established towns in other parts of Mexico and Arizona around a central, open-front church suited to their ceremonial needs. The Yaqui have maintained a cultural identity through connection to their homeland and continuing the practice of ceremonies in new communities.

SCENTS AND FLAVORS OF HOME

"The flowers and plants of the desert, the smell of water where the fish are, the smell of the dirt from the home that I built. Unfortunately, it's not where I live today. You don't smell that today. You smell car fumes, metal and plastics, and they just don't feel right to me. Glass and brass, it's not me. A favorite dish is a pudding made from mesquite pods that they grind up like a flour. Mesquite pods have a kind of caramel flavor, and they can be used to make tortillas or bread. But my grandma would make this pudding for us. I remember her grinding the mesquite pods. It was really sweet and delicious. I've made it a few times for my nephews and they really like it, but it's something we don't do too much any more. When I was 4, I still remember sitting in their adobe house on the dirt floor and her cooking the pudding on the stove, using pods from the mesquite tree in her front yard, right in front of her kitchen. It's one of the few memories I have from a really young age—about that mesquite pudding. It's really good." MERCED MALDONADO, PASCUA YAQUI

LANGUAGE The Yaqui and Mayo Indians of Sonora, Mexico, speak related dialects called Cahita, a Uto-Aztecan language. After centuries of living with the Jesuits, modern Yaqui is an amalgam—65 percent of modern Yaqui words are borrowed from Spanish. A study of language speakers in Pascua Yaqui in 1993 by Dr. Octaviana Trujillo found that more than 80 percent of both children and adults spoke English. More than three-quarters of adults, but fewer than half the children, spoke Spanish. Yaqui was spoken by less than a quarter of adults, and 10 percent of children were Yaqui speakers. Cultural revitalization programs and the Yaqui language are taught by the Pascua Yaqui Tribe and at community colleges in Tucson and Phoenix.

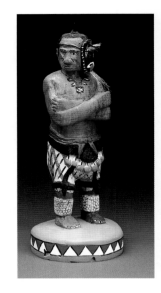

ALEX MALDONADO (B. 1959), PASCUA YAQUI. *Figure*, 2004. "The pascola in this carving is just waiting his turn to dance. He's taking a little rest. And he's also the elder. There are usually three pascolas that dance, and there's always an elder. Sometimes four, but generally there's three. When he's not dancing, he's got a wooden mask on the side of his face because he's not going to be wearing that all of the time. Sometimes he'll put it on the side, sometimes he'll move it all the way on the back of his head. The necklace that he wears, hopo 'orosim, is also part of the regalia. It's for protection. Around his ankles, he would be wearing butterfly cocoons. Tenevoim is what they're called in our language. They're like rattles. They'll make a lot of noise, and they're filled with little pebbles. A pascola dances with rhythm." Alex Maldonado.

"Rio Yaqui is home. Guadalupe is home. And, to me, also, home is a way of life." MERCED MALDONADO, PASCUA YAQUI

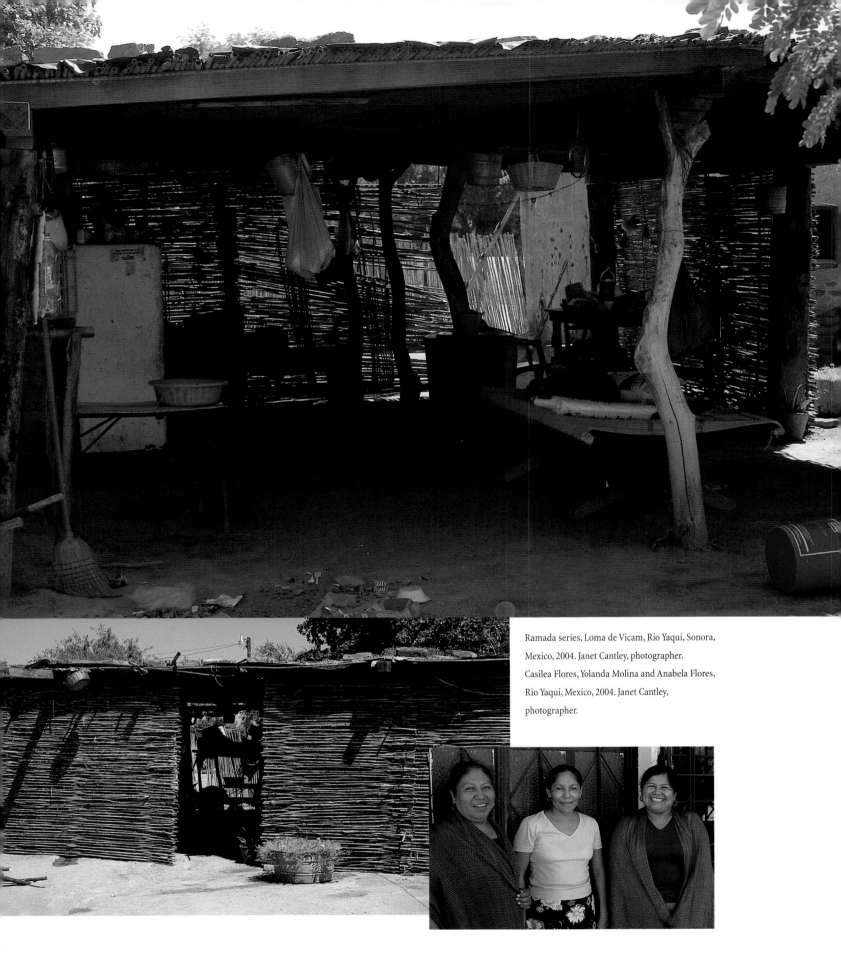

Ramada series, Loma de Vicam, Rio Yaqui, Sonora, Mexico, 2004. Janet Cantley, photographer.
Casilea Flores, Yolanda Molina and Anabela Flores, Rio Yaqui, Mexico, 2004. Janet Cantley, photographer.

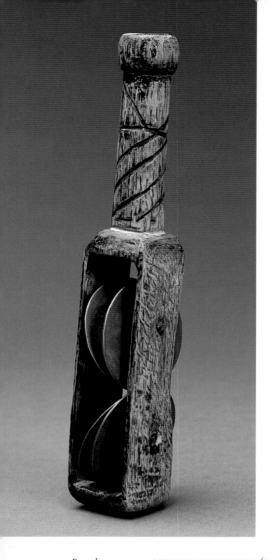

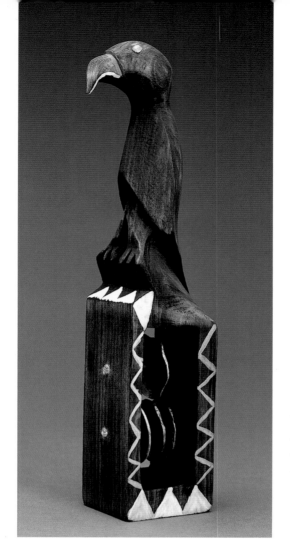

FACING, LEFT: YAQUI. *Pascola mask,* early 1900s, 20 x 6 x 5. This mask was made at Potam village in Sonora, Mexico. The cross on the forehead protects the pascola dancer during ceremonies. FACING, RIGHT: MERCED MALDONADO (B. 1956), PASCUA YAQUI. *Torim mask,* 2004, 8.5 x 11 x 7.5. "This is the mask of Torim. He's like a tree rat. In our stories, he is the first drummer, but we also call him Tampaleo. But he doesn't just drum, he also carries a melody. He whistles through his teeth, and he's the one who originated our cane flute. We don't have teeth like he does or a mouth shaped like his; his mouth is actually like a flute. The red spots on his chin represent pomegranates. When I made this mask, I imagined that he was eating pomegranates— really enjoying them—and he's got all these seeds on his chin. I carved the teeth out of a buffalo rib that I had at home, because I wanted something that was just like teeth. You can see the little hole that he would be whistling through. So this is Torim." Merced Maldonado.

YAQUI. *Pascola rattle,* 1960s, 8.25 x 1.4. Gift of Mr. and Mrs. Byron Harvey III.

MERCED MALDONADO (B. 1956), PASCUA YAQUI. *Buzzard rattle,* 2004. 12 x 2.6. "This is a story about a buzzard and a man who is always dreaming of things. He wants to have magic powers to go underground and visit caverns. He sees the birds, and he wishes he could fly. And he sees men that play harp or violin, or whatever talents they have, and he wishes he had that talent. And some of them are willing to teach him, but he's lazy. He starts something, and then he goes back to a shade tree and then is daydreaming and wishes he could just magically get that power, have that instant knowledge. And so he listens to a lot of stories about magic. He wants the easy road. So one day he's looking at all these birds flying above him—eagles, hawks, buzzards, vultures—and he's saying, 'I really wish I could fly, and, boy, look at those buzzards, they really fly the best. They don't have to flap. I just want to kind of like cruise around in the sky. I don't want to have to do any real work.' He's admiring that buzzard and speaking out loud. And that buzzard hears him, and he flies down and he lands on the tree next to him. And the buzzard says to him, 'I've heard your wish.' So this buzzard is an enchanted bird and he says, 'I can grant you your wish, but I have to warn you, being a buzzard is not easy. A lot of times, we don't have anything to eat. So, if you choose to take my place, you're going to know hunger.' The man's not listening. He just wants to be able to fly, so he says, 'Yeah, yeah, sure, I'll do it.' And so the buzzard says, 'I'll give you seven days, and then we'll meet again and we'll change back.' So, he takes off his suit of feathers and he hands it to the man, and the man strips himself of his shirt and his pants and gives him his clothes. And as they change clothes, they become each other. The man becomes a buzzard and the buzzard becomes a man. But they still end up retaining some of their own traits. So the buzzard is not having a good time being a man because he does not know how to walk and he smells like a buzzard. And the man is spending all his time looking for food and not having any time to fly, and he really learned what it meant to be hungry. So when they meet after seven days, the man says, 'I'm ready to be a man again. I will never wish to be a buzzard again, because now I really know what it's like to be hungry.' And it helps this man, because all the jobs require some kind of hard work." Merced Maldonado.

"As a pascola when we're in ceremonies—especially funerals and anniversaries—we bring the humor, and we really have to turn around all the sadness at funerals. It almost sounds like we're making fun, but we're not. We're just turning feelings so that people are not so sad, *feeling so much pain."* MERCED MALDONADO, PASCUA YAQUI

PASCOLAS Every Yaqui fiesta must have a pascola. He is the host of the fiesta, the master of ceremonies whose behavior during the fiesta is full of contrasts. He is serious and he clowns. He is an orator, and he is a mime. A major fiesta may have several pascolas. The name pascola is a combination of two Yaqui words: pahko, which means fiesta, and ola, which means old man. The pascola has three musicians associated with him. One plays the harp, one plays the violin and one simultaneously plays the drum and flute. The pascola begins his dances with his mask on the side or back of his head, accompanied by the harp and violin. Next, he dances to the flute and drum with his mask on his face.

Fiestas may be associated with major religious holidays or smaller private events, such as a birthday or a death anniversary. Most fiestas begin at sundown and continue through the night, ending early the next day.

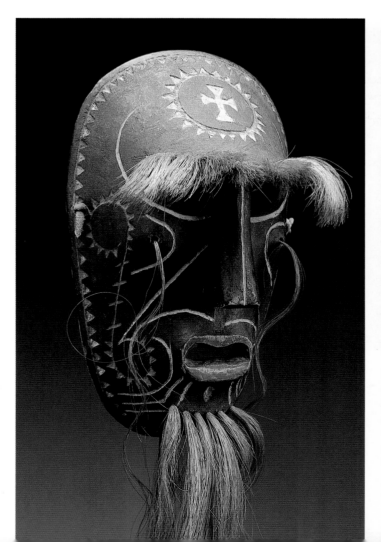

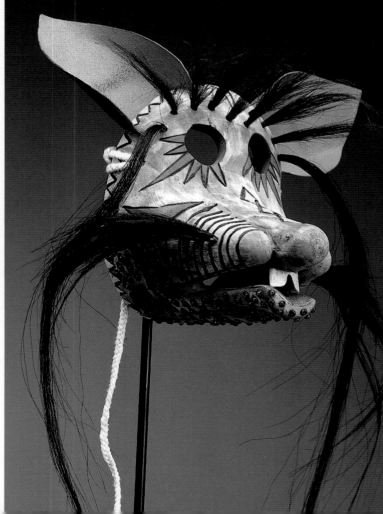

8 Defending Home

"I volunteered my service for this country. I was a Japanese prisoner of war in the Philippines. I survived with a determination to come back because of my people and my land." TONY REYNA, TAOS

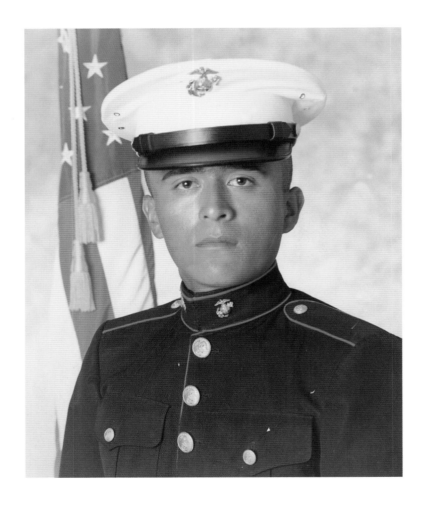

Jesse Monongya, Navajo, while in the United States Marine Corps, 1972. United States Marine Corps, courtesy of Jesse Monongya. During Jesse Monongya's eighteen months of service in the Marine Corps, he won several medals, including this one for rifle sharpshooter. Craig Smith, photographer.

RIGHT: Paul Saufkie and son, Lawrence Saufkie, Hopi, 1993. After returning home from World War II, Paul Saufkie began work as a silversmith. He taught the art not only to other Hopi veterans, but also to his son, Lawrence. Owen Seumptewa, photographer.

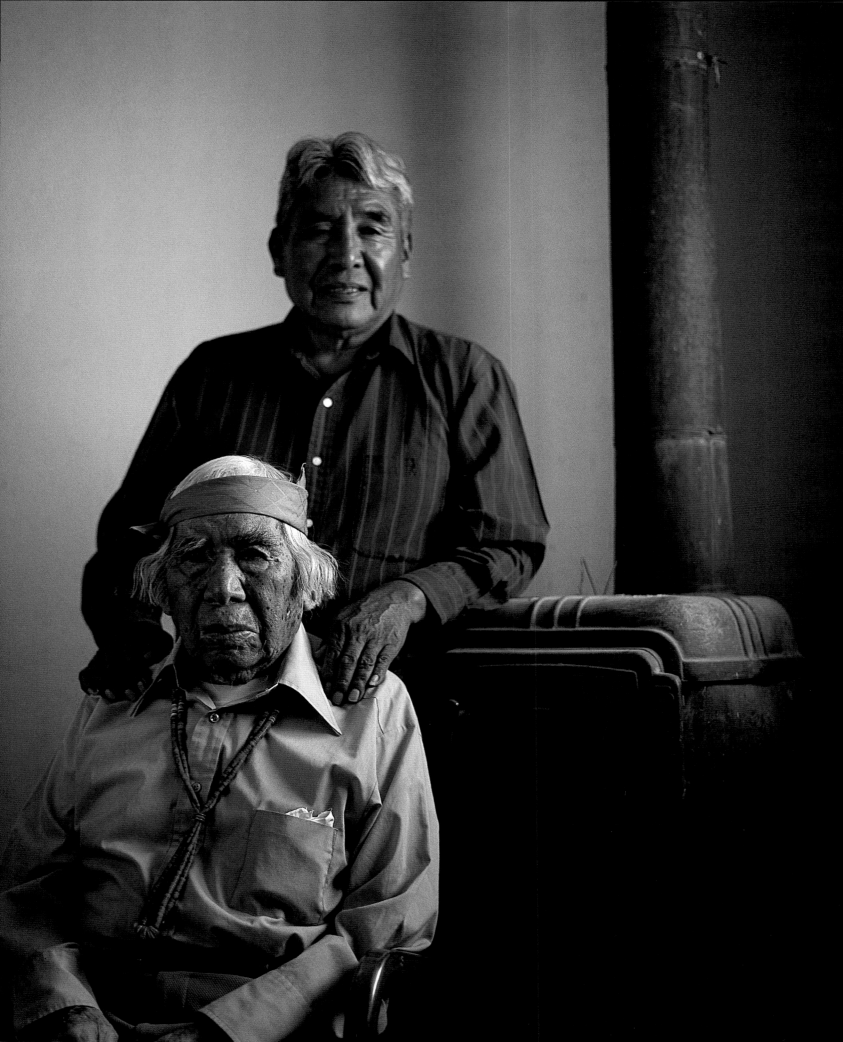

"My dad would get letters from my Uncle Blackie, who was in Vietnam. We'd go to Grandma's and he'd translate them into Indian for her. Then she would make care packages for him with chili, bread, cookies and jerky."

MARIE REYNA, TAOS

NATIVE AMERICANS AND THE MILITARY Native Americans are three times as likely to have served in the military in the 20th century as the rest of the population. It has been said they were pulled by patriotism and pushed by poverty. The military also offered opportunities for education beyond high school as well as vocational training and employment.

During the Civil War, Maricopas, Akimel O'otham and residents from Sonora served in the Arizona Volunteers, replacing regular Army troops as defenders of the region against Apache and Yavapai raids.

During the Indian Wars of the 1870s, 10 Apache scouts were among the early recipients of the Congressional Medal of Honor. In the 20th century, six American Indian soldiers have received this honor.

The most famous American Indian military participation was the Marine Corps Code Talkers of World War II. The military had some experience from World War I with the use of Native languages, especially Choctaw, but speakers of Oneida, Ho Chunk, Sac & Fox and Comanche also were recruited for the Signal Corp. However, it was not until World War II that an actual code was developed using the Navajo language. The Navajo language seemed particularly fit for the task because of the comparatively large number of speakers, and because it was not a written language that would be known to the enemy. Also, the Navajo tended to develop their own descriptive words for something from the outside world rather than simply adopting the foreign term. Twenty-nine people were in the original group, and 375 to 420 more were trained later. Due to continued use of the code, the actions of the Code Talkers remained secret until recognition began in 1968, culminating in the award of Congressional Gold Medals in 2001 to the original Code Talkers and Silver Medals to those who later qualified.

Among the best-known soldiers was Corporal Ira Hamilton Hayes, Akimel O'otham, from Sacaton, Arizona, on the Gila River Indian Community. Hayes enlisted in the Marine Corps Reserve in 1942 and trained as a parachutist. He took part in hard-fought Pacific campaigns including one of the final battles of the war on the island of Iwo Jima. He and five fellow Marines were photographed at the moment when they raised the flag on Mt. Suribachi in the midst of battle. The image came to symbolize the incredible struggle and ultimate victory of the war.

Many distinguished Native artists first served in the military. Following World War II, some soldiers who returned to their homelands took up jewelry making and excelled at that art form. Some Hopi veterans participated in a special GI program that provided 18 months of training in silversmithing taught by Paul Saufkie and Fred Kabotie. It is estimated today that Native American men and women constitute 10 percent of all living veterans, and the American flag is often incorporated in a wide range of art.

LORENZO REED, NAVAJO. *Carving,* 2002, 20.75 x 11.5 x 5.25. In recent years, recognition has been given to Native servicemen who used their language to communicate military information during World War II. Known as Code Talkers, this carving represents two Navajo servicemen. Other Native people including Hopi and Comanche also served in this capacity during the war.

NAVAJO. *Bracelet,* 1940s, 2 x 3.5. This bracelet belonged to someone who received a Purple Heart medal in World War II. It's set in a bezel of heavy twisted wire and flanked by turquoise stones. Fred Harvey Fine Arts Collection. Jeff Crespi, photographer.

"My grandmother worked two jobs and lived here in Phoenix in an enclave of the O'odham from the reservation. They came up to find work during the Depression. During World War II, it was easier to get communiqués in Phoenix than it was out on the reservation, so families would move up here."

GARY OWENS, PIIPAASH/TOHONO
O'ODHAM, SALT RIVER PIMA-
MARICOPA INDIAN COMMUNITY

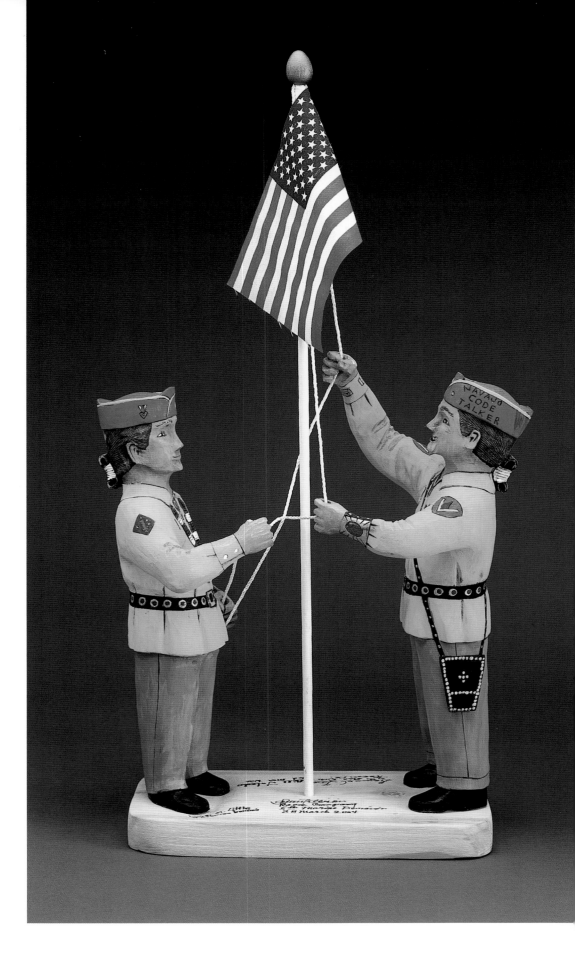

JESSE MONONGYA (B. 1952), NAVAJO. *Bracelet*, 1980, 1.75 x 2.5 x 2.25. Jesse Monongya began making jewelry following service with the Marines in Vietnam. Reviewing this bracelet, Monongya said, "This is one of the first pieces I did using high-grade stones—malachite and Royston turquoise. It is also the first one I did in this style of inlay. The design on the bracelet shows a Navajo sun face, and the dots around the face represent the Four Sacred Mountains." Gift of Mr. Jesse Lee Monongya.

LLOYD OLIVER, NAVAJO. *Bracelet,* early 1960s, 2 x 2.62 x 1.37. Lloyd Oliver was a Code Talker during World War II, and he was recognized for his participation in that capacity at veterans' events. This bracelet was made by him following the war. Gift of Mr. and Mrs. Byron Hunter.

ESKIESOSE, NAVAJO. *Belt buckle,* n. d., 2.5 x 1.5. "I've been in the military, and this is similar to one of the brass buckles that I used to shine all the time. The owner was probably in the military a long time and fell in love with the buckle and got home and had a silversmith do this overlay. And then somebody bought this beautiful spiderweb turquoise and included it in the buckle." Jesse Monongya, Navajo. Gift of Mr. C.G. Wallace.

"In the Marine Corps, I was in Okinawa for 14 months. I thought of home a lot. I'd close my eyes and picture my community. I could hear my father outside chopping wood—imagine my mother sitting on the ground over the open fireplace cooking our breakfast or making tortillas. I could hear over the ocean, dogs barking or children playing in the village. Early in the morning, I could hear the owl hooting. I'd get up early and go out and look at the stars. Espelo, that's really what we call the Morning Star. Way out there in the old fields, I could sometimes hear the coyote howling, and it would bring me back home, even though I was thousands of miles away." DANNY LOPEZ, TOHONO O'ODHAM

EDWARD BEYUKA, ZUNI. *Bolo tie,* c. 1969, 20 x 3.37. The artist is known for his figurative work such as this multipart bolo tie of a Plains dancer. The shield removes to become a pin, and the feather in the dancer's left hand detaches to become a tie tac. Edward Beyuka survived the Bataan Death March of World War II and took up jewelry making in 1956. Gift of Mareen Allen Nichols.

DAN SIMPLICIO, SR. (1917-1969), ZUNI. *Necklace,* 1945, 18. "This piece of jewelry was created by my father, Dan Simplicio, Sr., in 1945 soon after World War II. My father got wounded in World War II, which actually made him go through a long rehabilitation for recovery of his leg. Consequently, it restricted a lot of mobility for him. Being very sedentary also allowed him to sit and work on details for a long time. In this piece, there are a number of tiny little elements that required an extensive amount of time. These are all handmade drops that he did. He would actually get small pieces of silver, melt that down and shape it into a round ball. And while it's still hot, he would take a poker or prod and touch it to imprint the design on it while it's still flexible in a melted state. After it cooled off, he would solder it to the design." Dan Simplicio, Jr., Zuni. Gift of Mr. C.G. Wallace.

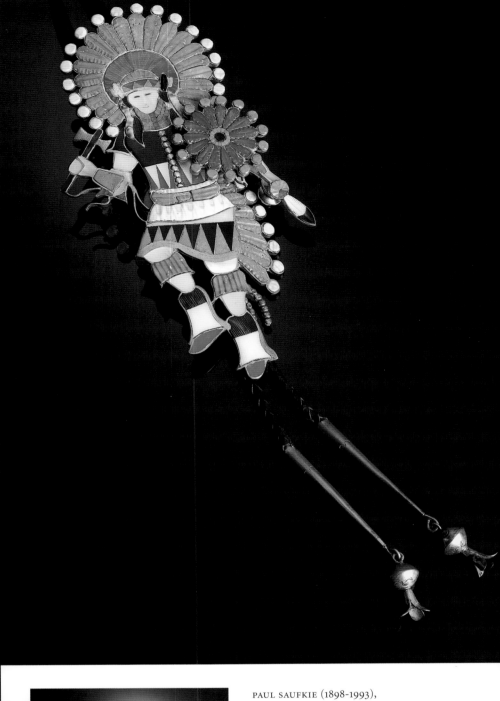

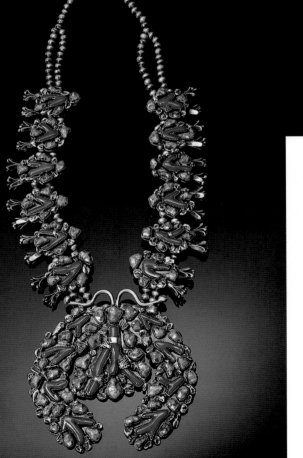

PAUL SAUFKIE (1898-1993), HOPI. *Belt buckle,* early 1960s, 2.25 x 3. Paul Saufkie was the principal technical instructor for the Hopi GI silversmithing program. Saufkie began making jewelry in the 1920s.

9 Home on a Path

"We are on a path together, at the same time, generations traveling together. My past and future are at my side; you are never too far from your past or future." KATHY SANCHEZ, SAN ILDEFONSO

"We know for a fact that we're stewards of the earth, and we care for the earth that we bring home to make our work with. And so for us, it is a sacred act of creation, that when we work with the clay, we're taking care of this little bit of real estate that you hold in your hand and make something that is of beauty, that is worthy of the earth." PRESTON DUWYENIE, HOPI

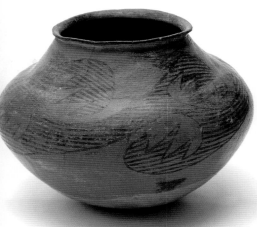

WESTERN ANCESTRAL
PUEBLO. *Tusayan black-on-red
jar,* A.D. 1050-1150, 8.5 x 12. This
bird wing motif was a popular one
at the time this jar was painted.

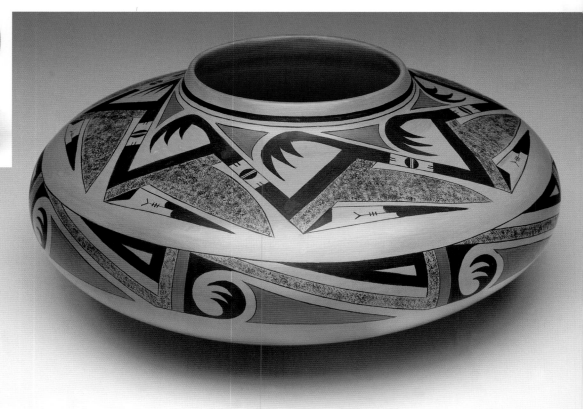

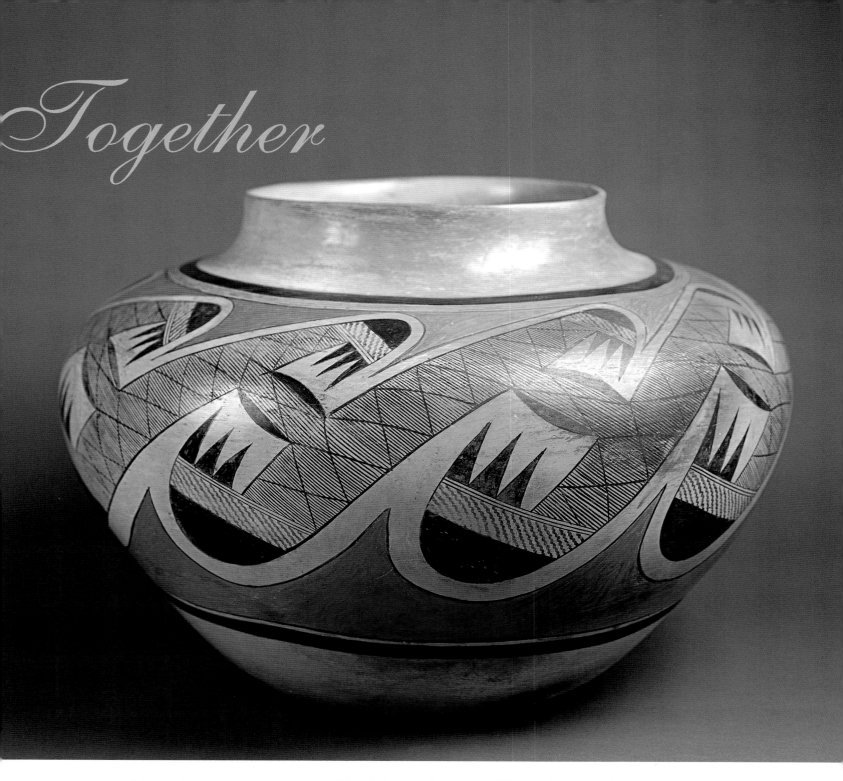

Together

NAMPEYO (1862-1942) AND FANNIE NAMPEYO (1900-2000), HOPI-TEWA. *Jar*, 1930s, 30 x 26. Gift of William and Louise McGee.

FACING: CAMILLE QUOTSKUYVA (B. 1964), HOPI-TEWA. *Jar*, 1991, 6.75 x 13.5. Like other innovative potters, Camille Quotskuyva, Nampeyo's great-great-granddaughter, created her own version of the bird-wing design. Purchased with funds provided by the Goldsmith Foundation.

The bird-wing motif has been reinterpreted through the centuries to become a distinctive motif of Nampeyo family potters, who consider the motif to represent a migration pattern.

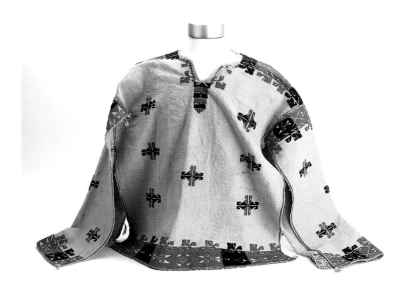

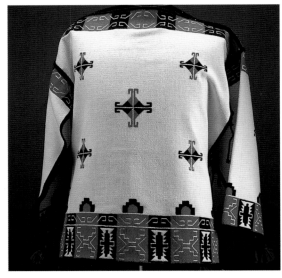

JEMEZ. *Shirt,* late 1800s, 30 x 24. When textile artist Lorencita Bird, San Juan, saw this shirt, she said it was made by a man who was an accomplished weaver and embroiderer. She pointed out that the design represents seven stars and may refer to the "Seven Sisters" of the Pleiades constellation. Fred Harvey Fine Arts Collection.

RAMONCITA SANDOVAL (B. 1923), SAN JUAN. *Shirt,* 1986, 28 x 24.

These men's shirts are separated by nearly a century, and yet share design similarities and evidence of their makers' care and talent.

Swirl designs have variously represented water and a migration path. In a dry land, the migration path and water are linked throughout time.

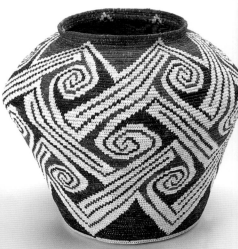

ANNIE ANTONE (B. 1955), TOHONO O'ODHAM. *Basketry olla,* 2001, 12 x 11. In this basket, Annie Antone has used a design from ceramics of ancestral desert people, the Hohokam. The ability to create curvilinear motifs on basketry is a particular achievement of this artist.

HOHOKAM. *Santa Cruz red-on-buff plate,* A.D. 900-1150, 4 x 19. At the time this plate was made, the success of Hohokam water management was making it possible for people to live together in larger settlements.

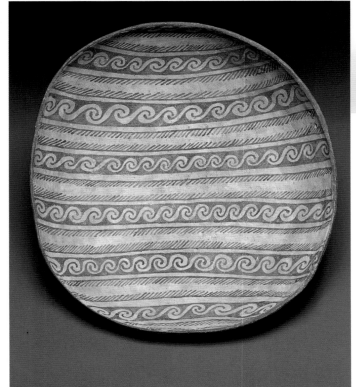

THE PEOPLE WHO CREATED THIS ART have been listening and watching as elders passed on ideas and ways to create beauty. They bring original expressions to a shared idea. Today, future artists are watching, listening and learning. They innovate as they honor the past and offer inspiration for the future.

> "We pray for the world, that the people of the world will embrace harmony, that they will show respect, tolerance, acceptance for each other, and for all living things. This is what my people have taught me, and it is my responsibility to continue living this way of life. In doing so, I am telling my ancestors, 'I'm still here practicing your teaching so that my children and all other generations will continue to practice this way of life—life will go on and on, even after I'm gone.'" RACHELE AGOYO, COCHITI/SANTO DOMINGO

The Laughter of children, of women / The serious talk of men / The voices of the old people / Worn and tired from their journey of age / Talking, talking and praying / Their knowledge will pass on / To all willing to receive it. OFELIA ZEPEDA, TOHONO O'ODHAM

Mosaic jewelry has been made for centuries by artists who excel in fitting the pieces together like a puzzle.

ANGIE REANO (B. 1945), SANTO DOMINGO. *Mosaic shell pendant,* 2003, 2.75 x 2.9 x .5. *Bracelet and ring,* 1986. Bracelet 3.625 x 3.25 x 1; Ring 1 x .5. "The shell dictates to me a design, the work, the material I'm going to use. There are times that I plan on using certain stones, but then it doesn't look right, so I don't use it. I kind of visualize as I'm gluing because, as you're gluing, you're going to see a lot more glue than the material, so you kind of have to visualize the end product, how it's going to look." Angie Reano.

HOPI. *Earrings,* c. 1900, 1.5 x 1.25. The mosaics on these earrings represent kernels of corn, a life-giving food for the Hopi people. Gift of Mrs. Joseph C. Green.

CHARLES LOLOMA (1921-1991), HOPI. *Bracelet,* 1975, 3 x 3.5 x 1.625. This bracelet is made of gold, ironwood, lapis, yellow shell, coral, turquoise, mother of pearl, malachite and fossilized ivory. It has 148 separate stones and is made in the style that Charles Loloma called a height bracelet. Height bracelets represent the Southwestern landscape, with the various sized and shaped stones of uneven height echoing the mesas and buttes of the Southwest. Heard Museum purchase assisted by donations from Ms. Mary Hamilton, Mr. and Mrs. Dennis Lyon, Mrs. Carolann MacKay and Mrs. Mareen Nichols.

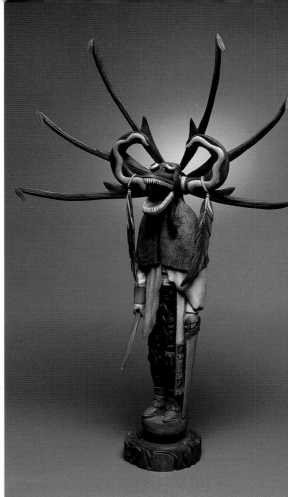

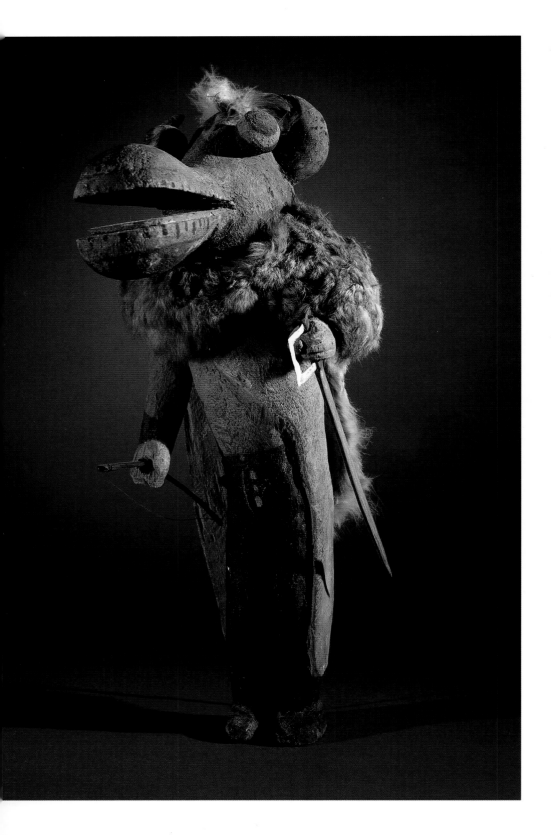

LEFT: HOPI. *Nata'aska,* c. 1900, 18.5 x 7 x 4. This is an uncle of the ogre family who frightens the children by his appearance with a threatening big sword or saw. This carving by an unknown artist inspired carver Brian Honyouti as he carved his version of the Nata'aska. Both old and new carvings stand very still, feet together, increasing in size as they rise from the ground. They are figures of power. Gift of Senator Barry M. Goldwater.

ABOVE AND DETAIL FACING: BRIAN HONYOUTI (B. 1947), HOPI. *Nata'aska or Ogre katsina doll,* 1998, 33.25 x 23.125 x 10. This ogre, who demands correct behavior from people, rages against what people have done to the environment. He stands on a base with petroglyph symbols representing all life —humans, animals and plants—with a spiral symbol showing their common origins from the earth. The carver's initials "BH" also are on the base to indicate the ogre's message is for him as well, and for each person to consider how they can change their personal actions to improve the quality of their homeland.

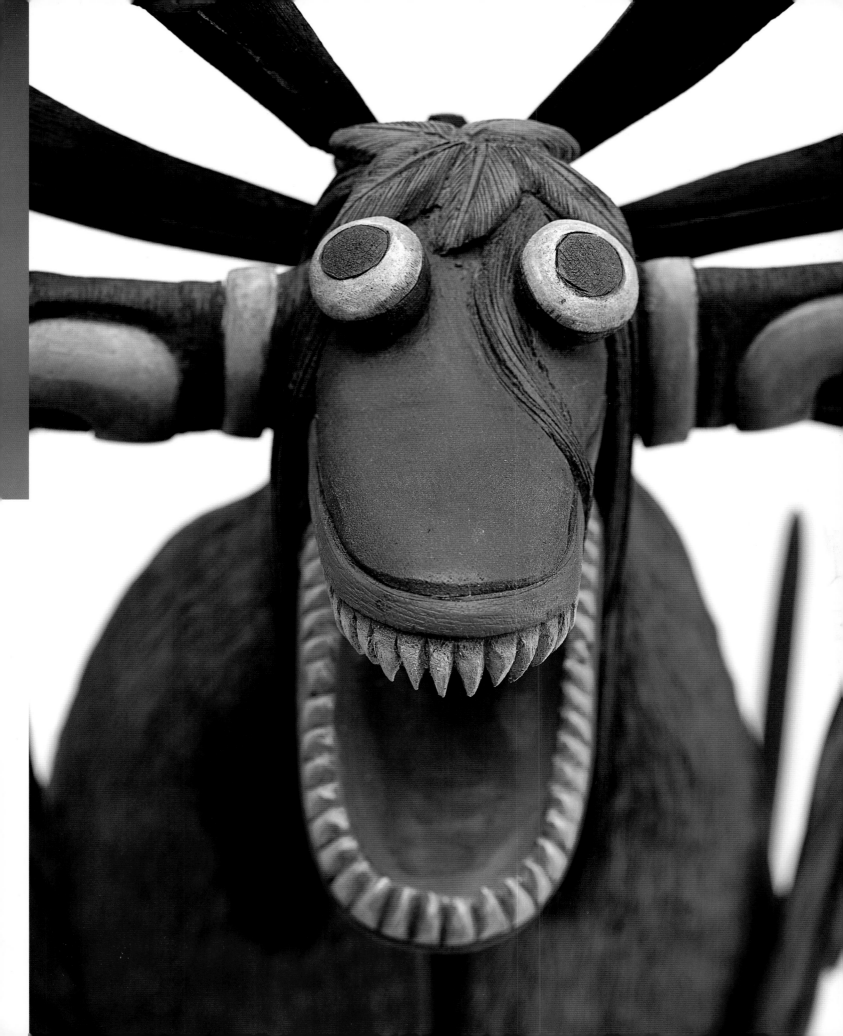